Con/Artist

THE LIFE AND CRIMES OF THE WORLD'S GREATEST ART FORGER

TONY TETRO

AND GIAMPIERO AMBROSI

NEW YORK

Hachette Books
Hachette Book Group
1290 Avenue of the Americas
New York, NY 10104
HachetteBooks.com
Twitter.com/HachetteBooks
Instagram.com/HachetteBooks

First Edition: November 2022

Published by Hachette Books, an imprint of Perseus Books, LLC, a subsidiary of
Hachette Book Group, Inc. The Hachette Books name and logo is a trademark of
the Hachette Book Group.

The Hachette Speakers Bureau provides a wide range of authors for speaking
events.

To find out more, go to www.hachettespeakersbureau.com or call (866) 376-6591.

The publisher is not responsible for websites (or their content) that are not owned
by the publisher.

All images used by permission. The two photographs on the lower half of page
one of the art and photograph section, the top photograph on page five, and the
bottom right photograph on page six are by Peter Calvin. The photograph at the
bottom of page four is by Steve Kimball. All other images are presented courtesy
of the authors.

Print book interior design by Linda Mark.

Library of Congress Control Number: 2022943897

ISBNs: 9780306826481 (hardcover); 9780306826504 (ebook)

Printed in the United States of America

LSC-C

Printing 1, 2022

*In memory of Officer Thomas Wallace
and with gratitude to Severino and Santina
Ambrosi*

Corot painted 3,000 canvases, 10,000 of which have been sold in America.

—René Huyghe, former chief curator,
Louvre Museum

Contents

Contents

Prologue
(April 18, 1989)

I WAS LYING ON THE COUCH FALLING ASLEEP WHEN I HEARD A rustling at the front door and someone saying, "Tony? Tony? You there?" I said, "Yeah," and the next thing I knew twenty-five cops burst into my condo. The first thing one of them said was, "A man just gave you eight thousand dollars in cash. I'm going to need that back right now." It was true, so I handed the money over immediately.

The cops began demolishing my place, slicing up the wallpaper, pulling up the carpets, emptying all the drawers. The whole time I sat there on my couch sweating bullets, staring up at my secret room, which was reflected in the mirror on the mantelpiece. The room was in an odd-shaped space behind the upstairs bathroom. If you pressed #* on the cordless phone, a full-length mirror would pop open and reveal my secret stash of special papers, pigments, collector stamps, light tables, vintage typewriters,

certificates of authenticity, notebooks with signatures—everything a professional art forger might need.

The cops were rifling through my medicine cabinet, knocking on the walls, checking inside the toilet tank. If they had found my secret room, I would have been buried for real. The whole time, the cops were going back and forth to a big truck, filling it with artwork, boxes, books, anything they could find. Finally, after six or seven hours, the chief detective decided they'd done enough and told everyone to quit.

Everybody stopped what they were doing and walked out. I breathed the biggest sigh of relief in my entire life. But they didn't really leave. They just stood around at the doorstep. There was a long, uncomfortable silence. I was confused. I started to stand up because I thought they were waiting to handcuff me. One of the cops waiting on the doorstep caught my eye, raised his eyebrows, and gave me a shit-eating grin.

Then, the chief detective turned around and shouted, "OK, second walk-through!" and all the cops rushed back in, switching places and calling out, "I got upstairs now, I got the bathroom, I'm over here." My heart dropped out of my ass. I collapsed back on the couch and went completely numb.

If they found my secret room, the life I had been living would be over.

one

"NOW YOU'RE GONNA SLEEP IN IT"

(1950 to 1969)

FULTON, THE SMALL TOWN WHERE I GREW UP, BILLED ITSELF as "The City with a Future." My father called it the asshole of New York. Today it's just another Rust Belt casualty, but then, it was a thriving all-American town populated by Italian and Irish immigrants who pledged allegiance, went to church, and worked hard at one of the factories—Sealrite, Armstrong Cork, Miller Brewing, or Nestlé, making chocolate, which you could smell from across the river when it was about to rain.

We all dropped our native languages, accents, and foreign names and got on with the business of making it in America. We played baseball, rode our bikes, and swam at Fair Haven Beach on Lake Ontario, where I would spend all day building and decorating elaborate sandcastles. We attended Rotary Club and had charity carnivals for the volunteer fire department. And though we traded insults—us calling the Irish kids "micks," and them calling

us "guineas," "goombahs," and "greasers"—it never led to any real animosity. Every Italian guy ended up marrying an Irish girl and every Italian girl married an Irish guy. Even one of my own best friends, Gary Battles, married Rosalie Arcigliano.

My father, James, who everybody called The Gump because of his resemblance to Andy Gump, the 1930s cartoon character, had come over from Bari, Italy, as a child, living first in the Bronx, where he carried ice blocks up the tenement stairs of Arthur Avenue, before moving to central New York. My mother, who had entered Ellis Island from Sicily as Beatrice Di Stefano, came out as Bee De Stevens and married my father at the age of eighteen. They bought a house, had four kids, and got on with getting ahead.

The curve of First Street where we lived was called Spaghetti Bend. It was the center of what had been the Italian part of Fulton for decades. In the thirties people called Fulton "Little Chicago" because of its reputation for Al Capone–style killings and the fact that it was the mob's stronghold in central New York. When I was growing up, the mob was everywhere, but it was low-key and un-remarkable—just part of the atmosphere that you breathed. At the Italian American Club on Broadway, you could see the bosses, Anthony Di Stefano (no relation to my mother) and Bobo Ranieri, playing cards while their entourages hung around, waiting. As far as I knew, they controlled jukeboxes, pinball machines, and the clipboards in every diner and café where you could bet on sports or play the numbers. If you were in trouble, you could borrow money—which everybody told you, "You better pay it back"—but there was no drugs or prostitution or anything seedy that I could see anywhere.

Of course, Fulton did seem to have a lot of failing businesses with paid-up insurance policies and faulty, fire-prone wiring. The Derby Lanes bowling alley, Gayle's Bar and Grill, the car dealership, the furniture store—all of them went up in flames. One of my brother's friends, Lefty Levy, told my brother about torching a few places and even his own car. Lefty had called it "Jewish Lightning." When Bobo Ranieri died, Fulton had a funeral that was talked about for decades, a procession of a hundred black Caddies, as far as the eye could see, coming to pay their respects.

It was impressive, but it didn't do much for me. My heroes weren't mobsters, they were Enzo Ferrari and Leonardo da Vinci— geniuses I could be proud of and aspire to. When I was young, Enzo Ferrari was still in his prime and his cars were absolutely dominant on the racing circuit. They were marvels of engineering, winning every race and overshadowing all the other manufacturers in the world. At the 24 Hours of Le Mans, while other cars flamed out or seized up, the Ferrari cars were so well engineered that they almost never broke down. They became the ambassadors for Italian artistry, breathtaking style, and design excellence, far superior to the bland and simple muscle cars Americans produced. As a child, it made me proud to think of a string of culture from ancient Rome to the Renaissance all the way through to these cars, and that I was in some small way connected to that. Every child constructs a story about where they come from and where they fit in, and I liked this one.

At school, I learned about ancient Rome, and at the time, Hollywood was full of epic films about the majesty and glory of the Eternal City. *Ben-Hur* had won eleven Academy Awards and filled my mind with panoramic, Technicolor images of opulence

and civilization. To think that my ancestors constructed hundred-mile-long aqueducts and that Roman homes had both hot and cold running water when other people lived unwashed in thatched huts impressed me.

I wasn't much of a student, slouching my way to solid Cs because I wasn't interested in most subjects. I was, however, always good at and interested in art. Even at just nine or ten years old I was copying photographs from books or magazines that my mother, an avid reader, would leave lying around the house. I remember once I copied, freehand, a photograph of Steve Reeves, the bodybuilder and actor from the movie *Hercules*. He was wearing his half toga, holding chains, and pulling down two columns—the pillars of mythical fame. When I finished my drawing, I proudly showed my mother, who praised me, but my oldest brother, Jim, belittled me, accusing me of tracing from the photo. "*No!* That's not true," I shouted, and then I showed him that my drawing was actually much larger than the photograph. I was deeply offended because I was very proud of my work.

Our town had a beautiful Carnegie library and it was there that the Mickey Mouse Club held its meetings. Every Tuesday night after dinner, we'd troop downstairs with our ears on to sing songs and learn about the practice of good citizenship according to the gospel of Walt Disney. After our meeting, I'd wander over to the art section and leaf through Abrams art books, looking at the pictures.

My father, who thought I might be musical, bought me a guitar and arranged for me to have lessons. It was a futile waste of *my* time and *his* money. But my mother, who noticed that I had a talent for art, bought me a beginner's set of oil paints. It had little

tubes of color and four or five brushes, some thinner, and a small stack of eight-by-ten canvas boards. I'd practice at the kitchen table while my mother cooked dinner nearby. When I'd get started, I'd be engrossed in what I was doing, but being only a child, my attention would start to wane after a while. Still, I was ambitious with what I painted. I tried a portrait of my dog, Duke, but I didn't yet know how to capture the way light hit the dog's hairs. My mother's friend, Mrs. Pommeroy, once complimented me, saying she thought my painting was wonderful. Instead of being proud, I said I wasn't happy at all and that I had done much better on other occasions. Even then, I was demanding of my efforts.

At Holy Family Catholic School, where I attended junior high, we were under the strict rule of grim nuns who wore full penguin habits and handed out education and their own shriveled sense of discipline—also known as corporal punishment—in equal measure. I used to draw my teacher, an old nun, as a Vargas pinup girl—long luscious legs, curvy hips, plump breasts, and a sour, wrinkled Sister Antoninus face. When she finally caught me, she smacked me hard across the knuckles with her pointer and dragged me down the hall by the ear to the principal, Father Hearn, who struggled to suppress his chuckles and made me promise to knock it off.

High school was the first time I had any real instruction in art. My teacher was a college graduate in art history who encouraged us and introduced us to the great painters and to concepts like perspective, color theory, and technique. For a lesson on abstract art, I remember I did a clumsy painting of a female nude. I got a failing grade, but nobody pulled me out of class by the ear for it. For a class on perspective, I drew a detailed view of the room, showing

everything I saw in front of me. I received an A+ and was very proud. This time, I felt like I deserved it.

At night, I'd go to the public library and head downstairs past the newest class of Mouseketeers to spend hours looking at artists I had only barely heard of. I didn't understand Picasso, and Mondrian did nothing for me. I didn't get the point of mastering all that technique just to make geometric shapes with primary colors.

My teacher showed us Chagall, calling his work "visual poetry," and it was true, I could see the poetic movement of color. We were introduced to Dalí, the whole class being asked to repeat after the teacher: "Sur. Realism." Dalí was weird, but I was impressed by his imagination and thought I couldn't have come up with that kind of unusual imagery. Pointillism, to me, seemed too laborious; carefully filling in dots of color on a big canvas seemed like a waste of time. I liked the Impressionists. Their paintings were pretty and I could recognize talent in them. But to me, all of this modern art lacked soul.

What really struck a chord were the old masters and Renaissance painters. Now, my mind is trained, but then, I used to think, "How could they think up all these things—the sky, the angels, the crucifixion, the people and their expressions, the clouds, the light?" I thought it was magical that they could do that. I didn't feel that kind of awe about modern painters.

I started to learn about artists like Perugino, Verrocchio, Michelangelo, Raphael, and Botticelli, but Leonardo was the greatest hero of them all, although when I was young, I was more fascinated by Leonardo the engineer and scientist than Leonardo the artist. I was drawn to his notebooks, with their ingenious feats of

engineering: his aqualung, his flying machine and parachute, the war machines, his intricate studies of human anatomy, the enigma of his mirrored handwriting. You can see how that would have captivated a boy my age.

Michelangelo was the first artist I loved solely for his art, the Sistine Chapel and the Pietà. I remember reading as a boy that Michelangelo was only twenty-two when he started working on the sculpture, laboring alone for three years. And I remember reading that Michelangelo had heard others saying that his masterpiece had been made by one of his rivals. Outraged, he sneaked into the Vatican and carved his name on the sculpture—the only artwork he ever signed. I don't blame him. It's ironic considering what I do, but years later when I forged a piece that somebody else claimed, I think I understood what Michelangelo must have felt.

But despite my interest in art, in most ways I was just an ordinary kid who liked baseball, cars, hanging around with my friends, and girls. If you had asked me what I wanted to be then, I would have told you, without a doubt, a pool hustler. As a teenager, I spent almost all of my spare time at a dark, dingy, ancient pool hall called Polly LeGrew's—which, if you didn't know any better, could have been a movie set built in the 1920s. It had six tables, a gumball machine filled with peanuts, and a couple of benches to sit on. It had only a men's restroom because no woman ever came into Polly's. The toilet was so ancient that it still had a pull chain and was manufactured by Peerless Victorious, a company that probably went out of business during the Taft administration.

Then, no respectable person spent their time in a pool hall. It was where hoods, loudmouths, gamblers, and bums hung out,

but I didn't care. I loved it. I used to play for hours on end, betting kids and adults in games of Nine-Ball or straight pool. At thirteen, I was beating thirty-year-olds and pocketing ten and twenty dollars a game. If I didn't have money, people would back me and I'd split the winnings afterward. In school, I got kicked off the basketball team because I left practice to go pick up my new pool cue that had just come in.

When I was "on," I couldn't miss a shot. Once, I sank 125 balls straight. At Nine-Ball, I went six racks without missing a shot. These are the kinds of performances you'd expect from a mature adult professional. But to be a real hustler you had to have heart. Heart is when a gambler shoots the same shot whether there's a dollar on the line or a thousand. I would choke thinking more of the money than sinking the ball. If I had heart, you would have never heard of me as an art forger.

Like many of my friends, I was an altar boy. After mass we'd count donations on a big table in the back room. Some of the guys would slip a couple of fives, tens, or twenties under their robes; then we'd go play pool. I never took any money from the church; I'd just win it later playing Nine-Ball. When they got busted, I got blamed because my pockets were full of cash. It was a bitter disappointment to my mother. Stealing from the church was considered worse than being a child molester. No matter what, though, I never ratted. Ever.

In 1965, I got my girlfriend pregnant. My mother, who had a way with words, said, "You made your bed, now you're gonna sleep in it." At sixteen, I became the father of a beautiful baby girl. I got married and started working as a runner on a milk truck.

"Now You're Gonna Sleep in It"

The night of my wedding, a few of us had a toast with a six-pack of beer and then I went straight to bed because I had to get up at three a.m. to make deliveries in the freezing rain. It was so cold that winter, I used to sit in the refrigerator to "warm up." Lying awake at night, I stared down the long road ahead and thought to myself, "There's no way I'm doing this for the rest of my life."

So, planning to bring Marguerite and my daughter out later, I moved to California.

two

FULTON—WITH PALM TREES
(1969 to 1972)

WHEN I WAS NINE YEARS OLD, MY FATHER, WHO OWNED A Lincoln-Mercury dealership, won a sales award and received an all-expenses-paid trip to the West Coast. We put on our best suits, boarded a silver propeller plane, and flew to Los Angeles. Then, LA was not considered the smoggy, crime-ridden sprawl that it is now but rather a newly minted sun-drenched and smiling city of the future, powered by the glamorous movie business, a burgeoning aerospace industry, and the promise of sunny days under swaying palm trees.

My uncle, Anthony, who had come from Fulton a decade earlier, picked us up in his station wagon and we stayed at his ranch house in Montclair, a nice little town at the base of Mount Baldy. My father spent the next week driving us around the small highways and byways of greater Los Angeles to an endless array of roadside

attractions. Now, these places would seem corny, but sixty years ago, to a nine-year-old kid, they were miracles of wonder and excitement.

There were places to eat, great never-ending smorgasbords where my dad piled magnificent roasts onto his plate and where you might have ten kinds of pie and ice cream. There were animal parks, aviaries, miniature railways, Old West towns, Indian villages, alligator farms, and pony rides—everything a young boy would love. Though it was February and too cold to swim, I pestered my father until he agreed to take us to the ocean. To me, the fact that you could have a pleasant, sunny beach day in the middle of winter seemed magical.

The next week, we all piled into the station wagon and headed across the desert toward Las Vegas, which was then just a sparsely built boomtown in the middle of endless rocks and sand. On the way, we stopped in Baker, California, at the famous Bun Boy restaurant, where we had the most delicious strawberry shortcake I'd ever tasted, with piles of giant, juicy fresh strawberries and mountains of whipped cream. Fresh strawberries in winter—what a miracle!

As we rolled into Las Vegas at night, you could see the lights and blinking marquees twinkling in the valley below. It seemed like magic. We stayed at the famous Stardust, which then was just a casino surrounded by separate motel sections with space-age names like Jupiter, Saturn, Venus, and Mars. At night, my parents got dressed up and went to a show while my brother Don and I stayed in the motel gorging on the dazzling array of TV channels that dwarfed the measly three we had in Fulton.

The next day, my father took me to the casino for a lucky spin on the slot machine. Though a security guard politely informed my

father that children weren't allowed in the casino, I managed to pull the arm and see the wheels spin. I didn't win, but I felt about as lucky as any kid had ever been, and I didn't care. When we returned to Fulton a few days later, I recounted for weeks and weeks the wonders of California and the shining mirage that was Las Vegas as my friends listened in awe with their mouths agape.

Ten years later, my life in Fulton was in a depressing spiral and California had become a distant dream. After a year and a half of running milk deliveries, I had moved on to selling cheap furniture in a chain store called Roy's, and with the little money I earned, Marguerite, my daughter, and I just managed to get by with our dreary life. Before, my friends and I used to laugh at Fulton's "City with a Future" sign, but now it seemed more like a bitter joke on me.

That winter, like tens of millions of other miserable people in snow country, I watched with envy as vividly colored floats cruised down the sunny boulevards of Pasadena to the cheers and smiles of happy, attractive people at the famous Rose Parade. Stuck inside, I cursed the endless sheets of freezing snowfall raining down outside my window.

Months later, when my sister and her husband visited from California and brought with them the latest edition of the *Los Angeles Times*, I devoured every single page and column, remembering the magical trip I had taken as a kid. I must have read the classifieds for jobs and apartments a dozen times, and because I didn't have a clue about geography, I dreamed of living in Long Beach or Santa Monica or Downtown. The details didn't matter.

Over the next year, I worked hard and saved up $200, which I plowed into a stock tip I had gotten at the pool hall. Every day, I

used to call a broker in Syracuse, who I had found in the telephone book, and asked him what the price of Benrus Watch Company was. Dollar by dollar, the stock started to climb slowly upward, and when it had finally doubled, I cashed out, quit my job, and told Marguerite that I would be leaving for California, where a better future for our family was waiting.

January 3, 1969, I shoveled my beat-up Austin-Healey 3000 out from under a mountain of snow, kissed my wife and baby girl, and took off for Pomona, where my grandmother lived in a small but well-kept apartment. Before, I had been scared about becoming a father, about being able to earn a living, and about making something of myself; now I only felt excitement at the beginning of a journey and a grand sense of adventure.

An Austin-Healey is not a car you drive three thousand miles across the country. By the time I hit the Will Rogers Turnpike in Miami, Oklahoma, I had lost my right front wheel—the spokes ping-pinging for the last fifty miles until the wobble became too much to control. Nobody in Oklahoma had a replacement, so I had to wait while a local junkyard managed to get one from across the state line. It cost me $200 plus three nights in a motel, and $10 from pumping quarters into the pay TV. My stake was now down to $100, but my enthusiasm was not diminished, and as I pointed the car west toward Las Vegas, I was flush with the certainty that I would win all my money back at the blackjack tables and live to fight another day. After playing for about an hour, I was calling Fulton to see if they could wire me enough gas money to reach LA.

In the morning, I retrieved $75 from Western Union and hit the road. Finally, January 15, 1969, I rolled into the driveway

of my grandmother's modest apartment, at night, in a torrential downpour. I had $35 in my pocket and a useless car with a fried clutch and sandblasted exterior. I stayed with my grandmother and tried to find a job while, for a solid month, cold rain fell outside the window. It was the kind of storm you see only every hundred years. Houses were sliding off of hillsides and cars were being swept away by rivers of mud and sand. Everywhere we went was soaking wet and freezing cold. It was like Fulton—only with palm trees.

My oldest brother, Jim—who lived nearby in Claremont—got me a job working with him as a painter. We were contracted by a big company, and after the rain finally let up, we started working from morning until night applying Tex-Cote to modest homes all around Southern California in places like Bell Gardens, Duarte, Downey, La Habra, and Cypress. At night we'd go to bars, and I was surprised to learn that California had country-western places where cowboys danced the two-step.

Soon, I had moved into an apartment with a roommate also from Fulton and scraped together a few dollars to send back home to my wife and daughter. In one of my first expensive toll calls to Marguerite, I complained about the nonstop rain and told her that I would bring her out as soon as I could.

Then my brother and I moved in together. He suggested we live at the beach, but I had stars in my eyes and insisted we should be in Hollywood, which to me meant glamour, excitement, and style. We moved into a high-rise called the Hollywood Mt. Cahuenga Apartments and became close friends with our property manager, Bill, the first openly gay man I had ever met. In Fulton, they did not

exist. He would have dinner with us, enjoying my brother's home cooking and our small-town, real-people personalities.

When we weren't working, we would drive around stopping in at dive bars, record stores, and burger stands. It was only a few months before the Manson murders, and there was a strange vibe in the air with freaks and hippies and crowds hanging around the seedy Sunset Strip.

We were like nomads then, chasing work wherever we could find it. One day we got a call to Tex-Cote a big mansion in Fresno, five hours away, up the Central Valley. It was going to be at least a month of work and we were told that Fresno was a nice place that would have plenty of other jobs when we were done. We brought Bill to work with us, and we all went to live in a motel for a couple of weeks. I liked Fresno then, but I missed my family and focused on putting money together so that I could bring them out.

Jim and I used to go to pool halls after work, where he would back me and we would hustle whatever we could. One time, in a beer bar, I ran the table and we made over $200, which we collected apologetically before rushing to our car ahead of the locals who were starting to reconsider their bets. I didn't know it then, but my brother didn't have the money to cover me. If I had known, I probably would have been too nervous to make my shots.

In a month, I had finally saved enough money to fly my family out, and as they came off the plane, I was thrilled to hug Christine, who I hadn't seen in almost five months. That night, we all celebrated at the motel diner and slept together in the king-size bed. In the morning, we went to see the little apartment I had rented. It wasn't much, all that I could afford, but it was in a complex for

families and I was glad to see other kids playing and running around. The apartment itself was a shock. It was filthy, with flies everywhere and broken windows. Marguerite, who had nervously flown across the country with our little daughter, far away from home and far from anyone she knew, began crying and, with the depressing, unfamiliar surroundings too much to take, did not want to stay.

I promised her we would go back to Pomona where we had family and people we had known in Fulton. Luckily, the kind old landlady at the apartment complex gave us back our money, and the next day, we were on our way to LA, bouncing down the 5 Freeway in the Austin-Healey. We rented a little apartment a few doors down from my grandmother, and I got the first of a series of jobs selling furniture around Pomona before ending up at Barker Bros. in downtown LA, scratching out a drab and frugal existence.

Every day, I would wake up early and watch *Sesame Street* with Christine before driving fifty miles to work. Marguerite, who controlled the money, would give me a dollar for gas, a dollar for parking, and a baloney sandwich in a plastic bag. If Marguerite hadn't pinched every penny, we could not have eaten. She was a master at economizing, and I'm grateful because I was very bad at it.

Selling furniture in those days was a real old-school game, with gimmicks and tricks to bring the customers in and sell them—no matter what. I learned from old pros, lifers who had been there thirty or forty years. They would advertise a cheap sofa set for a super-low price, like $89.95, using an attractive drawing, and then when you got there, in real life, the fabric was so ugly no one would possibly buy it. Of course, a different fabric would almost double the price. You'd walk around with a clipboard and a clip-on tie.

Every piece of furniture had on it what was called a "button" or a "spiff" that let you know how much commission you could earn if you upsold it. Everything was bait and switch, boosting Scotchgard or a king-size bed instead of a queen. You were hustling and chiseling for every dollar you could get. It was exhausting, boring, and demoralizing.

I didn't make much money at it and I didn't get to spend much time with Christine and Marguerite. I used to work six days a week, either early morning until six p.m. or noon until nine, coming home when Christine was already asleep. If we had time, we'd do things that didn't cost any money. We might go window-shop or go to the park or to the little Mexican carnival in Ontario. We never went to a movie; we never went out to dinner. For fun, I used to stay up at night painting detailed, elaborate copies of the masters—Rembrandt, Picasso, and Renoir—letting my mind run with the flowing colors and brushstrokes.

At the time, I was still just learning how to paint. I would copy from books that I'd borrow from the library—picking out whatever caught my eye or whatever I wanted to practice. To save money, I got art supplies at a hardware store and stretched my own canvas over cheap bars with a staple gun. Most nights, I would paint two or three hours at the kitchen table after everyone had gone to bed. I would try to paint the flesh tones of a Rembrandt soldier or his golden armor and buckles glinting out of the darkness. I did a simple *Clown* by Bernard Buffet—who was very popular then, though hardly anyone remembers him today. My learning was random and chaotic, without any real plan or course of instruction.

In LA, I went to my first museum ever—LACMA, the Los Angeles County Museum of Art—to see a Rembrandt. I was fascinated to see a real portrait, something that I could almost touch and carefully examine for clues to the secrets of his technique. I remember an oval portrait of a man, and what struck me was that you could see he had a twinkle in his eye that looked so real and alive that he seemed to have a soul. I remember seeing that it had been donated by William Randolph Hearst, and as I looked through the collections, I was surprised that almost all the paintings had been donated by wealthy patrons. To think that you might own a Rembrandt and just give it away.

Rembrandt's flesh tone was different from everyone else's. Viewing it close up, you could see that it was almost three-dimensional. On TV I had seen a movie that showed Rembrandt at work. He would finish a painting and then in the last seconds, working frantically, add dashes of color from his palette; a dot of white to make a gold chain glimmer in the light, a dab of red for the end of a drunkard's nose.

His famous lighting—an extension of Caravaggio's chiaroscuro—was unparalleled. Rembrandt was just a boy when Caravaggio died, but the Italian had a tremendous influence on the Dutch masters who had gone to Rome in search of inspiration and commissions. Seeing Rembrandt then was astonishing. Rembrandt's use of light and dark was more subtle, how it transitioned between the subjects and the background, and the emotions were more settled. Now, as much as I love Caravaggio, everything they say about Rembrandt is true. I really do believe that he was the

greatest painter ever. But there would have been no Rembrandt without Caravaggio.

I also visited the Norton Simon Museum in Pasadena. Its founder was a wealthy industrialist who owned the Hunt's ketchup and food empire. He had amassed a wonderful collection of European masters and opened his museum to fanfare in 1969. I had heard about it then and knew they had Picasso and Van Gogh and Renoir—all painters that I wanted to see in person.

At the museum, I was shocked to see Van Gogh's paint palette. He built up his colors almost a half inch thick, smearing paint on with what I imagined must have been a trowel. Looking at his work, I could feel the lonely and manic psychology of his art. I wasn't in love with him, but I could see that there was nobody like him.

Examining the Picasso, I could see that his paint was thin and soupy. You could see the drips, painted very quickly. There were parts of the canvas that had thick impasto and spots so bare you could see the texture of the canvas.

In one room, I studied a Renoir from different distances and angles. I loved how he would make a painting full of blurred activity and leave one face in focus so it would draw your eye to the emotion.

Gradually, as I practiced putting these insights into my own paintings, I started to feel a little more confident. On Sundays, I would go to art fairs and try to sell my copies, happily chatting with Christine while I put the finishing touches on a Rembrandt. I would charge $150 for my Monet and $250 for my Rembrandt, which had taken me weeks to paint, but the public, who wanted something cheap to match the curtains, wasn't interested. I soon decided that

it was a waste of time, and I was at a loss for how I could earn any money from my paintings.

Too green to know any better, I took my copies, signed Tetro, to any gallery I could find in Pomona, Upland, or San Bernardino. If they sold art—I didn't care what kind—I went in there. They told me that I wasn't a recognized name and that they weren't interested. One or two told me if I wanted to, I could leave them on consignment, but nobody wanted to part with any cash. I even went to French restaurants, cold-calling during the off-hours between lunch and dinner to ask if they wanted a beautiful Monet that I had painted. They didn't say much, but the withering looks conveyed exactly what they were thinking: "Get the fuck out of here," however you say that in French.

I was just a kid then, twenty years old, and without any real plan, trying every angle I could to make my way through life and too dumb to know any better. I wasn't really making much headway. But though I was striking out, I learned a valuable lesson. It didn't matter what the art was. All that mattered was the signature.

three

FAKE!

(1972)

AFTER I FAILED TO SELL MY PAINTINGS, MY DREAM OF EARN-
ing a living from art pretty much hit a dead end. It was like I
buried it away and closed the lid. I felt defeated.

Furniture sales is not an exciting occupation. I would like to
say that I waged a heroic struggle and that I never gave up, but the
reality was that I had a wife and daughter and I resigned myself to
going back to the grind, to the hustling and spiffs, six days a week.
Marguerite and I told ourselves that as we went on in life, we would
get more connections and that something good would happen for
us. In the meantime, we tried to give Christine a solid middle-class
childhood. Marguerite was a good mother and always made sure
our daughter was well kempt and presentable and that she wouldn't
lack for anything important. I bought her a bicycle.

I was young and had wanderlust. When I drove out to Califor-
nia, I had picked up a hitchhiker. She asked me why I was going

to LA and I said simply, "Fame and fortune." The secret fantasy I stashed away was to one day own a Ferrari. Now I had to face the depressing reality that my dreams were pulling farther and farther out of view.

The fifty-mile commute to work really began to wear on me, wasting hours of time and gallons of gas every day. Every week, on my day off, I would stop by a furniture store in Pomona to ask for a job. Finally, just to stop answering my calls and to put an end to my impromptu appearances, they hired me. I thought I was doing pretty well, but it wasn't long before the store cut back and, as the youngest and newest salesman, I got fired. I went on unemployment and hated it. We only managed to scrape by because Marguerite had gotten a job at the Ontario public library a few months before.

I'd like to say that I used the unemployed time wisely, but in reality, I was pretty low. I would watch *Sesame Street* with Christine, walk her to school, then come home and make calls for job interviews that never materialized. Then I'd flip around on the TV, watching the corny *Tempo* program, where they'd interview people on the street or have on some guy who had a nice Christmas tree. I painted to pass the time.

My life was on repeat and I couldn't see any way to change things. Marguerite and I started to fight about money, our lifestyle, and how to raise Christine. One time, my whole family came out from Fulton to take a trip together to Las Vegas. I was so excited to take a break and be with my family that I begged Marguerite to agree to go. She said we didn't have the money, and though she was right, I got so mad that I didn't speak to her for three days.

Fake!

After a few grim months on unemployment, I finally got a job selling furniture in a department store in the brand-new Montclair Plaza. It was more of the same, but at least everyone from the mall would go to the Jolly Roger for happy hour after work. It was my only outlet, though I always left early, just as people were starting to have fun. I was the only person with a wife and kid.

Eventually Marguerite and I drifted apart. I didn't know anything about how to be in a relationship and we ended up getting divorced, as was probably inevitable. I'm grateful for my daughter — my greatest joy — and Marguerite is a good woman, but nobody should ever get married at sixteen. They moved down the street to a nice little apartment and I moved three minutes away with a couple of roommates. We saw each other when we could. Though I was barely scraping by, for the first time, I enjoyed a little bit of the youth that I had never had. It was the first time that I had ever lived alone and could make my own schedule. It was strange but liberating doing everything for myself.

One Sunday, like any other, I drove my beat-up Volkswagen Bug with no brakes to the Alpha Beta supermarket to buy bread and pasta, and to treat myself to a bruised, purple, manager's special chuck steak. It didn't seem like it then, but it was the day that changed my life and set me on the course I would pursue for the next fifty years.

I had finished shopping and was waiting around bored in the line at the check-out stand when I noticed a little circular book display. As I spun it around, something caught my eye, a book with a colorful Modigliani painting on the cover. It was *Fake!* by Clifford Irving. I picked it up and, as people streamed past me, I started

reading, mesmerized by the story of the notorious Hungarian art forger Elmyr de Hory, who had had an illustrious twenty-year career as a European socialite selling Chagalls, Picassos, and Modiglianis to unsuspecting galleries and collectors in Spain, France, and Italy. I bought the book, drove home, and devoured it in one sitting, staying up late into the night. As I read, one idea became clearer and clearer: the only thing I could think was "I could do this."

In the book, Irving talked about how Elmyr had risen from obscurity to become a respected dealer and sought-after guest at European summer homes. He had operated secretly, trading on a fictional personal relationship with the artists, and his main insight was to make paintings that weren't exact copies but rather believable paintings in the style of the great masters and popular painters of the time. I thought it was brilliant that this guy had thought of doing these things and that he had the balls to carry it out with little more than his wits, his talent for art, and a plausible line of bullshit.

The very next morning, I resolved to put my own plan into action. I drove down to the big Art Deco library on Olive Street in downtown LA, where I searched the shelves for old, large-format art and architecture books whose pages were tinged with age. Usually, these books had three or four blank pages at the beginning and several more at the back. I would bury myself deep in the stacks and when no one was watching, cough and tear a blank page from the book. After a few trips and what must have seemed to others like a bout of tuberculosis, I had accumulated a little stack of paper, perfect for drawing.

Fake!

My first steps were timid. Somewhere between a forgery and a prank. I was ignorant, but I was smart enough to know that an oil painting or anything by a major artist would draw attention. I also knew from Elmyr's story that provenance—the history of who had owned an artwork and where it had been—could be a problem. So, rather than do a Chagall or Monet or Picasso painting, I decided to do a little drawing that was meant to be a fake Chagall, signed by de Hory, who, with the release of *Fake!*, had become notorious. I imagined that knowledgeable people in the art world would know who he was and would get a kick out of the piece of memorabilia. And since it wasn't an actual, real work of art that would have been in a collection or museum, I wouldn't need to come up with any kind of provenance. The idea seemed perfect.

I searched books and found a self-portrait that Chagall had done. His was a simple black-ink line drawing showing his curly hair. Mine was based on that but a little more elaborate and had a donkey, one of his iconic symbols, on his head. I signed it, "À *mon ami*, Elmyr de Hory." For three days, I practiced the drawing over and over again on regular art paper until I was finally happy and could do it without hesitation.

When I was done, I bought a sheet of plexiglass, which I held on my knees over a lamp like a poor man's light table. Carefully, over and over, I practiced tracing my drawing until I could do it confidently. When I was finally ready, I took one of the pages I had torn from the library books and traced my work. When I finally stepped back to appraise the drawing, I was very happy with the result. And so it was that the very first piece of art that I ever

forged was a portrait of Chagall that I signed with the name of another forger.

In those days, Palm Springs was glamorous and cosmopolitan, at the tail end of the Rat Pack era and the boom of modernist architecture. Many galleries on Palm Canyon Drive and Tahquitz-McCallum catered to a cultured and wealthy clientele, and it's there that I decided to bring my work. I had concocted a story that my grandfather, old and in failing health, was giving his art away before he died and the collection ended up in probate. I said I was selling the art because my beat-up car needed a transmission. With my dying, brakeless VW Bug, it wasn't too much of a stretch.

At first, I went to a few galleries, but the dealers weren't interested or wanted to put my piece on consignment. I had had enough of that with my own art. Finally, I went into the gallery of John Mercante, a young, stylish, and charming guy. His gallery was full of beautiful works and I admired his suit and Gucci loafers, which he wore without socks—the kind of easy, relaxed elegance I associated with stylish, rich people in Palm Springs. As I showed him my *Elmyr Chagall*, we chatted about my grandfather and my backstory, and I felt like we had an easy rapport.

He liked the piece, got a kick out of the novelty, and offered me $200, though I asked for $400. He wrote me a check with a casual flourish, and as I left the gallery, he called after me, "Let me know if your grandfather has anything else." That was it. It took fifteen minutes. This was incredible to me, to think that I could make a simple drawing and walk out with $200 after failing so miserably with my own art. Signed by me it was worthless; signed by a famous forger, it was worth money I could bank. The check Mercante had

just written with such ease was twice my rent at the time. To cele-
brate, I went a half block down the street to treat myself to lunch at
a nice restaurant.

As I sat there, I started to have second thoughts. If I cashed this
check, I would have $200, but I would probably never be able to
go back to Mercante, with whom I had developed a good feeling.
I felt like we had hit it off and I had a sense that he could be my
guide and teach me so many of the things that I didn't know and
would need to learn. I left my half-eaten sandwich, paid my bill,
and headed back to the gallery.

When I walked in, Mercante was sitting with his feet up on his
desk, bored in the middle of a weekday afternoon. He was surprised
to see me back so soon. Sheepishly, I confessed what I had done
and pleaded that he let me make paintings for him. I told him that
I could come up with wonderful art that he would like and that he
could make a lot of money on.

"First thing," he said, "give me back that check." I'm sure he
was thinking, "What balls on this fucking kid," but he wasn't angry.
Maybe he felt a little sorry for me or liked my hustle. I don't know.
I handed him the check and he gave me back my drawing. He told
me that he wouldn't buy any of my art, but if I wanted, I could bring
it to him and he would tell me what he thought of it. He didn't
make a big deal or threaten to call the cops. I think he had a good
business and didn't want to jeopardize it. It was interesting to see
that dealers would rather take a hit now and then than raise a big
stink and spook their customers.

When I went home, I was happy. Despite the fact that I had
not made any money, I felt like the day had been a big success.

Mercante had liked my piece and had bought it, at least before I confessed. And though he didn't want to buy my art afterward, he told me that I could bring him things to look at.

Now, I felt a real boost of confidence and was sure that I could take my Elmyr drawing anywhere. I drove to Beverly Hills and sold it to a place on Robertson. There, the old-time actor Vincent Price, who was known as an art connoisseur, looked at my piece and succinctly canned it. "I don't like him," he said, pointing to Elmyr's name, "and I don't like him," pointing to Chagall's. Despite Vincent's scathing review, the owner took out a jeweler's loupe, examined my drawing, and wrote me a check for $250. I gladly sank the money into back rent and bills that had just come due.

Having sold my first quasi-forgery, I was now ready to step up to the full-fledged thing. Too dumb to know any better, I decided to do a Modigliani, like the one that had caught my eye on the cover of *Fake!* An artist like that would have been too big, too significant for a clueless kid to have, but at least I was smart enough to do a pencil drawing instead of a painting.

In the 1920s Modigliani had done an oil painting of a nude woman on a bed that I had admired. I based my drawing on the same woman, but instead of lying down in bed, in my piece, she was sitting up. This made sense, as it could have been the preparatory drawing for the known painting. I did my drawing, tracing it as I had done with the Chagall, then signed it "Modigliani" and framed it in an inexpensive black frame.

Near me, there was a smorgasbord restaurant of the kind that was popular in the seventies, called Griswold's. Attached to the restaurant, there was a motel, and then, I remembered, an art

gallery. I knew that the guy there wouldn't be an expert, but it was nearby and would be a low-risk way to check how I had done. The dealer liked the drawing, commenting on the strong and confident lines. Little did he know the lines were strong just because I had traced them instead of working freehand. I knew this guy was probably a three out of ten in knowledge, but still, his response told me I was on the right track.

A week later, my roommates, Don and Gary, planned to go to LA to see *The Dinah Shore Show* at CBS Studios on Beverly. I tagged along and asked them if they minded if we stopped on the way. I told them about my drawing and said they could come with me to Sotheby's so they could see how it all went down. I wasn't worried telling them; being a forger then was such a pie-in-the-sky idea that I didn't mind if they knew. It seemed more like a prank that teenagers would do, like climbing a fence to go skinny-dipping, rather than a serious crime.

So, the three of us went to Sotheby's, where I met with an appraiser while my friends browsed around the gallery. When I showed the drawing to the expert, giving him my story about my grandfather, he didn't seem impressed. He examined the drawing for a while, then handed it back to me, saying, "It doesn't feel right." And that was it. There was no more to say. I felt like he had been too abrupt, but I said OK and left without an argument. At the time, I thought his statement was hokey, but he was right. Someone who really knows an artist can get a feeling just by looking at the whole thing. At the time, what did I know?

We left Sotheby's with a shrug and ended up at *Dinah Shore*. Everything seemed rinky-dink compared to what you saw on TV.

Before the show, they sent out a comedian to put us in a good mood, but it ended up doing the opposite. My friends were annoyed at how hard they tried to rile us up and get us into a good humor. Later, I would see the same kind of song and dance at galleries and auction houses, where the bells and whistles were meant to distract you from what was really going on.

Still, I wasn't satisfied with Sotheby's opinion. So, I took my drawing out to Palm Springs and showed it to John Mercante, whose opinion I trusted more and with whom I had more confidence. When I showed it to him, he said it looked good, agreeing that my nude looked like the same model from the oil painting, and that the preparatory story and signature seemed plausible. A couple of days later, I was sitting on the beach reading a newspaper when I came across a listing for Empire Gallery, a fine art auction house in Santa Ana near me, with its other outlet, Desert Auction, in Cathedral City, near Palm Springs. The listing said that they bought fine estate items: Tiffany lamps, Steuben vases, and paintings by well-known artists. It seemed like the right place to go.

I dressed like a naive kid in jean shorts and flip-flops, put my drawing in the car, and pointed it toward Santa Ana. The auction wasn't like what I had imagined from TV. It was a jumble of items, like an explosion at a rich man's house. There were vases, tables, elephant tusks, mosaic mirrors, jewelry, antique floor lamps, all kinds of paintings and sculptures. I told them I had a drawing to sell and they brought me to meet the owner, Carl Marcus, a tall, slick man in his early forties. Carl talked fast but was polite and had the mannerisms of a genteel old-world European with, I thought, just a trace of an accent.

Fake!

He was sitting at his desk with a sly smile on his face as he listened to my story about a sick and elderly grandfather and his art collection. I told him that my drawing had been a centerpiece in the family and that my grandfather had bought it in France. He smiled and nodded politely. As he examined the drawing, to fill the awkward silence, I explained about my dying car and its ailing transmission, which Carl acknowledged with a sympathetic look. He told me that he could wallpaper his living room with fake Modiglianis and asked if I had provenance. I told him I didn't and, though he seemed skeptical, I think Carl might have just been beating down the price. He offered me $1,600, and a chance for more if it sold well on consignment. I told him I had wanted $4,000, but in reality, I was shocked and elated. I would have taken $400.

For me, $1,600 was a fortune, untold wealth, almost the price of a new car and more than I had ever earned at one time. Carl wrote me a check, filled in my name and phone number for the consignment slip, and shook my hand. I walked out floating on air. It was like an ecstatic vision. I quickly rattled away in my Bug and drove straight to Carl's bank in Tustin, where I hammered the check immediately. I remember they had me sit down with the teller in a big comfortable chair and treated me like royalty, as if I was a valued customer. As I walked out of the bank flush with cash, I remember feeling that everything had changed. I had started the day as an unemployed kid, with $100 to his name and no clue. Now I was a professional and I was going to make my fortune.

To celebrate, I took Christine out to dinner at Griswold's Smorgasbord. She was only six or seven, but she knew that I didn't have

a lot of money. Though she had told me she was hungry as a horse, when we went to fill our plates, I noticed that she came back with only a few things on hers. She hadn't realized that it was a buffet—all you can eat—and she told me that since I didn't have a job, she wanted to economize. It touched me so much, how brave and sweet she was, but I laughed, telling her that from now on, she could have anything she wanted, and as much as she wanted, anytime. She returned to the buffet and came back with a plate stacked so high that she could barely carry it.

By the next day, I was already planning my next forgery and had started working on a Chagall watercolor. I knew that if I painted instead of drawing, my works would be worth more money, but I knew that I couldn't do an actual full-scale oil painting. Chagall did these loose, sloppy watercolors that were colorful and bright and that everybody liked. They seemed like the perfect choice. I was just dipping my brush in water and swirling around the color when the phone rang.

It was John Mercante, talking fast, with an urgent tone in his voice. He was yelling at me, shouting at me to stay away from Carl Marcus, that he was a bad man and that I should not go anywhere near him. This shocked me, because I didn't know that he knew Marcus and because I had never told him about my sale. Just as I was trying to piece it all together in my head, my line beeped and another call was coming in. I hung up on John and switched to the other line, where I heard the voice of Carl Marcus, his vaguely European accent now transformed into straight Brooklyn menace.

"You know who this is, you little cocksucker? Do you have paint on your hands?"

Which was funny, because I literally did have paint on my hands.

"You fucked me," he said, chuckling. "You fucked me good, but I'm gonna turn this around for you. You come see me tomorrow and we'll straighten it out. I'm gonna make you a deal and you can make a lot of money."

Instead of yelling at me and threatening me, he kept things calm and tried to make me feel at ease. To tell the truth, I was still nervous, but I agreed to go see him anyway. I had no choice. If he wanted to, he could have called the cops and ended my career right there.

Later, I found out that John Mercante had accidentally ratted me out to Carl. John's girlfriend, Emily Davenport, had been the mistress of Jack Warner, the movie mogul, who had given her a stunning thirteen-carat diamond ring worth a fortune. When they split up, she kept the ring and sold it to Carl Marcus, who, of course, screwed her, giving her a cheap bracelet, $5,000, and the promise of more money later. When Mercante found out, he went to confront Carl at the gallery in Cathedral City, which displayed right in its front window a Modigliani drawing made by a kid with an ailing grandfather, who had shown it to him a few days before in Palm Springs. Mercante argued with Carl, shouting, "You bastard. I know you're stealing Emily's money. Give me back that ring!" When Carl refused, Mercante went nuts. "You stupid asshole, don't you know that's not a Modigliani? A kid came in here with his grandpa's art and a bad transmission, right?" That's all Carl needed to hear, though instead of exploding in anger, he saw dollar signs. I was going to be the goose to lay his golden eggs.

The next day, when I saw Carl, he received me politely, as an ally, with his dirty little smile and his now unvarnished New York accent. He never even mentioned the Modigliani and he never mentioned the $1,600 he had paid me. He only asked me if I could paint. When I answered yes, he walked me over to a back room and showed me a landscape and a seascape: nice, straight-ahead Romantic paintings, competent but not spectacular, and technically something I could handle. He told me that they were by Robert Wood, an artist whose paintings hung over every sofa in every middle-class home in every city in America.

"Can you paint these?" Carl asked.

"Yeah, I can do that. No problem."

"OK," he said, "then you're gonna work for me now."

And that was that. I didn't disagree. I went to work for Carl, without a second thought. What can I say? Some people have art school. I had Carl Marcus.

four

MY APPRENTICESHIP
(1972 to 1975)

Carl knew nothing about art except that he could make money at it. He had gotten into the business after buying his wife a ring at an auction house and getting screwed in the deal. He went back, traded for another ring, and got screwed again. Rather than getting upset, he was happy. He thought, "Now this is the business for me! You could screw people without even trying."

Carl was cruel and crass; the word *cocksucker* to him was like the word *the* to everyone else. He delighted in fucking people; I mean he took real pleasure in it. Like most dealers, he could have been selling timeshares or diet pills. It didn't matter—and this was a real insight to me. Naively, I had thought that these people would be art lovers, but mostly they knew little and cared less. Good, bad, real, fake—none of it mattered to them so long as everybody was making money. As a customer you only saw the

facade. The reality was that it was one big confidence scheme. I didn't know that then, but I was a wide-eyed student and tried to absorb everything I could learn.

When Carl had shown me the Robert Wood, the meeting was quick and straightforward. I could paint whatever I wanted, take it to a certified appraiser, and Carl would give me 10 percent of whatever it was worth. I had to pay for the appraiser myself because Carl didn't want to know anything about it. Simple. Easy. That's how Carl operated. There was always money to be made somewhere and he didn't have time to screw around.

By the time Carl's lips stopped moving, my mind was already working out how I was going to do my Robert Wood paintings. I was looking at the stretcher bars and the back of the canvas noticing how it was attached, with staples instead of nails as older European paintings were. Compared to the Rembrandts and Monets I had been doing in my spare time, I didn't expect Robert Wood to give me much trouble at all. He made nice plein air paintings, but they were not complicated or especially difficult. They almost never had people in them and they were contemporary, which meant I didn't have to worry about old canvases, stretcher bars, provenance, or aging.

All in all, I was OK with how things had turned out. I would have preferred to be working with someone like Mercante, but Carl was what I got. I had a job and, to my relief, he let me keep the $1,600 he had paid for my Modigliani as a deposit against future work. It was all water under the bridge.

The first Robert Wood I ever painted was a fall landscape, a forest of yellow and orange leaves. Marguerite and I had had a print

in our apartment and I went to borrow it back as inspiration for my own. At the time, there was no book about Robert Wood—he wasn't considered a serious artist—so I bought a little calendar that showed one painting for every month. I used to study them to learn his style and the distinctive way he applied his paint, putting dabs of color for leaves, or dabs for bark that he'd smear around the edge of a tree.

That first painting only took me a couple of days. I found a nearby appraiser in the phone book and called him up to tell him that I was bringing a Robert Wood landscape. He didn't know much about it and he didn't care. He just collected his $50 up front, looked it up in a price catalog, and wrote me a certificate. He didn't care if it was real or fake—it wasn't any of his business.

As I got rolling, I could do maybe three or four Robert Wood oils a month, switching appraisers and stopping off at Carl's in Cathedral City. Usually, the paintings would be valued around $3,500 or $4,000, and at 10 percent, I'd clear maybe $400 minus the $50 or $100 for the appraisal. All in all, I was making about $1,000 a month just from painting Robert Wood, which was more than I ever made selling furniture six days a week.

That's when I started to think of myself as a professional artist. To me, it was like a regular job, going to work in the morning and punching a time clock. And the regular, steady practice made me more focused and confident, and handier with a brush. The only hard part was getting paid. Every time, without fail, Carl would make me wait for at least two hours to get a check. I'd show up with my painting and appraisal slip and he would just be heading out to lunch or talking to somebody important, or he was in a meeting. If

I wanted to get paid, I had to drive out to the desert and waste half the day sitting around. It was infuriating. The reality was he just enjoyed the power trip and lorded it over me because I was just a kid with few options.

When I got to know him better, I saw that this kind of thing was routine, all part of his way of doing business. One time, I came into the parking lot just as he was checking out some damage to his car. Someone had filled glass Christmas ornaments with yellow enamel paint and had pelted his brand-new Rolls-Royce. I chuckled when I saw him and told him it must have been just another one of his satisfied customers. In truth, it could have been any of a thousand people. He used to have little old ladies come in with their Tiffany lamps worth $10,000. He would give them $500 and promise them more when their item sold, though of course they never saw another dime.

Carl made me act as a shill in his staged auctions. It was so obvious. He'd point to me and I'd raise my paddle, goosing the prices. It was so brazen. Carl made me dress up in a suit or a sport coat to look presentable, but I'm twenty-two and I'm bidding on $50,000 diamond rings or rare Lalique vases. It couldn't have fooled anyone, except somehow it did. I hated going to the auctions, which seemed like a boring waste of time, although I did learn about many subjects like stamps, sculptures, furniture, and antique art glass—collected most avidly by a local Hells Angel who came dressed in full biker gear to bid on these delicate glass cherubs and painted violets.

At one auction I was bidding on my own Robert Wood painting, casually chatting with the nice old lady sitting next to me. I think she thought I was trying to lull her into complacency, because

whenever Carl pointed to me and I raised my paddle, she raised her paddle too. It ended up that she beat me out of my Robert Wood, at a very inflated price, and when she went away, she gave me a smug look of satisfaction and triumph.

I was in the audience when Carl auctioned the famous Transvaal diamond, announcing to the press that Richard Burton and Elizabeth Taylor were coming and that the shah of Iran was sending his personal emissary to bid. Of course, there were no movie stars or Persian royalty. The whole thing had been fluffed up for a single buyer that Carl had groomed, an Oregon timber baron who bought it for a half million dollars. Carl made $400,000 minus expenses, while the diamond ended up in the Smithsonian as the Leonard E. and Victoria Wilkinson Transvaal Diamond. He probably could have bought it outright for seventy-five grand.

Every day, Carl saw all kinds of art and antiques come through his auction house. Some of it was fake. I had read about Elmyr, but now for the first time, I got a glimpse of what other forgers were doing in real life. Once, a man came in to sell a landscape painting by the Fauvist artist Maurice de Vlaminck, and Carl asked me to take a look. The guy had a bill of sale and stamps and documents that showed how he had come to own the painting. This guy even had a photograph of himself posing with his arm around the waist of Vlaminck's wife. You could see that the guy had pasted a photo of his own head onto a photo, and then had taken a photo of that. It was so chintzy and obvious that I was offended, telling Carl—loud enough that the guy could hear me—"How could you go to all that trouble of making a painting, and producing documents and photos, then make such a half-assed effort?"

From the inside at Carl's auction house, I was becoming more practiced in the ways of the art market and what a professional buyer would be looking for. For me, it was a kind of forgery school, learning to identify items that were in demand and how to create a logical and plausible reason for them to exist, as well as a reason why somebody would want to buy them.

I had seen from Carl's auction that many Americans on the West Coast were passionate collectors and paid good money for the work of cowboy artist Frederic Remington. He would do Old West stuff, longhorn steers, cowboys, Indian warriors on ponies. Reading, I learned that he was an avid poker player, though apparently, he didn't win too much. So, I made a loose sketch—what's called an "oil sketch"—of a rider on a horse with some wild horses in the background and wrote, "To the luckiest fella I ever met, Lieutenant M. Williams," imagining that he had lost at cards and had paid his debt with this painting. Carl called up a big Remington collector he knew and sold the painting the same day, before the paint was even dry.

By then, I had started to make enough to eat better and live more comfortably. I was helping to take care of Christine, though I wish I had done more. With the few dollars I saved, I was able to buy a secondhand, slightly beat-up Maserati. It was not the Ferrari of my dreams, but it sure beat the VW Bug. I even managed to move into my own place at the Apple Apartments, a few doors down from my old roommates. The Apple was what was then called a singles complex, intended for young people who didn't have children and wanted a social, fun place to live. I painted by

the pool or on my patio, hanging out and meeting a whole new group of friends.

I'd play pinball at the rec center and use the telephone hanging on the wall as my personal office, mostly fielding calls from Carl, who screamed at me whenever he rang. "Where's my painting, you cocksucker? I want that thing today!" or "What the fuck, you guinea greaseball, do I have nothing better to do?" It was a never-ending torrent of abuse shouted down the telephone line from his office in Cathedral City or from a roadside payphone if the need to vent overcame him while he was driving.

Despite the abuse, I had learned a lot during my apprenticeship. People think that because you're an artist, you already know how to do things like printing or etching or sculpture. I didn't. I had never had a formal education and would learn by reading, asking questions, and trying things out on my own.

I could see that prints were becoming very popular, more accessible to a wider audience, and very much in demand by Carl's clientele. If I got them right, I could make a lucrative stream of sales, creating them once and printing more when I needed them. At the time, the most popular artist for middle-of-the-road collectors was Chagall, but then, nobody knew how to copy color lithographs properly. You had to put a single color on each print plate separately and then overlay them precisely over one another—virtually impossible to do right.

I checked out a Chagall book from the library and set about studying subjects I could do in a limited black-and-white palette. I searched the phone book for a printer nearby who could help

me figure out all the technical details. Almost randomly, I picked one in a rough, seedy part of town in Pomona. When I rang the bell, the printer appeared holding the half-open door in one hand and a baseball bat in the other. Despite the suspicious welcome, Ray Galpin and his brother Barry were the best blessing I ever had. They were expert printers from a previous era when master pressmen were talented artists who mixed their colors by hand and skillfully manipulated the complicated mechanical processes needed to create first-rate art.

We talked about how we could create the illusion of a lithograph photographically, and looked through the book together for images that would be easiest to re-create. Our idea was to take high-quality photographs of the images from the catalog, blow them up three or four times their normal size, and correct the gray halftone dots from the printed book. Enlarged, the dots appeared like half circles or scalloped edges. I would fill them in with a felt-tip pen and then take out any stray halftone dots on the negative.

When we reduced the photo back down, the edges were smooth and did not appear to be reproduced from a halftone printed photograph. With a good image, we could burn the likeness onto a metal plate, wrap it around the print cylinder in the press, and roll off as many copies as we wanted. For authenticity, I printed them onto French *papier* d'Arches, which I had learned was the paper that Chagall, Miró, Picasso, and Dalí all used for lithographs. We had a good time working together, this eager young guy and a couple of veterans. They knew what I was up to and enjoyed solving these puzzles with me.

When the lithographs were printed, I still needed to sign and number them. I knew that John Mercante had had some genuine Chagall lithographs at his gallery and he let me study and research them there. I rented a high-quality 35 mm camera and tripod and took careful, close-up photos of the signature and the pencil numbering of the limited editions. Like most artists, Chagall did not do his own numbering. Instead, his printmaker, Charles Sorlier, would number them in a distinctive European script. I didn't like how my twos came out, and so none of my Chagall prints ever had the number two in them. Today, people write to me all the time asking if I did a particular Chagall lithograph. I never comment, but I can say that if it has the number two in it, I probably didn't do it.

I practiced Chagall's signature so many times that I finally got very good at it. Then, I was just learning; now, I've signed his name so many times that my own signature has come to incorporate some of his mannerisms and strokes. When I was happy with the signatures, I'd frame the prints and put them on consignment with Carl. He'd sell them for $2,500 and I might make $800 apiece on them. It was the lucrative deal I had hoped for.

With the success of the Chagalls, I thought I could branch out to other artists. I saw that Norman Rockwell had also done black-and-white lithographs and that he would have been an excellent subject. He was enormously popular, and as he was an American artist, I would not have to source my paper, expensively, in France.

Back then, the art world turned its nose up at Rockwell and his cornpone appeal, but I admired his skill and technique and I

still consider him a great artist. At the time, it was inconceivable for Christie's or Sotheby's to carry a Rockwell, but now his oil paintings sell for tens of millions of dollars at exclusive auction houses around the world. I'll go so far as to say that Rockwell was the equal of Rembrandt in how he breathed individuality into each figure in his work. The unique humanity, facial expressions, and body language in a painting like Rockwell's *Doctor and Doll* or *Freedom from Want* is on par with Rembrandt's famous painting *The Night Watch*. But Rembrandt's paintings look posed, whereas Rockwell's do not.

Rockwell was known as America's sentimental grandfather, but I had read that he had a real thirst for liquor and a real hunger for women and that one of his sly business associates kept him knee-deep in both. When it was time for Rockwell to sign his limited editions, instead of signing two hundred copies, the associate would slip in at least another hundred. Rockwell, who wasn't numbering them and who was already two-thirds of the way through a bottle of bourbon, never suspected a thing. Now there was a plausible reason why supposedly limited editions always seemed to have additional copies in the wild.

Between the Chagall and the Rockwell, I started to gain a little financial independence from Carl. I had grown tired of driving to the desert, waiting hours to get paid, being berated on the phone. One day Carl called me at the rec center when I was playing pinball and talking with some friends. He screamed at me and called me a cocksucker, a worthless bastard, and every other name imaginable. I was embarrassed to be humiliated in front of my friends. Finally, I had had enough. I told him to go fuck himself, slammed the phone

down, and quit. I didn't see him again for the next ten years. I even left a couple of lithographs on consignment in the desert.

Eventually everybody got tired of Carl. He had four ex-wives. One of them, who must have borne the heaviest brunt of his abuse and humiliation, finally snapped. She ran off with one of Carl's longhaired day laborers who moved boxes and waxed his car. She took him, the diamond ring Carl had bought her, and his freshly repainted Rolls-Royce. I don't think Carl ever saw her again.

five

THE LAST LAUGH
(1972 to 1975)

THE MORE I LEARNED, THE MORE I OUTGREW CARL, AND THE more the power started to shift. I had gotten better at painting and started to feel more comfortable doing a wider range of artists and media. At first, I had been satisfied with 10 percent, but by the end, I was getting 30. Carl had always threatened me, saying that he did not want me "whoring paintings all over town," but I had already started to take my art to LA and Beverly Hills. He must have known that eventually the golden goose would fly the coop.

Now that I was on my own, the things that an art student would learn in college Art 101 I had to learn myself. In high school, I had been a voracious reader, devouring books about cars, history, music, and art, as well as novels. I fell in love with *Moby-Dick*, and as I read, I could smell the salt in the air, picture the *Pequod* and Queequeg's tattoos, and feel Ahab's slow descent into madness from his pursuit of the whale. I remember being engrossed in *The*

Adventurers by Harold Robbins, *Salem's Lot* by Stephen King, and Sidney Sheldon's *The Other Side of Midnight*, which I read only because my mother had left it lying around.

Back then, my reading had been random. Now, my reading became completely focused and pragmatic. I only read books that could reveal clues about the artists I wanted to forge and that could help me come up with plausible paintings. I focused on Chagall, Dalí, Miró, and Picasso, who at the time were like an industry unto themselves. Their pieces were so desirable and so liquid that a dealer could quickly turn them into a nice profit, sometimes within the space of twenty-four hours.

Marguerite, who had become a librarian at the Ontario City Library, would help me find books and order them through the Riverside County Library System. She even got me volume two of Chagall's catalogue raisonné, which was a miracle to find in a public lending library, since the edition contained real lithographs and was worth over $1,000. I spent many hours at the library, poring over that catalog and quietly studying the high-quality color photographs and in-depth information in Abrams art books.

At first, I would read what critics and academics said about an artist, trying to get insights, but all the flowery words that they would write seemed like bullshit to me. A critic would say that something was inspired by Dalí's Freudian period and come up with a sentence like "the apparatus was an antonym of symbols decaying matter and the object of artist's admiration as an ardent devotee of science." Maybe that's true—whatever it means—but it confused me and seemed phony. It certainly didn't make me a better forger.

I read that Chagall once met a bunch of schoolchildren look-
ing at his famous stained-glass window in a synagogue in Israel.

He asked them, "Do you understand Chagall?"

They all said, "Yes."

But Chagall replied, "That's funny, I don't."

This was an epiphany to me, because I'm sure he didn't. So, I
stopped reading as much and started just looking at the work itself,
trying to understand it, as one artist to another.

I tried to be as concrete and physical as I could and to avoid phi-
losophy. I saw that Chagall might put seven birds in the sky during
a certain period. Others might explain why or interpret what that
meant, but I didn't really care. If he put seven birds in a painting, I
put seven. Not six. Not eight. Seven.

Though I had started to paint artists like Chagall and Dalí
professionally, I would not have known how to give a lecture on
them. Some dealers would talk to me about Dalí's interpretations
and meanings; all I knew was that you couldn't put his home in
Portlligat from the 1950s into paintings from 1975, or lobsters from
1936 into a painting from 1950. I developed a physical hands-on
understanding of artists, which I thought was better than trying to
get inside their heads without actually painting.

Dalí himself is often considered a guru of mystical and
stream-of-consciousness painting. In reality, he was also a classically
trained and practical draftsman. He famously created a scoring grid
that he used to rate the great painters from 1 to 20 on concrete cate-
gories like Drawing, Technique, Composition, and Color. Vermeer,
the highest scorer, got 20 for everything except Originality. Mon-
drian scored 0 for everything except Color (he got a 1), Originality

(½), and Authenticity (3½). With that, I could agree. Dalí gave himself decent scores. Personally, I thought he was a great drafts-man, and it was useful to learn that he judged artists in an objective and straightforward way.

I searched for practical things that I could translate into ac-tion. I found that Chagall used only a few pigments during spe-cific parts of his career: lead and zinc whites, Prussian blue, cobalt blue, ultramarine blue, vermilion, red and yellow ochres, Naples yellow, cadmium yellow, viridian and emerald green. If you wanted to paint Chagall during that time, you used those colors, period. If you wanted to do an early Picasso, you used house paint, and if you wanted to paint like Dalí, you put the paint on so thin you could see the texture of the canvas underneath. These are the things that I needed to learn as a young art forger, not the abstract philosophical musings of some critic or expert.

I had already learned this way while working for Carl, but it had been a rough apprenticeship. With John Mercante, I had found a friendly role model who was happy to teach me what he knew. He was about ten years older and represented all the things I aspired to be: stylish, well traveled, and urbane. From him, I learned how to conduct myself as an adult, with maturity and polish that I didn't have before. I even started to wear my loafers without socks.

In the early seventies, Palm Springs was a fun, star-studded place full of rich and sophisticated people who flew in from across the country for the winter season. John and I would hang out at old Rat Pack places like Pal Joey's, named after Sinatra's friend Joe Hanna, or Jilly's, which was always packed with attractive women who came to town to tan and relax. Sometimes in the off-season,

when it was too hot, I would go with John to Beverly Hills, where he would conduct business or spend time with his girlfriend, Emily, who I liked very much. She had been an international jet-setter, with important friends like Jackie Onassis and Lee Radziwill, but she never talked about that and always acted like I was the most interesting person in the world. I was proud when I heard John tell her nice things about me, calling me a "talented kid." It was light-years away from Carl.

Running a gallery can be a lonely and boring business. John would sit in his gallery, making calls or passing time. I would bring in my black-and-white Chagall and Miró lithographs or small watercolors, with the books I had used for inspiration. He would compare the books to the artworks, looking back and forth like he was watching a tennis match. When he smiled, I knew that he liked it.

John was not as knowledgeable as I was about the artwork itself, but he knew the art business inside out. He could tell me whether my pieces were good, how they would be examined, and how much someone would be willing to pay. He also gave me general advice that I took to heart—though probably not enough. He told me to be careful about who I sold to, to get paid up front, and to never sell to galleries that were too close to each other. The most important advice was to just keep him out of anything. He did not want any trouble.

Palm Springs was nice, but after cutting off Carl, I had outgrown it and needed to find new clients. So, I went to LA and canvassed an area between Robertson and La Cienega, with Beverly Hills as the center. I would stroll the streets, looking in gallery windows, checking to see if they had Chagalls, Mirós, and Dalís. I finally

ended up at the Kaiser brothers, well-known dealers with galleries in Beverly Hills, Las Vegas, and Hawaii. Like Carl, they turned out to be crude, foul-mouthed hustlers.

When I went into their gallery, I was still using the cover story about this naive kid selling his grandfather's art. I showed them my black-and-white Chagall while they bantered to each other.

"Holy shit, Jerry. It's a guinea with goodies from Grandpa," Lenny said.

"Wow," said Jerry. "Junior came to the big city to make a killing."

They both laughed, jeering, "Are you gonna fuck us for a million?"

I laughed along, but it really got under my skin. After a couple more rounds of tired insults, they examined the lithograph. Though they seemed intrigued, they weren't convinced and wanted to check with another dealer. In those days, before cell phones, if you wanted to reach someone, it was hit or miss. So, they called over to the famous Polo Lounge at the Beverly Hills Hotel, where Charles Fletcher took his calls. He agreed to come over, and as we waited, Len and Jerry talked about their wives and bragged about "fucking them in the ass" or "getting blow jobs" from their girlfriends. I barely paid attention because I was nervous about the big-time dealer on his way. I thought if he said my art was fake, there might be a fight.

When Charles showed up twenty minutes later, I was immediately relieved. Instead of a worse version of a Kaiser brother, he was a jovial, handsome British man in his forties with an upbeat and friendly manner. He held the Chagall up to the light, checked for the watermark, a faint translucent design that manufacturers put in paper to indicate authenticity, then looked at it with a loupe before

announcing in a cheerful tone, "Well, gentlemen, I think this is a wonderful Chagall."

When they heard this, the Kaiser brothers' eyes lit up and they immediately offered me $600. I claimed it was worth more, but they offered me cash on the spot, fanning out hundred-dollar bills and saying, "We got green," which I came to learn was their signature move. I took the money and handed over the art, happy that a guy like Charles had blessed it. Charles and I walked out together and when we said goodbye, he passed me his card and told me, "Let me know if your grandfather has anything else."

A week later, I met Charles at his office on Melrose and sold him some gouaches, a drawing, and some lithographs I had done. I repeated this three or four times, telling him that now I was selling the art that my grandfather had given to my brothers and cousins. They had day jobs and didn't have time to go walking around to galleries all over town.

Eventually, I brought him so much art that my story began to look ridiculous. He asked me to come clean and hinted that it would be OK if I had done them myself. When I confessed, he wasn't upset at all. Instead, without skipping a beat, he gave me a commission for fifty lithographs, which I did the following week. Real or fake, the art business rolled on. It simply didn't matter to anybody.

Charles was amused by my green, unpolished ways. He called me a "diamond in the rough" and treated me like a genuine friend. I considered him a true gentleman, well spoken, charming, and always impeccably dressed with a tie or ascot. I thought he must have been an aristocrat. Later I learned that his real name was Nathan

Herschlag and that he had been in the clothing trade before changing his name and moving to America. It didn't make any difference to me. I considered him a great friend, better than any duke or earl could ever be.

Charles and I hung out together at Café Suisse or the Moustache Café or we'd go to dinner at Figaro or Chasen's. Everywhere we went people knew and liked him. I would always kid Charles that when I grew up, I wanted to be just like him. In reality, we were very different, but it's true that I did want to be a happy-go-lucky man-about-town like him. I couldn't believe how things had changed. A couple of years before, I was a small-town kid selling furniture and eating baloney sandwiches—now I was hanging out in Beverly Hills and stars like Jack Lemmon or Michael Caine would wave at us happily and call out, "Hi, Charlie!"

I still did business with other dealers, including the Kaiser brothers, because even though I disliked them, they would always buy my stuff in cash. When I'd come in, they'd double-team me with insults from the second I stepped through the door. Hassling me, chiseling me, and putting me down. Finally, one day I decided they needed a little taste of their own medicine, so I came up with a prank and had a few laughs at their expense.

Matisse had done a pencil drawing of a nude sculpture of the Greek god Hermes that's in the Louvre. In Matisse's drawing, the perspective is from the front, showing Hermes bending forward and fastening his sandal. I decided to draw him from behind, a little private joke that I was mooning the Kaisers.

To prove the drawing was real, I planned to present them with an Abrams Matisse book that would have my drawing in it. I bought

two copies of the book and with the help of my printer made a fake page. It had all the same text as the original book, but instead of a photo of Matisse's drawing, we had swapped in a picture of mine.

With a razor blade, I carefully sliced the real page out of the book and glued in my fake page. It was excellent, but it stuck out just a millimeter from the rest of the pages, so I sanded it down until the size was exact. Now I had a genuine Abrams Matisse book complete with my drawing to show the Kaiser brothers.

Though I wanted to show them my book, I did not want to leave it with them so that they could examine it too closely. So, with the help of Marguerite, I turned my store-bought book into an Ontario City Library book that was not supposed to be removed from the reading room, which gave me an excuse to take it back immediately and not leave it with the Kaisers. We put a real library card and pocket in it and stamped it ONTARIO CITY LIBRARY and DO NOT REMOVE. Then, I placed a Dewey decimal sticker on the spine and sheathed the whole thing in clear plastic. It looked exactly like a real library book.

Finally, just before I went in to the Kaiser brothers, I stopped into the Rizzoli bookstore near the gallery and into the Brentano's bookstore down the street. I found their copies of the Matisse book, took them off the shelves, and hid them in the middle of the gardening section. Now, even if the Kaiser brothers went to look for the real book, it would be weeks before they ever found a copy.

When I went to show them my drawing, I told them that I absolutely could not leave the book behind and that I had to bring it back the same day so that Marguerite would not get in trouble. After some haggling, which led to me walking out, they chased me

onto the street and waved $4,000 in cash in front of my face. I pretended to break down, handed them the Matisse, and cursed their good fortune. I told them they were lucky I needed the money that day. Secretly I was chuckling to myself, imagining the look on their faces when they saw the real book and discovered I had screwed them.

It cracked me up, though ultimately they had the last laugh. A few years later, I went to their gallery in Hawaii and saw my drawing hanging in the window. It was on sale for $25,000 and had a certificate of authenticity. On the back, in tiny print, was a thousand-word legal disclaimer saying that the drawing might not be real, and that if it wasn't, it wasn't their problem. Like it or not—whether on the customer or on me—the dealer always had the last laugh.

six

PRINTING MONEY

(1977)

SALVADOR DALÍ WAS AN ORIGINAL THINKER AND ACCOM-plished artist. He was also a ham with dramatic flair and the ability to attract attention, which he knew how to play to great effect, making a spectacle of himself and harnessing the attention for fame and profit. In the forties, while he was living in Monterey, California, Dalí threw a famous party to raise money for European artists fleeing the Nazis. It featured his wife, Gala, dressed as a unicorn, bottle-feeding an ocelot. Dalí, who wore earflaps shaped like faces, served his guests a menu of fish presented in satin slippers, a tray of live frogs under a silver banquet dome, and an erotic course of aphrodisiacs. The press ate it up as movie stars like Jackie Coogan and Bob Hope mugged for the cameras.

Dalí's sense of the absurd, his self-promotion, and his ease at mixing high and low art made him a popular figure, with mass-market appeal. Even as a kid I had heard of Salvador Dalí before I

knew anything about his art. Dalí knew how the world viewed him and he cultivated his crazy cartoonish persona freely. In the fifties and sixties, he appeared in TV ads for Lanvin chocolates, Alka-Seltzer, and Braniff airlines, where he made this big flourish and proclaimed, "If you've got it, flaunt it!" while his eyes bugged out and his handlebar mustache jangled in the air. He also appeared on the game show *What's My Line?* and popular talk shows like *The Merv Griffin Show*.

So, in 1976, it wasn't that surprising that Dalí presented, with his usual showmanship, his new oil painting, *Gala Contemplating the Mediterranean Sea Which at Twenty Meters Becomes the Portrait of Abraham Lincoln*, at a big Bicentennial gala at the Guggenheim Museum in New York. The eight-by-six-foot oil with this strange, elaborate title was finished in his suite at the St. Regis Hotel in the company of his pet ocelot and became one of his most famous images. The piece showed the nude figure of Gala from behind looking out over a fiery sky and blue-green seascape, and, as the title indicates, if you stepped back and looked at it from twenty meters away, it resolved into the portrait of Abraham Lincoln. It had all the makings of a Dalí: showy, interesting, quirky, and gimmicky.

Dalí's painting had been inspired by a 1973 *Scientific American* article about visual perception that explored the number of pixels needed to create an identifiable human face. Now, the concept is a cliché, something you see in ads, movies, and apps. Then, it was a new and mysterious effect. The researchers used Abraham Lincoln's face from the five-dollar bill as their case study and so it was for that reason that Dalí adapted it for his own purposes.

When Dalí released his oil painting, it did not receive serious consideration from the art world. It was not as groundbreaking as some of his early art, and not as unsettling as some of his film or performance pieces. It was met with a general shrug. I remember I read about it in *ARTnews* and I, too, shrugged. I think maybe I squinted at the picture in the magazine and thought, "Huh, that's kinda neat."

A year later Dalí released a lithograph version of the painting in a limited edition. Within a few months, the *Gala Contemplating the Mediterranean* that everyone had ignored as an oil painting became the most popular print in history as the newly reborn *Lincoln in Dalivision*. Everything about the piece was a perfect storm for commercial success; even the name was sloganized and branded. Most of all, the gimmicky nature of the optical illusion meant that an unsophisticated audience could understand and be delighted by the piece, without knowing anything about art. And at a price initially in the hundreds, it was the kind of entry-level art that novice collectors—what dealers called "ham-and-eggers"—could aspire to.

The worldwide rights to sell the lithograph were purchased by Center Art Gallery in Hawaii, and through relentless promotion and a calculated marketing plan, they made a killing, starting a feeding frenzy in lithographs. Center Art carefully controlled access, parceling out one or two copies to galleries around the country. Initially, galleries were able to buy the piece for around $750 and this served to whet the appetite of the market. Little by little, Center Art fed out additional pieces in dribs and drabs, the price doubling and tripling before climbing exponentially. Center Art's staff, specially trained to market the lithographs as "investments you could hang on your

wall," could show that the prints had in fact already doubled, tripled, or quadrupled in value. Finally, Hawaii's popularity was at its height and a huge influx of mainland and Japanese tourists, newly wealthy and hungry for Western art, flocked to the gallery.

Interest in Japan had become so strong that within a year a Tokyo-based collector paid a couple million dollars for the original oil painting that had initially raised so little excitement. It was probably the first time in history that an oil painting's value was propelled by its lithographic knockoff rather than the other way around.

A few months after the release, I walked into the gallery of a dealer in Beverly Hills. I had sold him a Chagall gouache, and as we chatted, he showed me a new *Dalivision* that he had just managed to score from Center Art. He had bought it for $2,000 and was selling it for $5,000 and was disappointed to have only one. He told me, "I could sell ten of them a day if I could get my hands on them."

That was all I had to hear. I knew if I could figure out how to make color lithographs, I would be a rich man. I left the gallery and went straight to my printer, Ray. Before he could even say hello, I told him, "We have to figure out color." Earlier we had discovered how to replicate continuous tone in black-and-white lithographs; with those, we had only to fill in the halftone dots our process left around the edges of an image. With color prints, the obstacles were many more, much more challenging, and much more expensive. We did not know how to do it.

Lincoln in Dalivision was made with a process called collotype, which produces images in pure color with continuous tone. It was a labor-intensive and secretive process, done only by a few masters on

antique machines in Chicago, New York, and Europe. In standard four-color printing, tiny dots of cyan (blue), magenta (pink), yellow, and black are superimposed to simulate up to sixteen thousand colors. If you look at an image that is printed in this standard way, either with the naked eye or under magnification, you will see colored dots. We had to create collotype's smooth color without dots. But how?

A newspaper might have 125 dots per inch and you can easily see the dots with your naked eye. At the time, pictures in the highest-quality glossy magazines had 200 dots per inch. You could not see these dots with your naked eye, but they were easily detectable under magnification. That's why dealers would look at a lithograph through a jeweler's loupe to see if they could spot dots and therefore a printed fake.

Lincoln in Dalivision was printed on soft, porous Arches art paper. Unlike hard, dense magazine paper, if you spilled ink on it, it would be absorbed and spread, like on a paper towel. We thought if we could print enough dots per inch, tightly packed, on porous paper, the ink would bleed and meld together across the dots to create the illusion of continuous tone.

We found a printer who could do an incredible 500 dots per inch, but even that was not enough. The Arches paper turned out blotchy, and with a loupe, you could still see faint dots. It was a bust, except as a consolation, the printer mentioned a company in Canada who claimed that they could do 900 dots per inch using advanced computer technology. Within a few days, Ray and I were on a plane to Toronto. Ray was a family guy with a solid business, but I think he relished the adventure of doing something exciting

and illicit. We stayed at the Four Seasons and before our meeting had lunch at the CN Tower, watching the planes fly beneath us as we talked about our plans.

When we went to see the printers, we were blown away. The kind of printing Ray did was a manual job, more art than science. But these guys had a room of supercomputers and their state-of-the-art machines could do magical things. Now, it's trivial to do things like copy and paste images or delete buildings and replace them with blue sky, but back then it was light-years ahead of what anyone else could do. You have to remember this was when *Pong* was considered an advanced video game, Microsoft had one employee, and the hottest computer was a Tandy with a 4 KB memory. Now, your cell phone literally has sixteen million times the memory.

When Ray came out of the building, he was floored. "Wow," he said, "this is fucking incredible!" I wasn't an expert, but I was excited because I saw how excited Ray was. On the flight back, I started to think that *Dalivision* was, just maybe, going to be possible and I resolved to go all in, sinking every last dime I had to make it happen.

When I got back to LA, I bought a real *Dalivision* and rented a Hasselblad camera, the best in the world. We took beautiful, clear pictures of my *Dalivision* and sent the film to Toronto, waiting eagerly as they turned the film into four 900 dpi print screens—one for each color through which the ink would be squeezed to create our *Dalivision*.

When the screens finally arrived, Ray called and simply said, "They're in." I dropped everything and went to McManus & Morgan, the paper dealer, and cleaned them out of Arches. At $4 a

sheet, I think I dropped over $4,000. Then, I went to see Ray and his brother, who were waiting for me. They let me in, locked the door, and drew the blinds. We went to work in the back room. The brothers were upstanding citizens, but they loved the intrigue. Everybody has a little larceny in their heart.

Though our print screens came from a supercomputer in Toronto, in the back room, we did old-fashioned hands-on work. The old Miehle press we were using was a simple workhorse that could handle only one color at a time. For each color, we had to painstakingly line up the prints and do test runs to make sure they were superimposing correctly. As we experimented, the microscopically perforated screens would clog. We would have to stop constantly and clean them. Between these tasks, we wasted enormous amounts of time and effort and maybe 40 percent of the paper. After hours of trial and error and disappointment, we finally thought we had gotten something to work. When I looked at it through a loupe, I felt like Carter opening King Tut's tomb. I peered through the lens and was astonished to find no dots. "Fuck me," I said, "we did it!" and hugged Ray. He was not an emotional guy, but even he practically had tears in his eyes.

We were so excited that we decided to strike while the iron was hot, printing through the night until we ran out of paper. By morning, we had about six hundred copies. I was exhausted, bleary-eyed, but happy. My work, however, was just beginning. In the real *Dalivision*, Gala's nude body was embossed in minute detail like a bas-relief, and at the bottom right, there was an etching of a woman sticking out her tongue. The etching had grooves, raised just enough so that you could feel them with your fingertips. If you

brought a *Dalivision* to a dealer, the first thing they would do is run their fingers over the surface to check for them.

I made a mold by pouring plaster of paris into the reverse side of my *Dalivision*. It almost ruined the print, but the mold mimicked the grooves perfectly. From it, a specialist made bronze male and female dies that you could squeeze together in an old Thompson press to create the embossed effect. We had to waste a bunch of prints to get it right, but in the end, it was perfect.

Genuine *Dalivision*s came with a little brass monocle that would help people see the optical illusion of Lincoln's face. I had mine made by local machinists, who copied, to exact specifications, the original I had brought in. They also helped me locate exotic Fresnel lenses—the kind used in lighthouses—to match the original eyepiece. Once I had signed the prints, copying the original signature by Enrique Sabater, Dalí's business agent, they were ready to go.

Because *Dalivision* was so popular, all I had to do to sell them was cold-call dealers and ask if they wanted them. From my first fifty calls I probably sold over forty. I'd meet dealers at their galleries or offices and sell them in ten minutes, pocketing $4,000 apiece.

After a few weeks, I had sold *Dalivision*s to everybody I had called. Then one day, I received a call from someone I hadn't solicited. In the thickest Bronx accent I had ever heard, Arnie Blumthal told me he heard I might have a *Dalivision*. I told him the price was $4,500 and he bristled. "For $4,500," he said, "I'll sell it to you." I took $3,500 and over the course of a few weeks I also sold him Dalí, Miró, and Chagall drawings, etchings, and watercolors. He was a happy customer, though not for long.

It turned out that Arnie had been going around to galleries asking people where they had gotten their stuff. Everywhere he went, he kept hearing Tetro. The same answer everywhere: Tetro. Tetro. Tetro. When it dawned on him that I had been making the art myself, he went insane, haranguing every dealer he could corner, "That motherfucker Tetro! He's a faker! This Tetro is a fucking faker!" He had already sold all my stuff, so he couldn't go to the cops, but he made it his mission to warn everybody. It turned out to be the best advertising I ever got. From that point on all the dealers came to me.

Real or fake, they didn't care. They would call me up and sweet-talk me. We played a cat-and-mouse game where we talked vaguely, saying nothing. They'd say, "People tell me you're good at what you do," or "I hear you're a lithography expert." Somehow without saying anything, we would agree on a price and quantity. Looking back, it wasn't very bright. I could have easily been set up. But the demand was so great and it was so lucrative that I could not resist. I would sell twenty of them at a time for $1,000 apiece. Even Charles, who had originally turned down the rights to *Dalivision* because he thought it was corny, bought some from me. Once, when he was writing me a check for three *Dalivisions* I had just sold him, his customers walked in. He sold them the exact same ones I had just given him for double the price. I might as well have just handed them over directly to them.

Compared to Center Art, my prints were a bargain, easy to get, and hassle-free. I had gone from being a cold-calling nuisance to the most popular guy in town. I started advertising them in the

LA Times and would take orders from all over the country on my cordless phone while I floated slow circles on a raft in the pool.

Dalí was good to me and I respected his work, but I had taken some liberties with *Dalivision*. In Dalí's version, some features in it are a certain color. I didn't like that, so I gave mine a different color. Now, mine are considered real while the original color—Dalí's—are considered fake.

But *Dalivision* was just the start. Whereas before I could only do a small range of black-and-white prints, now I could do literally any color lithograph I wanted. It was like I had found the Holy Grail. Dealers would commission me, asking, "Can you do this? Can you do that?" We'd come up with an image and set to work. Our operation became so smooth and the quality of the prints was so good, everybody wanted them. They even started calling them Tetrographs instead of lithographs.

Dealers would buy five Chagalls from Leon Amiel, the official publisher, because he had certificates of authenticity and a guarantee, and then they'd ask me to make thirty more. Amiel's work was shoddy, strictly for ham-and-eggers. I'd make mine perfect, with rich color and the layered effect of translucent inks. But because the dealers needed mine to match Leon's, they would tell me, "Don't make them so nice. Print them shitty, like Amiel's."

I thought, "Who am I to argue?" After all, I was pretty much just printing money anyway.

seven

THE DRUG KINGPIN OF UPLAND
(1979)

WHEN WORD GOT AROUND ABOUT MY TETROGRAPHS AND *Dalivisions*, I'd get calls and talk to people from all over the country. If I felt comfortable, and if I wanted to visit a particular city, I'd fly there—to Denver or San Francisco or Chicago—and sell them prints. Then while I was there, I'd look up other galleries in the hotel phone book and walk into them cold.

When my parents moved down to Florida, I'd visit them and bring lithographs for customers in Miami and Fort Lauderdale, where I had developed a pretty good business with Fat Billy Sutton, a wholesaler. Billy told me about a dealer named Ron Lewis in Minneapolis who wanted three *Dalivisions*. When I went up there, I saw that Lewis had a phone room operation selling the worst, most amateur *Dalivisions* I had ever seen. They were printed on industrial paper and looked like a comic book, with vague legalese on the back that hinted without saying that they weren't really by Dalí. He

must have been happy to get his hands on mine. We agreed on a price, and he told me to come back the next day for cash.

When I got there in the morning, two FBI agents were waiting for me, because Lewis had tipped them. I have no idea why he would have done that; maybe to mess with the competition, maybe he was mad that he couldn't make his Dalís good enough to say they were real. Whatever the reason, the agents questioned me hard. They gave me the good cop/bad cop treatment. I was so mad at this clown Lewis, who couldn't even make a print, that I snapped, swearing and poking my finger at him. I made the agents look at his Dalí through a loupe while I pointed out the halftone dots. Then I had them look at mine. They were never going to see dots.

I was ranting and raving so much that, by the end, they believed me. With all the adrenaline pumping through me, I had taken it out on the agents, but really, I was insulted by Lewis. How the fuck was I going to be questioned by a hack like that after I had worked so hard to make mine perfect?

A couple weeks later, I sold a *Dalivision* to a guy in Vancouver. I didn't want to fly up there, so I mailed it in a tube. He stiffed me and if I wanted to straighten it out, I would have had to call Canadian customs, so I dropped it. It wasn't worth the trouble and the risk.

These hassles were a wake-up call. I quickly wised up and decided to limit myself to a small circle of regular dealers I trusted and wouldn't have to worry about: Charles and his partner Tom Gray, Michael Fischer in Beverly Hills, Mitch Geller in Chicago, Donald Stein in LA, and Truman Hefflinger in the Valley, plus a dealer in San Francisco named Gérard Moulet, who everybody called François or Frenchie, because he was from Paris.

I even started doing business with the Kaiser brothers again. Once they figured out I had screwed them on the Matisse drawing, we had a few laughs, called it even, and got down to business. I was their kind of guy.

I'd still take a call occasionally and sell someone a Miró or a Chagall, but by then most of my sales were in bulk, to those guys. All I'd have to do is go see Ray and Barry, and in a week, I'd have a fresh stack of art to hand off. I couldn't believe the money that was rolling in. I might get $10,000 or $15,000 a couple of times a month—a fortune.

And with that money, I was finally able to realize the dream that I had nurtured since I was a child. I bought a used Ferrari from a dealer in Pasadena, a silver 1977 308 GTB that cost me $29,000. For a car like that, it was a good deal, and for a fanatic like me, it barely seemed real. I couldn't believe it was actually happening. I drove straight from the dealership to my daughter's middle school. She got off the bus and into the car, and we went for a drive, tearing up the freeway and tooling around town. She wasn't the type of girl to care about cars or money, but I could see that she was happy, because she knew how much I loved Ferrari and how happy it made me. To this day, that is the best I have ever felt about buying a car.

It felt so good that I bought another Ferrari, a 1974 Dino Spyder, with what fanatics like me called "chairs and flares," Daytona seats and wider arches to fit the wide Campagnolo wheels. I had read about it obsessively and found out there were only ninety-nine in the whole United States. Now I had two magnificent cars, which would have seemed completely impossible just a couple of years ago.

In downtown Upland, I set up a work studio in a nondescript little apartment off Mountain Avenue. I had a carpenter fit the closets with shelves and had some drawers brought in. I put all my books, paper, paints, pigments, certificates, and other stuff I needed to work in there. I decorated it, and when I put a cloth over my paint-splattered table and put my stuff away, you would have thought it was just a nice, normal, tidy little studio apartment. I used to park my cars in back, and kept my apartment a secret from everyone except for a few close friends. It was my little hideaway. Not even my girlfriend knew.

In my studio I started painting oils again, just for myself, as I had done in the early days at the kitchen table. I didn't really have any intention of selling these paintings or passing them off; I just enjoyed it. It would have been impossible anyway—old masters like that. In my work life, dealers wanted Dalí, Picasso, Chagall, and Miró, but I went back to what I really loved, Baroque masters and especially Caravaggio, who completely fascinated me.

I loved the way Caravaggio filled everything with powerful emotion, setting up a scene with live models the way we think of movie directors doing it in films. Caravaggio and his chiaroscuro lighting were a big influence on film noir and directors like Alfred Hitchcock and Martin Scorsese. You could see it in the dark backgrounds and bright lights illuminating faces in gangster films. You can see it in a movie like *Casino*, in the tableau of mob bosses posed under a hanging light. Compare it to *The Calling of Saint Matthew*. Everything about Scorsese's scene, the light, the poses, the fruit, the expressions, is straight out of Caravaggio.

Caravaggio used real people with real faces and real emotions. I found it endlessly absorbing, as did so many other painters. I mean it when I say that Caravaggio was probably the most influential painter in history. There was a group of artists called Caravaggisti—direct followers who were inspired by and, to varying degrees, copied his style, painters in Italy, France, Spain, and the Netherlands. Even famous painters like Velázquez, Vermeer, and Gentileschi could be called followers. At that time, even though there were many secrets I hadn't mastered, like how to paint flesh tones convincingly, I, too, started following Caravaggio.

I'd work all day and then, when I had finished painting, head across the street to Magnolia's Peach—the world's best watering hole, where I met many of my lifelong friends. Ask anybody who lived anywhere near Upland in those days, and they'll tell you the same thing. Like most of the bars I like, the Peach was the kind of place where people from eighteen to eighty-two would hang out. And because of the way the tables were set up, you couldn't help striking up conversations with people you didn't know. You'd meet mechanics, roofers, plumbers, salesmen, brokers, bookies, bikers, drug dealers, and kids getting drunk on a fake ID. On Fridays, if you wanted a table for happy hour, you had to go there at noon. I probably stopped in five days and sometimes seven days a week because I knew I'd run into someone I knew. At the Peach, I met people I still see forty years later.

I got to know everybody because I was there a lot and because the owner asked me and a couple of the other guys who had nice cars to park in front. It gave the place some glamour, and pretty

soon I was like a fixture—they even painted the curb red so that our spaces would be reserved. It raised eyebrows. Here was this young guy with two Ferraris who would show up in the middle of the day or at happy hour. People would ask me what I did for a living, and when I told them I was an art dealer, they nodded politely and smiled.

In reality, everybody thought I might be the biggest drug dealer there ever was. You couldn't convince them otherwise. I had people tell my friends that they knew where I got my drugs, who I sold them to, and when they were coming in. It was crazy. One time, one of the girls I knew from the Peach called me up and asked me if I could sell her cocaine. I politely told her that I didn't sell drugs, but she wouldn't believe me and kept badgering me. I told her I knew that some people thought I sold drugs, but that it wasn't true. "Yeah, yeah, Tony," she said. "I get it, but can I get an eight ball?" Finally, I told her to leave me alone and slammed the phone down. The next time I saw her at the Peach, she went nuts, screaming at me and making a scene because she thought I had blacklisted her from my list of customers. Even her boyfriend's chauffeur was so menacing that I had to ask his boss, George, to lay off.

Then, when my friend Jimmy got arrested for snorting cocaine in the bathroom at a local restaurant, I was on the front page of the *Daily Register* as the guy who sold it to him. In reality, I was just hanging around while he was in the stall, but it didn't matter. When I was acquitted, it was printed at the bottom of page seven.

A little while later, I bought a Lamborghini Countach. Before that, everybody suspected I might be a drug dealer. After, they were 100 percent sure. The car was a 1978 LP 400, the exact car that was

on the famous Alpine car stereo poster that every kid had on their wall, with big fat tires and a wing on the rear. I bought it in San Diego off a washed-out Saudi prince who had gotten it straight from the stage of the Geneva Motor Show. There were fewer than ten in the United States at the time. Every time I drove it, it was chaos.

When I picked up Christine, all the kids and teachers would come outside like the circus had just come to town. I think Christine was a little embarrassed, but I had a dozen friends ask me to pick up their kids and give them a ride as a special favor. I'd drive up, and when I opened the scissor doors for them, they went wild. I made sure I never missed a pickup no matter where I was, because the kids would have been so disappointed. I wasn't really trying to show off; I was just a genuine car nut who had been obsessed since I was ten years old. Driving the kids around, I was probably more excited than they were.

The downside was that if you're in your twenties and drive a car like that around a place like Upland, some people will not be happy. I must have gotten my car keyed five times and I made quite a few enemies. When the Peach painted the curb in front of their place red, it didn't sit too well with the new fire chief. He made the red curb official and even though there was no hydrant, he wrote me tickets and threatened to tow me away. One time, I saw him driving the fire engine, flying through the parking lot right at me, with this crazy look on his face. I swerved away, but I swear to God he would have rammed me if I hadn't punched it.

The cops didn't love me either. I was constantly being pulled over and having my car searched. Bad taillights, stop signs, lane changes; it seemed to me that San Bernardino County sheriff's

deputy Bob Raynes had made it his personal mission to bury me. The first day I got my Dino, I remember I stopped in at 7-Eleven to get a pack of cigarettes. He was waiting for me when I came back out, looking at the car with this big grin on his face. He shook my hand and kept staring at me like he was crazy. I didn't know him, so I told him my name was Tony and that it was nice to meet him. When I hopped in the car to leave, he said, "Nice to meet you, Mr. Tetro." Bob Raynes was putting me on notice that whatever shit I was pulling wasn't going to fly in his town.

I'd see him at the Peach once in a while dressed as a civilian. He'd be with his buddies and they'd be staring at me and making wisecracks. They thought it would only be a matter of time before I, the Drug Kingpin of Upland, fucked up and got caught. Once, at the Peach, I saw three or four small-time drug dealers cracking up when I walked in. "You take all the heat away from us, Tony," they laughed. I drove around in a Ferrari or Lamborghini with paintbrushes in the car and got stopped all the time. They drove around in Toyota Tercels with cocaine in the trunk and nobody ever said a word.

The cops even tried to set me up. People I barely knew would call me out of the blue to ask if I wanted to get together and "talk about stuff" privately. Jimmy told me they were low-level drug dealers who had been busted and were trying to plead out. I got a call from a husband and wife from the Peach. They, too, had been busted and asked me if I wanted to take part in a credit card scheme. Once, in a restaurant, I handed a bottle of perfume to a woman I was dating. As soon as I stepped outside to smoke a cigarette, the cops rushed in and demanded to know what I had given her.

Christine was still just in middle school then. I felt sorry for her. She would constantly hear the ugly rumors about me, and though I couldn't reveal the truth, I swore to her that the gossip was false. I told her I was an art dealer, and even though she knew that it was more than that, I couldn't tell her much else. I knew that it bothered her. I was especially upset when I got blamed for selling cocaine. It's not a good feeling when your daughter hears things about you, and then you have to keep secrets from her.

One of the only people I confided in was Vincent, a corporate bigwig for a defense contractor, who became one of my best friends. He had a straightlaced look and the squeaky-clean security clearance to match it. Every time I saw him, he was in a suit, having just come from his corner office at headquarters. He had a big house in the historical section of Pomona, a wonderful wife, and three daughters. We'd hang out a couple nights a week at the Peach, where he was always picking up tabs or tipping the bartenders too much. We'd go to Jimmy's in Beverly Hills, or we'd go hang out in Palm Springs or sometimes Las Vegas. Once in a while, he'd hang out at my studio since he was one of the few people I had let in on the secret.

I liked Vincent. His whole life he had been a straight shooter, but I sensed he had a dark side that started to come out. Sometimes he was a bad drinker. I remember him trying to get the key in his car and spinning around he was so drunk. One night I was driving with him in his Aston Martin after going out to a bar. He was driving 140 miles an hour down the freeway and I was screaming in his ear to pull over before we crashed.

He was a gambler, and to me he seemed like the kind of guy who would bet $100,000 on *Monday Night Football*, and then start

all over by Wednesday. Eventually, after some big losses, he must have figured out it was better to be bookie than bettor. Unfortunately, I think he wasn't very good at it, and it cost him a lot. That part wasn't fun to see.

To be honest, with everything going on, I probably should have gotten out of Upland and gotten some new friends, but at the time the complications seemed worth it.

eight

THE ADVENTURERS
(1979)

A S A KID, I WANTED TO TRAVEL THE WORLD AND LEAD A LIFE
of adventure. I imagined myself as Harold Robbins's pulp fiction hero Dax Xenos, a dashing man of action who knew his way around all the European glamour spots, Venice, Paris, Rome, the Riviera. Instead, I became a milkman and furniture salesman, making barely enough money to eat. When I was married, Marguerite and I never did anything. During our entire marriage, we never took a trip and never stayed anywhere overnight. Even in my early days as a forger, all I did was hustle around and try to generate business. If I traveled somewhere, it was to meet a customer for a day or two. I barely knew how to book a flight. I was almost thirty years old and I didn't even have a passport.

Today, with a computer, you can walk through every street in Rome without ever leaving your couch; back then, I bought a Frommer's guidebook, got a passport, and got on a plane. I had seen

Gregory Peck and Audrey Hepburn buzzing around on a Vespa in *Roman Holiday*; I had seen Anita Ekberg frolicking in the Trevi Fountain in *La Dolce Vita*. I had seen Fellini's *Satyricon*, about the excesses of rich ancient Romans. I had read a million books about art and history. In reality, I didn't know shit.

My great uncle Enrico, who we called Henry, was from Rome and he always said they were the aristocrats of Italy, which may or may not be true, but when I got there, I was blown away by what I saw. In Rome, you'd see a brand-new red Ferrari parked in front of a two-thousand-year-old pagan temple that had been used as a Christian church in 1300, a municipal court in 1600, and by 1979, a boutique selling fine handmade clothes for the stylish women of modern Rome.

Everywhere I went, people were well dressed, things were orderly and beautiful, and despite the polite formality and manners, everyone seemed more relaxed, less stressed, leading what seemed like content, easy lives, stopping in the middle of the day for a three-hour lunch. You didn't see the freaks, drunks, and bums you'd see in LA. There was no skid row. And as I headed to the Villa Borghese to see Caravaggio and Bernini, I strolled around the Renaissance gardens and saw families having picnics and eating gelato on a hill overlooking church domes and steeples. It didn't seem real.

Almost immediately, the Villa Borghese became one of my favorite places in the entire world. It had been the private home of Cardinal Scipione Borghese, a nephew of Pope Paul V, a politically powerful person and voracious collector of the art of his day. It was so opulent that when Martin Luther, the devout Christian reformer who railed against the wealth and corruption of the church, came

to Rome in 1510, he was sickened, thinking, "Did you forget about God?" And he was right. These people had lived in style. It was eye-popping and I ate it all up.

In Rome you could see twenty Caravaggio paintings within six blocks, in the Villa Borghese, the Capitoline Museums, the churches and chapels sprinkled everywhere through town. You could see how Caravaggio had lived. The traces of his turbulent, violent rogue's life were everywhere. Caravaggio had been a hustler, a starving artist, a fugitive, and a murderer; for a while he was the most famous artist in Rome, though he died at the ripe old age of thirty-eight—possibly from revenge, possibly by accident, possibly from illness. The details are unclear.

When Caravaggio came to Rome in 1592, he was on the run and arrived, he said, naked and almost literally starving. He had been in a brawl or a duel with an officer and had fled Milan in a hurry. In Rome, he was just one of thousands of artists who hoped to make it, the way people come to Hollywood now to be actors and directors.

Early on, he lived with a priest who barely fed him enough to survive. Caravaggio called him "Monsignor Salad" because apparently that's all he would give him to eat. At first, Caravaggio did hack work, painting heads, fruit, and flowers in the workshops of other artists for a few dollars a day. It reminded me of my own apprenticeship with Carl Marcus. The Borghese has one of Caravaggio's earliest paintings called *Boy with a Fruit Basket*. You could see that he was trying to show what he could do, painting beautiful, realistic fruit and putting it in the foreground as his calling card.

At the villa I also saw *The Young Sick Bacchus*, one of my favorite paintings. It shows the god of wine and revelry, Bacchus, but instead of looking heavenly, he's deathly pale and diseased. It's a common theme with Caravaggio, taking godly figures and turning them into rough reality drawn from his own life, right down to the dirty fingernails. The painting is a self-portrait from when Caravaggio was in the hospital, either with malaria or recovering from a mule kick, depending on who you believe.

Caravaggio used his friends—gamblers, whores, drunks, and street kids—as his models. In the Borghese there's a painting that's supposed to be *Saint John the Baptist*, but instead of looking like a holy man, Saint John looks like a bored teenage street hustler, which he probably was, and there's a strong homoerotic vibe. Caravaggio slept with both men and women and he was a pimp. Walking around Rome, I saw many faces that could have been taken from his paintings. They were probably the descendants of his models.

For sure, Caravaggio's art was real, human, carnal, and lusty, even his religious commissions. One cardinal said his art was in a gray area between the sacred and the profane. And that's one of the things I liked about him. In the Borghese you can see Caravaggio's *Madonna and Child with Saint Anne*. It sounds like a pious religious painting and he did it for the Vatican, but the Virgin Mary looks like a real woman, busty, dressed in a low-cut Baroque dress, as the model would have been. It was too much for the Vatican and they got rid of the painting. But Scipione Borghese didn't care. He grabbed it for his own collection and today, five hundred years later, it hangs in his villa.

The Adventurers

In 1594, Caravaggio hung his painting *The Fortune Teller* in a butcher shop, hoping that Cardinal Del Monte, a wealthy patron who lived across the street, would see it and hire him. I walked between the shop and Palazzo Madama where the cardinal lived, just fifty yards away. It was true, he definitely would have seen it, and in fact, Del Monte did buy the painting. It shows a gypsy reading the palm of a young man in an orangey suede jacket, and I couldn't believe how real the suede looked. I had read that Caravaggio used his fingers and thumbs, smearing the paint to achieve that soft effect. Later I read that under a microscope you could make out his fingerprints. I loved being in front of the physical painting that he had touched, and being close enough to touch it myself.

In Baroque Rome, wealthy families would purchase the rights to decorate chapels and churches the way big donors get pavilions at universities named after them today. It was one thing seeing paintings in a book, but entirely another to see them in real life, in the context of where they were meant to be: big, real, in candlelight, as part of a solemn, emotional experience. In the Cerasi Chapel I saw *The Conversion on the Road to Damascus*. As I stared at it, I thought, "This has been hanging here for four hundred years. How do you clean it? Did they build the frame around it after it was hung? How many people have prayed in front of it?"

The Catholic Church wanted illiterate people to understand and be moved by stories of the Bible, and so during this period, they expressly made a big push to illustrate these stories. The subject of this painting is Saul of Tarsus, a Pharisee, an official who persecuted the followers of Jesus. He was on his way from Jerusalem to Damascus to arrest the Christians of the city. As he got

close to Damascus, a light from heaven shone down and he heard the voice of Jesus saying, "Why are you persecuting me?" Saul fell from his horse, blinded, and was led to Damascus, where he converted, changed his name to Paul, and became the most important follower of Jesus.

If you look at that painting and don't know the story, it might not have much of an impact on you, but I had learned all of this from the nuns in Catholic school, and even though I wasn't particularly devout, I was a good student because I found the stories to be riveting. I could experience them as somebody during Caravaggio's time might have, kneeling in this chapel, praying.

In the Contarelli Chapel in San Luigi dei Francesi, I saw *The Calling of Saint Matthew*, the painting that Scorsese had imitated. And though it was a Bible story too, I was awed by Caravaggio's use of chiaroscuro. It is one of his greatest works and it's at this point that most academics say everything changed in painting.

The last painting I remember seeing was *David with the Head of Goliath* from the year Caravaggio died, on the lam once again. It shows David holding up the severed head of Goliath, and Caravaggio used his own head as the model for the giant. I thought he must have known that he was nearing the end, and that he was not going to die peacefully, in his bed, as an old man.

In Rome I really fell in love with the sculptor Bernini, who designed the enormous carved altarpiece in Saint Peter's. I was speechless at his *Apollo and Daphne*: the incredible way he captured—in stone—a woman turning into a tree. I chuckled when I saw *The Ecstasy of Saint Teresa* and her story of religious rapture, the way she recounted feeling overwhelming waves of pleasure and moaning as

an angel repeatedly thrust into her with a spear. It was the source of much teenage snickering when I was in Catholic school and in real life it looked practically pornographic.

As I walked around Rome, I stood in awe at the scope of time in which art had been continually made in this city where I was walking. I went into the unbelievably massive Saint Peter's Basilica to make a pilgrimage to the Pietà. I was surprised to learn that there are no paintings in Saint Peter's—they were all replaced by intricate mosaic recreations around 1700. There is a room in Saint Peter's with every color tile imaginable. For every day of the last three hundred years someone has been painstakingly replacing and repairing tiles continuously. When they reach the end, they go back and start all over again—into eternity.

I saw the Sistine Chapel before they cleaned it, with its patina of age and human presence. I learned that for four hundred years, kilos of sweat evaporated into the ceiling every day, giving it its color, the bodies of worshippers literally becoming part of the painting itself. I went back many years later and hated that they cleaned it. Now I've grown to accept it, though I can't help feeling something important has been lost.

As I wandered through the neighborhoods of Rome, everywhere I turned there was a fascinating fountain, a sculpture, or some piece of ancient history, layer upon layer upon layer.

I also met a girl there. A beautiful, elegant Italian woman named Anna. We had dinner together, but I think she was more interested in practicing her English than she was in me. I remember I spent a lonely, wistful evening sitting on the Spanish Steps—all by myself—surrounded by lovers. Rome deeply affected me. It was

almost like all the things that I had learned with my head had come to life and been made real in my soul.

From Rome, I went to Florence, arriving at night. In the morning the first thing I saw was the duomo, with Brunelleschi's massive dome that still dwarfs the entire city. At the Uffizi, I went to see *Adolescent Bacchus*, one of Caravaggio's most famous paintings. It became one of the most important and formative experiences of my life as an artist. When I entered the room, I saw an elegantly dressed old man in a suit and tie carefully making a beautiful copy of the painting before him. He had set up an easel and chair and was painstakingly working from his palette. As I watched him paint, I realized that he was a highly skilled master who knew the ancient techniques that Caravaggio and his contemporaries would have used.

I myself had never had a proper training and had to figure everything out on my own, picking up clues about how old masters painted by reading and by trial and error. As I watched him, I thought to myself, electrified, "This man could teach me!"

If you look at *Adolescent Bacchus*, you notice that his body is an almost milky white, but his face and hands are much rosier, with varying shades of color mixed in. To achieve Caravaggio's convincing flesh tones, the old man would lightly lay down a base of lead white, then mix other tones of white combined with vermilion, sienna, ochre, or umber, building up different layers to create his pale skin and the shapes and contours of his shoulders, ribs, and chest.

At the end, to achieve the rosy tones, he touched up the face and hand with diluted liquefied vermilion and placed it on lightly

with his feather brush and thumb. As he finished for the day, though I didn't speak Italian and he spoke only a little English, I complimented him on how wonderful his copy was and struck up a conversation.

The next morning, I returned to spend the day watching the old man, Carlo, who joked as he saw me over his shoulder, "Are you going to pay me?" I didn't pay him, but I did watch with admiration as he continued quietly painting in his suit and tie. I would ask him little questions, like why he used three completely different shades of red, and how he got the leaves to look wilted. Then I asked him how it was that he was so well dressed and never had any paint on himself. In Italian, he asked a nearby museum guard for a clarification, then, in his thickly accented English, pronounced, "Only amateurs get paint on their clothes."

On the third day, Carlo politely asked me if I would mind going out to get some materials for him. Painters always run out of black and white and linseed oil, so he would have had to stop for the day. I was only too glad to help. He gave me money, wrote down the list in Italian, and told me where to go. It was a magnificent old shop in an ancient building filled with all kinds of stretchers, hundreds of types of oil, pigments, stacks of brushes, Belgian linen canvas. I picked up materials for him and many supplies for myself and rushed back in a cab.

When I got back, he thanked me and asked if I would like to try to paint. He gave me a paintbrush and told me to go down Bacchus's arm and try blending and feathering with my brush. I mixed into his palette and started painting, but before I could barely start, he stopped me. "*Alt. Alt.* Stop. Too much. Delicate. Delicate." I

had put the paint on too heavily. He got some thinner and a cloth and wiped it off, shaking his head and muttering with a laugh, "*Stupido*, it must be much lighter." Using his thumb, he blended the paint in little by little until the flesh looked perfect. He let me try again and I eased off, gently trying to imitate him. Still today, when I do the flesh tones on an old master, I blend it with my thumb, gently, and I do that because of Carlo.

The day I had to leave, I brought Carlo a little cashmere cap, as a thank-you, and said goodbye. I had learned more in four days than I had in my whole life. As soon as I got home, I returned to my studio and its Caravaggios and painted over everything I had done before I met Carlo.

Leaving Italy after all those experiences was overwhelming for me. It was like I was leaving home. I still think it's the most beautiful country in the world and I credit it with opening my eyes to what my life could be.

The next year I returned to Europe, driving south from Switzerland, without a plan, pointing the car toward Genoa, and turning right when I hit the Mediterranean. I wound through the Maritime Alps between Italy and France high up on the Middle Corniche, not sure where I was headed or where I was going to end up. At three a.m. I emerged high above Monaco, saw the city lit up like a jewel with lights in the harbor, and fell in love.

I had known about Monaco from the famous Grand Prix car race, and from its reputation as a playground for the rich, aristocratic, and fashionable. On that first stay, I loved the glamour, the light of the Mediterranean, the allure of this beautiful and desirable

place, and it was here that I would return every summer as a base for my visits.

I'd come on July 15, before the highest point of the season, and stay at the Loews Hotel right through August 15, the pinnacle and official end of summer, when everyone in Europe returned from their holidays. As I returned each summer, I got to know my way around and made some wonderful friends who I would see each time I went back.

I would come with a girlfriend and we would spend a magical summer together, never getting jet-lagged because we would never acclimate to the local time. We would sleep until eight o'clock at night, then go to dinner on the terrace of some magnificent restaurant high above the sea. After dinner we would go to the famous Casino de Monte-Carlo, where tuxedoed guests would play baccarat and chemin de fer and where I would play the casino's unique version of blackjack and trente-et-quarante, which I didn't even understand but somehow managed to win. Then we'd go to the disco until dawn, partying with young and fashionable European jet-setters and the children of Saudi sultans.

At dawn, we'd head down to the harbor to the open-air market for something to eat. As we strolled around in the lightening day, we would see the people waking up on their big yachts, drinking coffee and having breakfast in their robes. Then we'd go back to the hotel to hang out by the pool and tan, my girlfriends first timidly adopting the custom of going topless, and then embracing it with a naturalness as if they had been doing it their whole lives. At noon, we would go to sleep.

One year, I invited a beautiful Dutch woman, the niece of an older woman I knew in Upland. Everywhere we went, she had admirers and met people. Once, she caught the eye of a young Italian who was the son of a wealthy industrialist from Naples. Carallo Cafiero was only eighteen, but he was the most urbane, lovable, and suave person I had ever met. When he saw that my girlfriend was already with someone, he behaved like a gentleman and adopted us both into his circle of friends. Each year, for an entire month, he would invite us to have dinner alfresco with his family and take us as his guest to the Paradise nightclub, where he had the best booth reserved, dropping thousands of dollars a night on Dom Pérignon and cocktails.

One year he invited us to the Red Cross Ball, the biggest social event in Europe, where Princess Caroline and Prince Rainier hosted people like Elton John, Frank Sinatra, the shah of Iran, Nastassja Kinski, Karl Lagerfeld, and many other VIPs. My girlfriend was literally the belle of the ball and I was so happy and proud of her.

In Naples, Carallo lived a low-key life because it was the time of Italy's Red Brigades terrorists, and he did not want people knowing his wealth or his business. But every summer, for a month in Monaco, he lived like a king. It was the golden age of Monaco then, full of excitement, fun, and wild abandon.

I remember meeting actors and princes, partying all night, and winning big at the casino. One year at blackjack, I won $25,000. Since I couldn't bring the cash through customs, I bought a two-thousand-year-old ring that had belonged to Emperor Marcus Aurelius. It was his personal signet ring that he pressed into wax to seal

documents. It was 24-karat gold and had two thousand years of use and dirt on it, which turned it a muted, soft yellow-brown. When I got back, I brought it to a jewelry store in Upland to enlarge it for my finger. I didn't ask, but the jeweler cleaned it and removed two thousand years of buildup and history, and turned it into what looked like a cheap high school class ring.

The next summer at the casino, I went bust gambling and sold it back to the same jewelry store. As with everything, sooner or later, the streak runs out. Now I hear Monaco has gone downhill, populated by gangsters and oligarchs. Then it was elegant, glamorous, and chic.

When I would get tired of the casino and lying around the pool, I would take side trips to Paris or Rome or Florence, haunting old book and antique stores and buying old pigments, stretcher bars, and paper with the idea that I would be using them for future pieces.

In Paris, I bought La France oils that Dalí, Chagall, and Picasso used, along with art paper and the BFK Reeves stationery that I needed for certificates and letters of authenticity. In Montmartre, I would buy canvas and stretcher bars, stuffing them into my big Samsonite hard-sided suitcases that I brought specifically for this purpose. Everything I couldn't carry, I would ship back.

In Rome, I bought natural pigments like those used by old masters, and old but unimportant paintings from the Renaissance and Baroque period. You could find them in hundreds of antique stores all over Rome. They might cost only a few hundred dollars. I bought natural pigments, little bottles of colorful powders that I mixed with the vintage linseed oil I bought. I also bought iron gall

ink, a natural black that could not be dated because it was made without carbon—the substance that was analyzed to indicate age. I would get European collector stamps made of rubber and ink them with the iron gall. It was the perfect touch to help authenticate an etching.

In Florence, I bought antique books. They were infinitely cheaper than in the United States and there were many, many more of them everywhere. I didn't care what the book looked like or what it was about. One time I bought a book on tithing during the Middle Ages, the equivalent of an IRS tax form. All I looked for were empty pages with watermarks that could be dated and used for drawings.

And all along the way, I met interesting people and saw magnificent art. Somehow, without really trying, I had become a regular at the casino of Monte Carlo, the cafés of Montmartre, and the antique stores of Rome. I had become, like Dax Xenos, one of the Adventurers.

nine

PROVENANCE
(1981)

ASK A HUNDRED PEOPLE WHAT THEY THINK AN ART FORGER does and ninety-nine will tell you, "They copy paintings." In reality, nothing could be further from the truth. And if you think about it, the reason why is obvious. No serious art forger could copy a painting simply because the original already exists. All you'd have to do to prove the copy is fake is point to the original in the museum and say, "There's the real one." To really make a forgery, you have to make something new that never existed and give it a reason for being born.

Dalí used to sell blank sheets of paper with his signature on them. You could put whatever you wanted onto them, and as long as he got paid, he didn't care. To me, that's not even forgery, that's just Dalí not giving a shit.

Whenever anyone asks me about forging, they always want to hear that it's some kind of esoteric, mystical process, communing

with the artist's mind until you can effortlessly do whatever they would have done without really thinking about it. I've heard it a million times, and it's still bullshit.

In reality, you have to learn, learn, learn and practice, practice, practice. I would devour every kind of information I could get: documentaries, books, catalogs, scientific papers; I'd read history and look at microfiche of old newspapers and catalog entries; I'd spend hours in an archive and come out with ideas about future forgeries.

Han van Meegeren, the famous Dutch forger of the thirties and forties, was a mediocre painter, but he was a master ager, having invented the use of phenol and formaldehyde—Bakelite plastic—to make his paint dry and crack from the inside out to simulate age. Van Meegeren's technique fooled the experts. He could bring his painting to a museum and say, "I got this from a wealthy Italian family who wishes not to be named," without any further explanation. That was not possible in my time, and this points out an important secret of modern forgery. For me, the documented history of the painting—the provenance—was more important than the work itself. You could have a real Rembrandt, but if you didn't have provenance, you could either hang it in your basement or sell it for a couple hundred dollars.

In 1947, van Meegeren was threatened with death because he had sold to Nazi occupiers what prosecutors thought was a genuine Vermeer. At his trial, van Meegeren revealed that he had forged the painting, and in order to save his life, he had to prove that he could replicate it, right in front of the jury. This would be unthinkable to me. I struggled to make a provenance that would

prove my work was real; he struggled to prove that an actual forgery with no provenance at all was fake.

For a forger, drawing and painting and aging is just the beginning and most obvious part of the process. To really be a forger, you must have a voracious appetite for information and a sharp eye for detail. As you learn and read and watch, you are always on the lookout for a weak point, an opening, a mistake, any bit of uncertainty that allows your work a chance to exist. You are looking for plausibility. If you think about it, the key to being a great forger is not being a great painter but rather a convincing storyteller. Like the best con artists, you must create a context and a backstory that justify an otherwise unbelievable circumstance.

When I was working with Carl Marcus, I had traded a piece of art glass for a couple of Rembrandt etchings, *The Angel Departing from the Family of Tobias* and *Portrait of Jan Cornelius Sylvius*. At the time, I didn't know much about the subject, but it seemed incredible that I could so easily own an actual Rembrandt. I was thrilled by the idea and brought the etchings to LACMA, to an expert named Ebria Feinblatt, so that I could learn more about them. She looked at the etchings very carefully through her magnifying glass and told me that *Angel Departing* was a valuable print made during the lifetime of Rembrandt, then gently broke it to me that *Jan Cornelius Sylvius* was actually a forgery, though a masterful one. I was, of course, disappointed about the forgery, though the etchings had started the wheels turning. I began working on yet another puzzle of a great master's work.

Etchings are odd things—made by an elaborate process that requires a meticulous, intense, hands-on approach and great

attention to detail. To make an etching, an artist scratches an image onto a metal plate with a sharp stylus. When the lines of the image are done, the metal plate is then dropped into an acid bath, which deepens and enhances the scratches, turning them into grooves large enough to hold ink. When the plate is inked and paper is pressed into it, the ink is sucked up from the grooves onto the paper to form a print. It is a careful and labor-intensive process that involves many steps.

Like many other artists, Rembrandt usually did not make etchings by drawing directly on the plate. Instead, he would make a rough chalk drawing on paper to get the general composition and main lines of his etching figured out. Then, he would place this preparatory drawing over the etching plate and use it as a guide, tracing onto it with a stylus and pressing the main lines onto the metal plate. After that, he would remove the drawing and work directly on the metal plate, adding cross-hatching and other details freehand.

Experts say that Rembrandt did three hundred etchings, but maybe only ten preparatory drawings remain. To me this suggested that the drawings may not have been considered important works of art in their own right and may have been discarded. I myself was less interested in the etchings; I wanted to make a preparatory drawing, which seemed rarer, more physical, and more intriguing.

In the early 1900s, an expert from the British Museum named Arthur Hind created a detailed catalog of every etching by Rembrandt, full of minutiae and little footnotes about how the etching was made, who had owned it, and what the experts thought about it. As I pored over the listings, I searched for any piece of information

that I could use as provenance—any excuse to make my drawing real. Finally, I noticed a little footnote on an etching named *Naked Woman Seated on a Mound*, and one of its details stood out.

In his book, Hind says that there was no preparatory drawing for *Naked Woman*. However, he quotes an expert, who quotes another expert who thought that a preparatory drawing for *Naked Woman* had been made and that an Englishman, John Malcolm, had owned the drawing in the 1800s. Hind did not agree, but he wasn't 100 percent sure. Instead of saying that the drawing definitely didn't exist, he just said, "I see no evidence to convict myself of error." It's kind of confusing, and it seems like an insignificant quibble between experts, but that little touch of uncertainty was all that I needed. Now, I had a beautiful provenance that was just waiting for me to make a drawing.

If you imagine paper pressing onto an etching plate, you can see that when you peel the print away, it would be the mirror image of the plate. I didn't have the plate, so I would have to work backward from the existing print and make a mirror image of that.

First, I found a book of Rembrandt etchings that showed each work in its exact details and dimensions. Then I made a photocopy of the image. I covered the photocopy with graphite using the side of a pencil and put this graphite-covered photocopy face up on a light table. Then I placed a sheet of paper on top. Pressing on the back with a stylus, I traced over the photocopy, getting the graphite lines to transfer onto the underside of my paper like a carbon copy. When I turned it over, I had the mirror image of the photocopied etching with the exact same orientation that a preparatory drawing would have had. I went over those lines with black chalk, as

Rembrandt would have done, practicing the whole process many times on ordinary paper until I felt confident.

When I was ready, I did my final version on the antique paper I had gotten from a three-hundred-year-old book with perfect paper. It was yellow with age and even had a watermark, a bunch of grapes that could be traced to northern Europe in the 1600s.

I wanted the paper to be washed of graphite and the chalk to be weathered as though it had embedded into the paper for hundreds of years, so when I finished, I put the drawing through a series of baths using distilled water that wouldn't leave chemicals like chlorine. I would soak the drawing in a tub, then put it between sheets of blotting paper before sandwiching it between plexiglass and covering it with weights to flatten it. I would change the paper, clean the plexiglass, and change the position of the weights every day. After about a week, the paper would be dry and I would start soaking it all over again, which I did three or four times, carefully smoothing out the paper each time.

When the soaking and drying was finished, I went over the primary lines with the stylus again, as Rembrandt would have done to trace his lines into the plate. Now I had a wonderful preparatory drawing, but I was still only getting started.

For centuries, people who collected art have stamped it with their names or identifying marks the way that you might write your name in a paperback book you've bought. With art, marks and stamps could be used as a physical provenance, tracking where a work had been and who had owned it through its lifetime. Hind's experts claimed that the drawing had belonged to John Malcolm. I needed to create some trace or mark of his ownership, and to do

it I turned to Frits Lugt. Lugt was an obsessive cataloger of collector's marks whose work *Les Marques de Collections de Dessins et d'Estampes* was the absolute reference for establishing the provenance of old master drawings and prints.

In this book, you could look up the stamps of every collector in great detail, identifying their shape, size, and variations over time. Lugt even noted where the collector would typically place their mark—on the left or right, front or back of their print. I was able to find Malcolm's stamp, which depicted an *I* for "Ioannes" (Latin for "John") and an *M* for "Malcolm," with a tower in between the letters.

From my other reading, I had learned about Nicolaes Flinck, an art dealer who had collected many Rembrandt prints and etchings and who was the son of Rembrandt's favorite student. I thought my drawing should bear his stamp too, which as I had seen in Lugt was a cursive letter *F* that Nicolaes placed on the lower-right front side of the art.

I asked a printer I had been using to make certificates to help make my stamps. He had a small letterpress that he typically used to print betting slips that bookies handed out to gamblers, and he loved doing anything that was out of the ordinary. Malcolm's stamp was easy enough because it's sloppy. Flinck's took us a few tries, because his mark, when stamped onto paper, would bleed out and grow bigger than it should have been. After enlarging and reducing the stamp, we finally got it right. I stamped Malcolm's tower and Flinck's *F* in iron gall ink on the bottom-right front and signed the back, also with iron gall, "Nicolaes Flinck," as I had read the collector would typically do. I now had a preparatory drawing that experts

had said might have existed. It was executed faithfully, and with its history marked by physical stamps, it now had a provenance. My drawing had become a plausible precursor to *Naked Woman Seated on a Mound*. I had contemplated selling my Rembrandt drawing through Charles, but instead I kept it in my safe, as a souvenir of this fascinating case.

I stamped my *Jan Cornelius Sylvius* forgery with Flinck and Malcolm marks and sold it along with *The Angel Departing from the Family of Tobias* to the Center Art Gallery in Hawaii, for $16,500. It was far too little, less than many Chagall or Dalí or Miró prints would have cost. When I pointed this out to the gallery, a light went off for them. When I had gone in, they didn't even have a single Rembrandt. Six months later, they had built a special room exclusively for the artist's prints and had started a new craze, with my magnificent impression from Rembrandt's lifetime and a bunch of later, less desirable impressions from Basan and Bernard on sale at premium prices. Pretty soon, everyone wanted a Rembrandt etching. Even the artist's drawings that had always been avidly collected were now being called the "new oils" because they had become so incredibly valuable.

Over the years, I did many similar operations. In my studio, I had letterhead from artist agents, collector stamps, stickers, marks, and seals from museums and galleries—everything that, when taken together, would will a painting into being. I had perfect stamps from the Perrot-Moore Museum in Cadaques, Spain; certificates from Dalí's agent, Robert Descharnes; letterhead from the Fondation Maeght that authenticated Georges Braque. I could even make the Maeght watermark by pressing two male dies together on

a Thompson press. Under pressure, this created the watermark's translucent sheen on Arches paper like you'd see on real prints.

Often the dealers would put their clout behind a painting, providing their own provenance or documentation, and sometimes even more. One time, I received a strange, anonymous letter in the mail. It had no return address, and when I opened it, I found only a red-and-blue-striped French Par Avion airmail envelope inside. It was addressed to a Mr. Hans Macholen in Manhattan and had a return address from La Colle sur Loup, France.

The letter itself was in French, so I brought it to my friend Pascal Blanc, a Belgian who owned a restaurant in Palm Springs. I was shocked to learn that it was from the deceased wife of a famous artist and said, "I can only tell you again, per the authentication of the foundation, that the gouache, *Ville et Mer*, is by the hand of my husband."

I know it sounds corny, but it's completely true. I turned it over and double-checked the envelope to see if there was anything else inside, but there was nothing there. Someone had decided to send me this letter anonymously though it was worth its weight in diamonds. Now anytime I wanted to create a piece by that famous artist, I could provide a letter from his wife as indisputable provenance.

I figured out the letter had been typed on an IBM Selectric II, and the next time I was in Paris, I bought the appropriate French-language print ball for it, plus the BFK Reeves stationery and the exact same Par Avion envelopes the letter had used. When I needed a new letter, I'd sign the wife's name on a hundred different sheets of stationery until I got it perfect. Then I'd pick the best one and type up the letter to fit above her signature. I'd even print a

fake postal cancellation stamp onto the envelope in red ink. It was perfect, just like it had been mailed from La Colle sur Loup, on whatever date I wanted.

To this day, I still don't know who sent this letter to me or what they had intended. It had to be one of my dealers who knew that I would be able to use it in my work and that he would probably have as much to gain from it as I did. They just put it in my hands and let me figure out the rest, which I loved doing.

Today, many of the forgeries like the ones I did would probably be impossible to pull off. Science would blow most of them out of the water. With radiocarbon dating and spectroscopic analysis, they can tell which exact mine your pigments or your ink came from. With DNA and dendrochronology, you can tell whether the wood in your paint panel came from Italy or Poland or Japan. It's what they use for finding a fake Stradivarius, and it doesn't leave much room for romance.

Then, forgery was fun, like a challenging puzzle or a riddle to solve. I loved figuring out intriguing ways to make an artwork plausible. I loved doing everything perfect—leaving little hints that only the most knowledgeable experts would appreciate. It's strange to say, but half the fun was imagining the oohs and aahs I would get and the little nods of appreciation I might receive. Without that, art forgery would have been just another job.

ten

THE WILD WEST
(1982)

URING THE HEYDAY, PEOPLE WEREN'T SO CONCERNED about getting caught. It was the Wild West and we thought it would never end. When Arnie Blumthal had told all the other dealers about my *Dalivision*, they didn't ask me, "Do you also *have* Chagall?" They asked, "Do you also *do* Chagall?" There wasn't even a pretense that what I was doing was legit.

In mob films, the guys go to payphones and talk in code: "I gotta meet Mr. Cleanface. What about the Chez Paris?" We never did anything like that. Years before anyone else, my Ferrari had a princess phone in the center console and I'd drive around with the cell signals bouncing off Cucamonga Peak. I could go twenty miles in any direction and have crystal-clear conversations. I'd get calls from dealers and we'd talk about all sorts of stuff. I never gave it a thought that someone might be listening in.

In the movies you'd also see these shady transactions, people passing around suitcases full of cash and complicated money laundering. I used to have people write me personal checks that I'd bring to the bank. For a while, I had a fake driver's license and people would write checks to Anthony Petrocelli, then I'd sign them over to Tony Tetro before depositing them. When I saw how brazen it all was, I figured why bother? So, I started having dealers write the check straight to me. A couple years later I got a letter from the state saying I had to surrender my Petrocelli license. I don't know how they found out—maybe I got pulled over once and gave them that ID, but I didn't even have to pay a fine or appear in court. I just put the license in an envelope and mailed it back. Today, if I did that, I'd be in prison.

Charles, who was older and much wiser, was more discreet than the rest of us. He used to make me meet him at the Moustache Café on Melrose instead of going to his gallery across the street. And while everybody referred to fake art as a "fugazi," Charles never used the term and never talked about anything at all. He didn't even acknowledge that anything was fake. In his mind it was just a Dalí of some other type, like some subspecies of a particular bird.

Though the cops routinely stopped me every few weeks, I didn't even consider that they might give any thought to my art or that it might get me into trouble. Back then, LA was not really much of an art market and the LAPD barely paid attention. I think there was maybe one guy who covered stolen art, but no one even bothered about forgery. It's not that the cops were dumb; they just weren't focused on art and didn't have the experience to know what they'd be looking for. Plus, if anybody ever got caught, we could just say

"No, that's not the one I sold, mine had a black mark up here."
Problem solved.

We'd hang out at the Mondrian Hotel, which was like my office
when I was in LA, we'd have dinner together, call each other. I'd
go see my new customer, Mark Sawicki, at his gallery in Sherman
Oaks or at his house in Agoura Hills, while his wife made lunch and
his kids played in the other room. When I was in Chicago, I'd have
dinner with Mitch Geller at crowded popular places like Gene &
Georgetti, the famous steakhouse. When I went to my printers to
get collector stamps or provenance, it wasn't like I told them I was
making props for a movie or that I worked for a museum or any-
thing. We just worked on fake art together.

And if somebody saw a piece of art, they always asked matter-of-
factly if it was real or fake, just like you'd ask if a baby was a boy or a
girl, without any subterfuge or moral judgment. And though I knew
what had happened to the infamous forgers Han van Meegeren
and Elmyr de Hory, none of the dealers had even heard of them.
In my mind, van Meegeren was ancient history and de Hory was a
strange tale of intrigue that had taken place twenty years before and
far away. When I say it was the Wild West, that's how it felt. I made
fake art and sold it to dealers who sold it to galleries who sold it to
anyone willing to buy it. Who was going to stop us?

One day I walked into a gallery on Rodeo Drive that belonged
to a flashy Texan who had made money in the oil business. He
walked around town with a bodyguard and always had some pretty
young woman with him. In the early days, I had sold him art in
Newport Beach before people knew my work was fake. I wasn't sure
if he would remember me or if I'd have a problem with him. I

chuckled to myself when I walked in and saw his walls were covered with my pieces—Dalí, Miró, Chagall. I told him I was a friend of a friend and he said, smiling, "I know who you are, and I know you did these, let's go to my office." We talked for a few minutes and he asked me if I could paint Picasso oils. I said sure, and just like that, the two of us were partners in the Picasso trade.

At the time, there was a big red barn on La Cienega in West Hollywood that sold old books. I had bought a few there for old masters drawings. I'd seen that they had many old paintings too, and so I went hunting for a canvas I could use for my Picassos. I didn't care much what was on it; I just needed something of the right age, the right size, and with the right construction. In Europe, stretcher bars come in sizes that are odd and different from American ones: 19 × 21 or 21 × 29 instead of 18 × 24 or 24 × 30. More importantly, European stretcher bars were joined at ninety degrees instead of being mitered—cut at forty-five degrees— as American stretcher bars are. I found two canvases from the Montmartre 1900s era—when the great masters Renoir, Picasso, Modigliani, Van Gogh, Degas, and others had all gathered in that part of Paris. My canvases were by the guys who had never made it and died in obscurity alongside them. I didn't think about it then, but I guess it was kind of sad that these surviving paintings, by artists who had tried and failed, were now going to be stripped and painted over. I paid $7,000 for each: about the same price you would have paid for a good car back then, so maybe that would have been some consolation to the artists.

To prepare the canvases, I wiped them down with commercial stripper, removing the topmost layers of paint. You could still

see the street scene underneath, like a ghost image. Then I sanded them lightly with fine black sandpaper, the kind you might use to wet-sand a car before painting it. I had built up a cardboard backing underneath the canvas so that the stretcher bars wouldn't leave imprints when I pressed down with the sandpaper. Then, to get a smooth, fresh surface, I applied several layers of gesso and covered it all with titanium white Lafranc oil paint, which Picasso, Dalí, Chagall, and Miró all used.

People look at Picasso and think, "It's so easy. A child could do that." I myself thought that when I first studied Picasso in high school. But you don't really know how difficult it is until you try to do one yourself. To me Picasso is harder than Caravaggio. He would load his brush with very thin paint and do a whole figure in a single pass. It was almost impossible to get it right. Many of his most famous pieces had this very loose, improvised air that really only came together spontaneously for Picasso. He would stand back, smoking a cigarette, then he would approach the canvas and make some fast gestures and lines. Then he would stand back again, smoking and looking, and then move forward again, painting very quickly. I had studied books and photographs of Picasso's works and I had seen them many times in France, Monaco, and the United States. Once you see enough Picassos, you can tell exactly when they looked right and when they didn't. They're fluid and seem improvised, but they're harmonious and complete. Everything just falls into place. That's part of the process too, because someone who knows Picasso can see when it isn't right just like someone can play a Miles Davis tune but you would notice right away if it's not him on the horn.

I didn't like doing those loose, improvised pieces for that reason. Part of the forger's trade is picking wisely what you should and should not do. I chose subjects related to Picasso's more obscure, more composed pieces. I painted a portrait of Dora Maar, Picasso's mistress, and another one I called *Naked Bathers* that had these strange creatures running on a beach. Most people would probably recognize the Dora Maar as a Picasso, but the bathers would not leap out as something by the famous artist. I liked that, thinking that only a knowledgeable person would know what I was up to.

It took me about a month and a half to finish the pieces. I'd go out to the Peach for drinks, then walk across the street to my studio, where I'd stay up all night painting at an easel on the kitchen table. I'd start around midnight and work for hours, then go to sleep and wake up at the crack of noon, emerging into the sunlight, blinking. When I brought them in to Tex, he complimented me graciously, though he was not by any stretch an expert on Picasso, or on art in general. We agreed he'd pay me when they sold, and about two weeks later, he gave me a check for $150,000. I don't know what he sold them for. It was none of my business to ask and it would have seemed impolite. All I know is that each of my customers made much more money than I ever did.

I also agreed to do a Miró oil and other stuff for Tex. In exchange, he would buy me a white Testarossa (one word for the new models) to match my Countach. I don't remember why we decided that, but it seemed reasonable. I would do some paintings for him and he would buy me a car. It wasn't about taxes or moving money. It was more like doing someone a favor and in exchange they would spring for lunch.

When I took a commission, I usually insisted on having carte blanche to choose the subject, something that I thought was plausible and made sense. Everybody always wanted a perfect masterpiece from the artist's height, but something obscure or nuanced was usually more interesting to me. I was very familiar with Miró because I had done many of his aquatint etchings and lithographs, including those I had done from Leon Amiel's "limited" editions. Leon had acquired the actual official Miró plates through the back door and had made a mint running them off whenever he felt like it. Apparently, Miró was an arrogant asshole and didn't pay his printers. He thought they should be grateful to be working in his divine presence; so instead of destroying the print plates as they were supposed to do, the printers sold them out the back door to Leon, who never paid Miró a penny. I always made it my policy to take care of the people I worked with and Miró should have copied me on that particular subject.

In any case, my idea was to take Miró's vocabulary of elements— starbursts, spots, triangles, and checkerboard effects—and combine them into a new composition. I practiced on a sketchpad until I came up with a balanced design that I liked. The painting I would do for Tex would be a classic 1960s Miró: black, blue, red, yellow, and green vaguely geometric figures on a white background. With a painting only fifteen years old, I would have usually been able to use one of the canvases I had brought back from Europe stuffed into my big Samsonite suitcases. Unfortunately, this Miró oil was to be bigger than any I could bring back, so I contacted the famous Sennelier art store in Paris, my usual spot, and had them ship several canvases to me in Upland.

When I painted, I smoked Lucky Strike unfiltered cigarettes, flicking the ashes into an ashtray and dropping the butts into a glass that was one-fourth filled with cold coffee. I would keep tossing my butts into the coffee and squishing them down with chopsticks until I ended up with a thick sludgy mix. Then I would strain out the butts and conserve the liquid. I would lay a new canvas down and lightly mist the coffee-and-cigarette mixture onto the stretcher bars and back of the canvas, wiping it gently with a cloth to give it just the lightest patina of age. With this newer painting, I kept it very faint.

Miró's style was loose like Picasso's but not quite as instinctual. I took the composition I had come up with and drew very faint images with just the edge of a pencil that I could use as guidelines for the placement of smooth, effortless, large strokes of paint. Miró used a house painting brush with thinned oils. I used a more supple brush about two inches wide, using both the edge and flat part to make my figures. The painting itself took only a day. When I was finished, I put a fan on the painting for four or five days to dry it out. I then covered it lightly with a semigloss varnish, and when that was dry, I very lightly misted the canvas with the coffee-and-cigarette mixture too, wiping it with a cloth to soften the colors and to just take the tinge of newness off.

I was happy with how the painting had come together. I gave my Miró to Tex and then went to Europe for a month of rest and relaxation. When I got back, his gallery told me that he'd been arrested. A couple weeks later, they told me that he had died. I asked, "Did you see the coffin?" He'd told me not long before that he was

thinking about retiring to Costa Rica, and years later, some people I know were sure they had seen him there. If you're reading this, Tex, you owe me a car.

At the time, my bread and butter was still Dalí, Chagall, and Miró lithographs. That's what paid the bills and kept the lights on, but what I really enjoyed doing was more ambitious oils, gouaches, watercolors, and drawings that were much more challenging. As I would listen to dealers and read and think about the artists' lives, in the back of my mind, I was always thinking about what might be a good piece to do.

I came across a letter that Salvador Dalí had written in 1952. He was vacationing at his home in Portlligat, Spain, and was writing letters back to his friends in Paris. In them, he recounted how he was painting day and night and barely resting. He wrote, "I made five exploding heads, so beautiful that my hands hurt from painting them." In reality he was screwing around with women and, as far as I could tell, had painted only two. I met Dalí's friend, Jose Puig Marti, once and he told me that Dalí would have nude models lie down on glass coffee tables and that he would lie underneath drawing them. That worked well for a little while until one of the models opened her eyes and saw that, instead of drawing, Dalí was masturbating. To be honest, I don't know what to believe, but the important part was that he had painted only two exploding heads; now I could paint the other three.

Dalí had these strange long names for his pieces, like *Debris of an Automobile Giving Birth to a Blind Horse Biting a Telephone* or *Geopoliticus Child Watching the Birth of the New Man*. In

comparison, I conservatively called mine *Nuclear Disintegration of the Head of a Virgin*. I based my painting on Dalí drawings that showed the exploding heads of Raphael-like Madonnas fragmenting into a shock wave of ripples in front of a sky and seascape, like a nuclear explosion.

Dalí had an incredible imagination, which fascinated me, along with this talent for technique and composition. He painted with virtually no texture, as I would in my own natural style, so when I applied the paint, working late in the middle of the night, it seemed to me to flow easily without a lot of effort. When I finished, I dried, varnished, and lightly aged the painting. This time, I also lightly rubbed cigarette ash onto the back because everyone smoked in the fifties and the ash was a plausible organic means to simulate gentle aging and the accumulation of dust.

I brought the painting to Charles's home in the Hollywood Hills. We sat at the breakfast nook looking out over Los Angeles and I explained how I had made my Dalí. Charles was very knowledgeable and understood exactly what I meant and I'm sure he already had specific collectors in mind. Charles had met Dalí and knew the people in his entourage. He used to take walks with Dalí's business agent, Captain Peter Moore, who would parade around Paris with an ocelot on a leash; and he was also friendly with Albert Field, who could authenticate all of Dalí's works. Charles never volunteered information and I knew enough not to ask, but I learned that my painting made its way into a private collection before appearing in one of Spain's most prestigious galleries, and then who knows where.

I kept a second version of the *Nuclear Disintegration* that had a Leonardo-like Madonna and was slightly different in its treatment

of the figure, the seascape, and the sky. It might have been my masterpiece. For sure, that painting came to cause me a lot of heartache. At the time, though, I was happy; painting at night and sleeping till noon, like a vampire. No wonder everybody thought I was a drug dealer.

eleven

OVER THE TOP
(1985)

IN 1985, I GOT BACK FROM A LATE NIGHT OUT TO FIND MY AN-
swering machine blinking. I hit rewind and flopped down to un-
tie my shoes. For some reason the machine kept rewinding and
rewinding and rewinding. Drunkenly, I thought, "Huh. I must be
popular tonight." When the tape started playing, I heard dealer af-
ter dealer after dealer—some I knew and others I didn't—asking
me to call them urgently. "Tony. Call me!" "Tony. I need some
Chagalls!" It took me a minute, but after listening to a few calls, it
finally dawned on me that Chagall, who was ninety-eight years old,
had just died and would no longer be making any art. Rest in peace
to a great artist, but it put me over the top. The next day, I doubled
my prices. One week later I was driving a Rolls-Royce.

You would think that I'd have been more careful, but I didn't
care what the cops and other people believed. "Fuck them," I said to
myself. "If they thought I was a drug dealer, now they're really going

to have something to talk about." I understood why they thought what they thought, but it really got under my skin because it wasn't true. My own friends were mad at me for getting the Rolls. You can understand a young guy being interested in a sports car, but a Rolls, that's a wealthy old man's car and a slap in the face to everyone else. To be honest, I knew they were right, but back then, I didn't care.

The reality was that I felt invincible. All of us believed the bonanza would never end. We barely talked about it, but when we did, it was just to say that it would go on for years and years and that we were going to make millions. I had a vague plan that someday I might switch my business to fine watches, which I had become obsessed with, but for the most part, it was all live-for-today. I never put money away. I never thought about a plan B. My only savings account was the cars I was buying, which I could sell in case I ever needed the money. But really, we just thought it would all keep rolling on.

It wasn't all easy, though. Even though I had worked with a group of regular customers, I was constantly getting the runaround. People would pay me six months late, they'd decide to take a 25 percent discount, they'd bounce their checks. One guy who owed me $50,000 even told me to quit bugging him because he had to pay his taxes. On the priority list, Tetro Inc. was always at the bottom. What was I going to do? Call the cops?

My dealers didn't know how good they had it. They were always getting everything cheap and marking it up enormously. For them, it was all a one-way street. Now, with Chagall's death, the power shifted. I know it sounds macabre, but I had prepared in advance for this day because I had experienced something similar eighteen

months earlier when Miró died. Then, when the day came, I had only a small number of lithographs on hand and I was sold out long before the appetite for his work had waned. Mark Sawicki, in Sherman Oaks, had wiped me out, buying all of my Mirós before bouncing his check—not for the first time.

With Chagall, I wanted to be prepared. Over that next year, each time I made editions that dealers wanted, I printed extras and held some back for myself. I spent a lot of money up front, but it was like an investment on a future sale. By the time Chagall died, I had put aside a hundred copies from each of the seven or eight editions. Instead of selling them for $500, I sold them in bulk for $1,000 each, cash on delivery, no exceptions. I sold everything I had in about three months. Eight editions, times a hundred copies, times $1,000 apiece—you do that math. You can see how I thought a Rolls-Royce might be in the budget.

I also bought my first home, a nice two-story condo in an up-scale part of Claremont. People were always hassling me that I needed to buy a house because I was driving around in exotic cars but lived in rented apartments. I didn't really care much where I lived, I liked to travel and I didn't like the responsibility, but to tell you the truth, what really motivated me was the parking. My condo was in a gated community and had a three-car garage. I could park my Ferrari, my Lamborghini, and my Rolls inside and get them off the street. What more could you want?

Before, I had never cared very much about furnishing my home, but now I poured my heart and soul into decorating the place in a wild "High '80s" style. White carpet, white furniture, lizard and suede wallpaper, a giant thirty-foot mirrored mantelpiece. I

designed it all so that the bold modern art I put everywhere would really pop.

On the first floor I had Dalí, including a huge eight-foot by six-foot *Lincoln in Dalivision* that I had done, various lithographs, and four oil paintings. On the second floor I had Picasso. His erotica up the staircase, a big cubist woman over my bed, gouaches and watercolors in the hallway. The condo had thirty-foot ceilings in some places, so I added a third floor and installed a gym, a sauna, and a Jacuzzi, which became the site of a lot of excess and debauchery. There, I placed a Miró, his most famous aquatint etching called *Equinox* (actually a fake by Leon Amiel), watching over the hot tub.

I always liked my home to be dark and quiet, and hated to have direct sunlight flooding in. So, downstairs I had a den that I could completely black out. It was my retreat, with a sofa, a bookcase, and a TV. There, I had a portrait of my hero, Winston Churchill, and a series of weird painted surrealist mannequins by Dalí's friend Jose Puig Marti lurking in the dark.

I had read that in his home in Ibiza, my art forgery predecessor Elmyr de Hory had had a secret room where he kept his most incriminating artwork, which I thought was a great idea. I would stare at the weird angles and volumes of my condo and think about how I could build one too—a place to stash my secret stuff and keep it away from prying eyes.

One day, as I was lying in my dark den, an idea hit me out of the blue. It's hard to describe, but if you looked up from inside the garage, you could imagine an odd-shaped angled void just off the bathroom above it. I wasn't really sure if I had gotten it right, but

I immediately jumped up from the sofa and got my friend Mike Beam, the carpenter who was working in the house, to rip open the wall right then and there. I was worried that I might have miscalculated, but voilà, as I looked through the hole in the Sheetrock, I could see enough space for a full eight-by-twelve room.

Mike started building it out for me the next day, dropping all his other work to lay out a floor, finish the walls, and install carpet, shelves, and lighting. He hung a door on heavy-duty piano hinges so that when you closed it, it hung perfectly flush and didn't budge.

Joe Merck, an electronics whiz who put in my car stereo systems, installed a solenoid spring that would open the door remotely. I was worried that the cops would find a hidden button, so he rigged it up with my cordless phone. When you pressed # and * on it simultaneously, the door would pop open to reveal my secret room and its stash of special papers, pigments, collector stamps, light tables, vintage typewriters, certificates of authenticity, notebooks with signatures, and everything else a professional art forger might want to hide.

We covered the door with a big floor-to-ceiling mirror and put a black frame around it. I even countersunk black screws into the frame so that it looked like it was affixed to the wall. Even if you examined it closely, you'd never know that there was a door there at all, or more importantly, what was behind it.

Inside, I moved all the sensitive materials from my studio apartment into my secret room. I didn't paint in it because there was no ventilation and I didn't want to mess things up, but I could work on just about everything else, tapping out certificates on my typewriter or practicing signatures.

I did Warhol drawings in Conté crayon, things like *Minnie Mouse, Richard Nixon,* or *Ivory Soap Bars.* The secret room was perfect for working on this kind of thing, and several of my drawings were brought to Warhol's "Factory" by my client, an ex-cop who had them authenticated by Warhol's flunkies. Sometimes I'd bring back paintings I had mostly finished, just to touch them up or age them using coffee-and-cigarette sludge. I loved working in the secret room—in a world of my own, undisturbed by the outside world.

At my new home, I saw more of Christine, who was finishing up high school then. I hadn't always been there for her when she was younger, but now we were starting to reconnect. I knew that I hadn't done all I could in the past, and I wanted to make it up to her. She used to come over regularly, riding over on her moped and then in her Honda Civic after I taught her how to drive. She was a great girl, hardworking, thoughtful, well behaved, and I was proud of her. Her mother had done a wonderful job raising her. We would go to lunch or just hang around and talk while I painted. She wasn't really interested in art or cars, but she was passionate about travel. We were more like equals than father and daughter because we were only sixteen years apart in age.

Later, when she was eighteen, she was hired by American Airlines, the youngest flight attendant ever. But when they asked her to move to Washington, DC, at the drop of a hat, she passed on the opportunity because she didn't want to be away from her family. I was disappointed for her, but I was glad she stuck around. I was settling in, putting down roots, and establishing a closer relationship with her. It felt like my life was beginning to even out and I started to relax a little.

Over the Top

One day Vincent and I were sitting at the Peach. I don't even remember how the conversation started, but I was saying that you could forge anything—that the same basic principles applied. Vincent disagreed and replied, "You can't forge a Ferrari." And though he wasn't challenging me, I said, "Yes, you can," and pretty much right then and there decided to prove that I could.

I always liked having projects, something that I would get obsessed with and immerse myself in. For me, there were no half measures. Like with my art, everything I did, I wanted to do it perfectly or not at all. And it was with that same intensity that I started my plan to forge a Ferrari.

In Hawthorne, I had met a guy called Doyle Manning who dealt in vintage Ferrari parts. He showed me a set of genuine taillights for a rare and valuable 1958 250 pontoon Testa Rossa (it was written as two words then). This was a fabled car that was made by the Ferrari factory for its racing team. In its time, it was the fastest thing going, easily winning races and outpacing the competition. Only nineteen were ever made. Eighteen were accounted for, but one, serial number 0728, was missing, maybe crashed, maybe destroyed, maybe forgotten in some barn after its owner died. Today it would be worth at least $25 million. I don't know how Doyle got the taillights, but when he showed them to me, I knew I wanted to re-create that car. I started from those taillights and moved forward, and for the first time in over a decade, I turned my mind to something besides art.

Forging a rare Ferrari is a massive and expensive undertaking requiring not just money, enthusiasm, and tenacity but also a team of master craftsmen and artistic geniuses the equal of any

Renaissance studio. To forge a Ferrari the right way, you need to re-construct everything in the most minute details. In my secret room, I would obsessively pore over mechanical schematics and carefully study blueprints. I researched how to acquire genuine pieces or how to re-create those that didn't exist anymore, foraging and forging to pull together a complex piece of sculpture and machinery that moves over the road like a rocket and reacts precisely to the driver's commands.

But in order to make this rare and expensive racehorse, you must first start with a humble and modest pack animal: the mule. A mule is the nuts-and-bolts structure that serves as the subframe on which you will build your car. It provides the base, engine, suspension, and basic chassis to which the engine is bolted, pretty much in the same way that unimportant old paintings I found in antique stores provided the canvas and stretcher bars for my forgeries.

In this case, the mule was a 1963 250 GTE. For a Ferrari, it was considered the most undesirable model, and in those days before vintage Ferraris had become the multimillion-dollar rarity that they are today, really, it was more like a donkey. The car I found wasn't running, and unbelievably it cost me less than $2,000.

Southern California is to hot-rodders and custom car craftsmen what 1500s Rome was to the Renaissance painters. It has probably the greatest concentration of car restorers, tinkerers, and automotive obsessives in the world. Making a car here meant that I had access to the kind of masters you cannot find anywhere else.

One of those masters, the electronics genius who did my car phones, dashboard electronics, and gadgetry, introduced me to a legendary body maker, Scott Knight, who became the center of

my efforts. Without him and his network of artisans, there would have been no car. Scott had won the most demanding vintage car show in the world, the Pebble Beach Concours d'Elegance, three times, which was unheard of. *Road & Track* magazine called him the "Bernini of Body Makers." When Scott agreed to work on my car, I knew the project had truly turned serious and there would be no backing out.

He in turn introduced me to Strother MacMinn, another legend, who would design the car. A revered professor at ArtCenter College of Design in Pasadena, pretty much any car in existence today has been influenced by his designs. Strother created the car-sized blueprints that showed in exact detail every aspect of my Testa Rossa's body and design. It would be the basis of everything else that would need to happen.

From these blueprints, Scott crafted the elegant curves and contours of the car from raw sheets of thin aluminum. The body of each 1958 250 Testa Rossa was a unique sculpture, hand-hammered by the expert artisans of the Scaglietti team so that the whole body, mouth, pontoon fenders, and wheel wells were all slightly different on each car according to the expert shaper's hand. Scott used vintage tools and hammered the aluminum over leather shot bags filled with sand so that its beautiful curves would fit perfectly to the wooden buck he had created as a guide.

Scott introduced me to Mel Swain, yet another expert, who created a perfect chassis, the tubular steel understructure on which the body would hang, as well as the plexiglass covers for the headlights, their chrome housing, and the egg-crate grille for the front of the car.

Chuck Betz and Fred Peters restored the engine and transmission to perform just like the original, a powerhouse racer with 300 horsepower. They were eccentrics, college economics and psychology professors who had turned down a $10 million offer for their own Testa Rossa, preferring to race it in the famous Mille Miglia vintage car race across Italy.

To match the original engine, I was able to locate for them six Weber 38 DCN carburetors that I was impressed to learn had been forged by an automotive master, right down to their Weber name plaques, which the seller wouldn't attach for me. I had to do that myself to avoid getting him in trouble. He also had the unique 250 Testa Rossa steering wheel for my car and the Borrani two-ear knockoff wheels that I needed for accuracy.

After Mel Swain fitted Scott's aluminum body onto his chassis, we brought the car to the world-famous finisher Tom Stratton. He smoothed the body to alabaster perfection in the old-fashioned way, using lead to fill any imperfections, and covered it with ten coats of hand-sanded nitrocellulose lacquer, now illegal in California. That alone took a year and cost $20,000, but in the end, it was totally flawless.

Mel's friend Julio did the spartan interior in Italian leather based on photographs we had researched. The seats were stretched over wooden frames reflecting the sparse, no-frills style that a race car had. I, myself, painted the Ferrari Scuderia design, the yellow Cavallino prancing horse emblem, in enamel paint on the car's front panels, as was the practice on certain cars from the 1950s.

In all, the car took over five years and cost me over $350,000, but the result was magnificent. It could easily have passed as real

but for the incorrect serial numbers on the engine, body, and chassis, which I was tempted to change, acid etching them off, and redoing them to read 0728.

It's hard to believe, after everything I went through and all the money I spent, I never got to drive the car because the suspension still wasn't finished when I was forced to sell it. It was a bitter disappointment, but that's a story for later.

Years after I sold the car, I went to Pebble Beach to relive the old days. There, behind a red velvet rope, I saw my car, the beloved 250 TR. It had a professional hand-painted sign with paragraphs about how the seller had made the car and the extraordinary lengths he had gone to to make it so perfect. I could have ripped his head off. When I told him that he was a liar, he just looked me in the eye and said, "I don't care." I had finally gotten a taste of my own medicine and found out just how the artists I forged must have felt.

But that was all later. At the time we were building it, I had happily settled into my routine, working on my condo, hiding out in my secret room, and watching my car progress. To be honest, I was probably more focused on the cars and the Jacuzzi escapades than I was on art. At least I had proved to Vincent that I was right and that you could, in fact, forge a Ferrari.

twelve

THE PRINCE OF FUGAZI
(1986)

I N 1986, CHARLES STARTED A STAR-STUDDED RESTAURANT, SIL-
vio, in Beverly Hills with his partner Tom Gray and the star chef
Silvio De Mori. It soon became the hottest spot in LA and the place
to see big celebrities like Sylvester Stallone, Jack Nicholson, and
Kathleen Turner. I would hang out there and Charles would treat
me like a king, seating me at Table 13, the only booth, the restau-
rant's best spot. He would always give me an elaborate, over-the-top
welcome when I arrived. "Mr. Tetro, what a pleasure, we've been
patiently waiting for you. Please come this way, we have a special ta-
ble set aside." He really hammed it up. One time as he was going on
and on, I looked over and saw Gene Hackman and Clint Eastwood
trying to figure out who I was. I could see Gene saying to Clint,
"Who the fuck is this guy?"

They were right. In their world, I was nobody. In the art world, it
was a different story, as I came to find out during Art Expo. Then, the

world's art dealers, gallery owners, artists, and collectors descended on LA and clamored to get a table at Silvio. The last year I went, I took my friend Tom Wallace on opening night. I had met him a couple of years before when Tommy had called me out of the blue. He told me he was coming to town from New York and asked if we could meet at the Beverly Wilshire Hotel. When I asked him how I'd recognize him, he said, "I look like a cop," which was true. Tommy was tall and imposing and looked like he could take care of himself.

Tommy told me that he was working for Leon Amiel and he asked me without the slightest hint of a threat if I would stop doing Leon's Chagalls because mine were undermining the value of his. Tommy was polite, almost apologetic. You could tell he was a stand-up guy and I liked him right away. I immediately told him he could consider it done, right then and there. I had no reason to get into a pissing match over a few Chagalls.

It turns out that Tommy had, in fact, been a cop. For fifteen years, he was in the NYPD art bunco squad. Finally, tired of the busts that went nowhere, and the slippery dealers, the bullshit, and the red tape, Tommy got out. The last straw was when he was tracking a terrorist who used fake art to bankroll his operations. The FBI had bombed the place while he and his partner were undercover inside, blinding the partner with shattered glass and injuring Tommy. Preferring a cushier and more lucrative life, Tommy took an early retirement, hooked up with Leon Amiel, and got into the art business. If you can't beat 'em, join 'em.

Though Tommy had come on behalf of Leon, I think his real motive was to work with me. By the time we went to Silvio, I had already sold him several Dalí oil paintings, some Chagall gouaches,

and various drawings, which he dealt mostly on the East Coast. When I did the Warhol *Minnie Mouse* and *Nixon* drawings, it was Tommy who took them to the Factory. Of all the guys in the art world, he and Charles were my favorites. Many years later, Tommy told me that when he had first come to visit me, he had brought two *shooters* with him, guys who would have taken care of me if I had refused to cooperate. This revelation shocked me, as it would have shocked anyone, but it didn't change my opinion of him. He was still my trusted friend.

The night we went to Silvio, the place was packed. Every person in town had tried to get a reservation, and those who got in came dressed to the nines, ready to show off. The room was full of bigwigs from the art world with their beautiful women and nice cars. I could see artists and their girlfriends drinking at the bar. In the restaurant, I saw my friends Mitch Geller, Truman Hefflinger, and Mark Sawicki all sitting together. Earlier, Geller had told me that it was best if I didn't sit with them. I understood why, but it still annoyed me. With his typical New York attitude, Tommy said, "Fuck them," and told me not to worry about it.

When we arrived, Charles wasn't there to give us his song-and-dance welcome, but when we sat down, he came over to say hello. Charles shook hands with Tommy in his polite and jovial way and told Tommy that it was nice to see him again. I didn't know that they knew each other, but after they made some small talk and Charles went away, Tommy told me that he had arrested him once in New York over a stash of fake Chagalls. I laughed and said that they were probably mine. They weren't, but it was surprising to hear about this coincidence, and shocking that Charles had gotten

busted. He had never mentioned it before, and I knew that he was always exceptionally careful.

As we got our first drink, I noticed that something in the room was off. There was a hubbub and then I kept hearing my name being whispered. "Tony Tetro . . . Tony Tetro . . . Tony Tetro." I looked out across the restaurant and I could see people were staring at me. Then, a couple at a time, art dealers I didn't know started lining up to approach our table. It was unbelievable, like they were coming to petition the pope. People would come up to me with their business card, saying how nice it was to finally meet me. They would ask me what I was up to these days, and if I ever went out to Chicago or New York or Florida. I thought, "Why is everybody kissing my ass?"

I had no idea what was happening, and as it played out, I said to Tommy, "What the fuck is going on?" Tommy leaned over and, chuckling, told me in his heavy New York accent, "You've been discovered. You're the Prince of Fugazi."

I was floored; I never realized that I was known outside of my own little circle. Charles, who saw what was going on, was not happy. He came over to the table and whispered to me to be careful. He told me I didn't know who I could trust in this business and that some of the people were snakes. For the rest of the night, when people stopped by the table to introduce themselves, I would dodge them, saying that I wasn't doing art anymore, that I had switched to the restaurant business, and that I kept hanging around only because I still had so many friends who were dealers.

To be honest, though it concerned me, I also got a kick out of it. I didn't know until then that I was known by so many people,

and I was kind of overwhelmed. I had heard Tommy's and Charles's warnings, and I could see my friends' worried looks, but somehow it didn't quite register.

Tommy and I were about to leave the restaurant when, from across the room, I saw the most stunning, elegant, and beautiful woman I had ever seen staring at me. I recognized her as the girl-friend of a New York dealer who everyone said was mob connected. I had done Erté serigraphs for him, and when I delivered them to his hotel suite at L'Ermitage, she had carefully examined them without saying a word, checking my signature against the originals for a long time, while her boyfriend and I talked at the bar. She hadn't spoken to me then, but tonight she came straight to me and held out her hand. "Hello, Tony. I'm Laura. I'm glad to see you again. I hope we can get together sometime." That's all she said. Next thing I knew, her boyfriend showed up and whisked her away into the crowd. It was like I had been struck by a bolt of lightning.

Outside, while I waited for the valet to get my keys, Tommy and I were surrounded by a group of younger art dealers who had been in the restaurant. They were pressing their business cards into my hand and introducing themselves. When I got into my Countach, you could see they were awestruck. This legend they had built up in their minds was real and he came complete with a rare Lamborghini. It was strange to me and it was almost too sur-real to imagine.

I had invited a few people back to my suite at the Mondrian, my home away from home, where I traded art in exchange for rooms. If you went into the lobby in the eighties, you probably saw my beau-tiful Chagalls hanging on the wall.

The party was just a dozen or so people, Tommy, Truman, Mark, Mitch and his wife, a few dealers and their girlfriends. Mitch's friend, a surgeon from LA County Hospital, supplied the medical-grade cocaine. When Truman and Mitch showed up, they took me aside to say how crazy the scene in the restaurant had been, and how glad they were that we weren't sitting together.

As people drank and the doctor cut up lines, the television was on in the background. There were alarming news stories about AIDS, this new, unexplained disease that was ravaging the biggest cities in the United States. Even though then most people still considered it a "gay disease," I remember straight people were scared too, because we didn't know what to do about it. You heard about blood transfusions, and Haiti, and infection rates, and it scared a lot of people. Before, casual sex had been fun; with AIDS, it all seemed like a roll of the dice.

After the party, as I was falling asleep, I started to think about the restaurant and I realized I, too, was taking a lot of risks. I even felt foolish that I had been so cavalier, taking on dealers as I had done without really vetting them. Any one of them could have been an undercover cop.

I respected Charles and Tommy and I decided to take their warnings to heart. I would only work with my regular customers and keep a low profile. Besides, between the Ferrari and the condo and the art I was already doing, I had enough to keep me busy. I didn't need to complicate my life.

A week later Mark Sawicki showed me some quaint, tiny cartoonlike miniatures by the Japanese artist Hiro Yamagata that he had seen at Art Expo. He asked me if I could do them. They were

only one-inch by two-inch, three-inch by four-inch, just tiny little watercolors. I said, "Sure," and did them along with some Mirós he had wanted. To be honest, I didn't think much about it at the time.

Over the next couple of weeks, I replayed the night at Silvio over in my head. I couldn't shake the image of Laura. It's a funny thing about art forgery. In most pursuits, notoriety means that you're being recognized for your work and that you're doing something right. With forgery, it only means trouble. I was smart enough to know that, but I probably should have realized how much trouble. Back then, the notoriety seemed worth it if only because it brought me Laura.

thirteen

ACTUALLY PRINTING MONEY
(1987)

A FEW WEEKS AFTER ART EXPO, I WAS DRIVING FROM LA TO Upland when out of the blue I got a call from Laura. The night at Silvio, she had really captivated me. I had been thinking about her ever since, and I was excited to hear her voice. I pulled over, and as giant semitrucks whooshed past me on the freeway, she told me that she was going to come to LA and wanted to get together. I was excited, but I wanted to play it cool. I told her it would be great and suggested that we go to dinner.

Before she hung up, she lowered her voice and asked me to please not tell anyone that she had called. She repeated it twice. Now my heart was singing. The fact that it was a secret meant that she had some intrigue in mind. I didn't know if it would be business or pleasure, but either way, it was music to my ears.

I immediately called Vincent and asked him to get us a table at Jimmy's in Beverly Hills, where he was an investor. Without him, it

would have been impossible. Jimmy's was a legendary place, where icons like Richard Burton, Elizabeth Taylor, and Cary Grant hung out alongside younger stars like Robert De Niro, Farrah Fawcett, and Michael Douglas. It was glamorous, elegant, exclusive, just the kind of place that I wanted for this special night.

When I went to pick up Laura at L'Ermitage, I took my Rolls-Royce. I wasn't naive enough to think that we were going to fall in love, or that she would be impressed by this kind of thing, but I was infatuated with her and wanted to make things perfect. What I really wanted, badly, was to shift things between us from business to something much more personal.

In the hotel lobby, I was waiting, looking at a Miró I had traded, when she walked up behind me, asking drolly if I recognized the painting. When I turned around, I was floored. She was dressed in a perfectly tailored Chanel dress, off-white, slit from her collarbones to nearly her navel, revealing alluring amounts of skin and her enticing neckline. She was even more beautiful than when I had seen her at Silvio.

At Jimmy's, when we pulled up to the valet stand, I could see that my Rolls wasn't going to impress anybody. Literally every single car in the parking lot was just like mine. There were no Mercedes, no Ferraris, no Maseratis, no anything. That night, it was just fifty Rolls-Royces, wall to wall. So much for making a big splash.

It was a beautiful summer evening and there was a buzz of people going into the restaurant. Everyone was dressed fashionably, more formally than at most other places in LA, almost like a red carpet event. Laura was magnificent. When she walked, she exuded a

confidence that suggested poise, class, and intelligence. At Jimmy's, with its Hollywood clientele, everyone must have thought she was a new star, just emerging into fame.

But Laura wasn't just beautiful and seductive; she was also intelligent and perceptive, especially about art. She was a few years younger than I was, but had studied art history, and already knew more than all the dealers and experts I had met. At dinner, she drew me out in conversation about myself, my art, and my life. She made me feel like she was fascinated, looking into my eyes and smiling, focusing only on me. I felt like the whole room had melted away. I could see that she was a smooth operator and a master at using her charms to seduce people. That night, I didn't care.

I knew that she must have wanted to talk about why she had come, but she never once hinted that she was interested in anything but me. It was a beautiful dinner, and though I'm no great wine expert, I splurged on Château Margaux and things played out effortlessly, naturally, and easily. To be honest, we were having such a great time that, even though I knew there was an ulterior motive, I just acted like we were there on a date.

After dinner, we went back to the hotel. I valeted the car and went up for a drink in her suite, the same one where a few months earlier she had examined my Erté serigraphs. She asked me to make us drinks and excused herself while she went into the other room.

When she came back, she was carrying a small portfolio. She put it on the table, opened it, and revealed a small, delicate pencil drawing, and asked me what I thought of it. I dried my hands and held it up to the light. It was a Degas. Fake. Not that great. I told her

so, and she asked me how I could tell, because the person she had gotten it from had thought it was perfect. I couldn't really explain it, but I told her the face wasn't quite right. When something is right, it's like traveling back in time, but if you get one thing wrong, the illusion is broken and everything falls apart.

With this, the tilt of the face was awkward. Degas was a great draftsman; it would have seemed more natural. She asked me about some other details, perspective on the leg and arms, and a couple of other things, but I could tell she already knew the answer and was just testing me. Satisfied, she put the drawing away and pulled out another version of the same thing.

Right away, something hit me. I could tell that it was real. And even though she denied it, I was sure that I was right. A drawing like this, even a small one, would have been very valuable. I asked her how she had gotten it, but instead of answering, she asked me how I knew it was real. I told her it was just a feeling, the same way you can look at someone and know if they're lying. When I asked again how she got it, she told me she was getting them both appraised for a friend who had connections at an auction house.

"Now that you looked at them," she said, "it's settled." I joked, teasing her that she had set all of this up only to get my expert opinion. She looked into my eyes seriously, and then she said, "Actually, I was thinking you might like to see me again." And then she kissed me.

The meaningless flings and sometimes girlfriends that I had in Upland were fine, but Laura was another class of woman. She was everything I wanted and she pushed all of my buttons. She was sophisticated, beautiful, intelligent, poised, and cunning, with just the right

amount of edge. We had an incredible night of passionate sex, taking each other hungrily, and falling, exhausted, onto the sheets. Then, in the aftermath, while we were still lying in bed talking quietly, she told me, finally, what this night had been all about.

She explained that she had been so impressed with my Erté that she had told her friends about me. They, too, were impressed and she said that they wanted me to do something very important for them. The work, if done properly, would make me a very rich man. Though I was interested to hear what it was all about, it almost didn't matter. The only thing I wanted was a reason to keep seeing her, to have some intimate project that we could share.

Then, she told me that her friends were in the mob and that they wanted me to make counterfeit money. Immediately, a million alarm bells went off. First, I wondered how she could have gotten mixed up with such dangerous people. Then, my mind racing, I started to think about all the logistics. How would I get paid? Where would the money transfer take place? Would they simply take me somewhere and blow my brains out?

Unlike with art forgery, where if you got caught you might get into trouble, with counterfeiting, if they didn't kill you, they'd lock you up and throw away the key. Everything about it was off, but somehow, I still didn't want things to end. For tonight at least, my only answer was yes.

In the morning, we woke up together and had sex again, passionate like the night before. Then, Laura made me coffee and I left. I told her that I would be in touch. I really wasn't thinking straight, and though I knew it was a terrible idea, as I drove back to Upland, I couldn't think of anything else.

At first, I hadn't even thought about the counterfeiting. Now, it started to sink in and began to form in my mind. It's a blessing and a curse, but when I start thinking about something that intrigues me, I become obsessed. I find it hard to think of anything else and it leads me on until I've solved the problem. Instead of going home, like I should have, I went straight to my printer, Ray, to see if we could do it.

I figured Ray would throw me out, but when I explained the situation, he confessed that he had often thought about it over the years and had even figured out some of the key steps. Today, US currency is different from how it used to be, much more complex and full of technological elements that make money much harder to counterfeit. Then, it was easier and could be done with fairly basic equipment if you knew what you were doing. Real money is engraved, but we thought we could figure out how to print it. After all, we had already done something similar with Tetrographs.

Ray and his brother had helped me with my forgeries. Now, as we put our minds to counterfeiting, it became like our communal project. I'd stop by the shop every couple of days or I'd call Ray and we'd talk about solutions for the various problems that we ran into. At first, we just thought about it idly, but little by little, things shifted, and as we went ahead, we started to talk about it like we were actually going to do it. I even proposed that we make $10 million in fake hundreds, and that I give Ray 25 percent of my take.

We already knew the basics, manufacturing the screens, registering the sheets, and mixing the right colors—these would not be a problem. The first actual problem we had was what to do about

serial numbers. If you look at US currency, you'll notice that every bill has a serial number, a string of letters and numbers that help track the notes and account for them when they are created, destroyed, or replaced. They're also used to catch counterfeiters.

In the seventies and eighties, the FBI circulated lists of serial numbers to merchants and businesses so that they could look out for fakes. If you went to a grocery store or a five-and-dime, you'd see them behind the cash register.

Over the years, Ray had studied these serial numbers and discovered something important. There was no pattern among the different types of bills. You couldn't tell if they belonged to a one-dollar bill or a hundred-dollar bill. He suggested we get a stack of crisp, new one-dollar bills and use the serial numbers from them to make our hundreds. To do so, we would lay them out and photograph them, blocking out everything except the serial numbers so that we could print the design of our fake hundreds around them. With three hundred one-dollar bills, we could make several screens and keep repeating the serial numbers over and over again. Who was going to keep track of one-dollar bills?

The other thing we had to figure out, which you might not think of, was what to do with wastepaper. Before we just threw it out, we would have to burn it, because people tend to notice currency sheets fluttering in the breeze behind a print shop.

For me, counterfeiting was a tense and high-risk business, and it was stressful to keep worrying about the mob, the cops, and jail. I was worried that if I could actually figure it all out, I wouldn't be able to stop myself from doing it, and that I would fuck myself up. I would seesaw between elation when I'd solve something and relief

when I couldn't. Each time I'd be stumped by something and give up, then somehow, as if fate was intervening, I'd figure it out and get pulled back into the frenzy.

After we had figured out the serial numbers, the next big road block was paper. We had never really found anything that was close. Sometimes the paper was too hard, sometimes it was too thin, sometimes it had the wrong texture, fiber, or flexibility. After weeks of searching, I finally gave up. To be honest, I was glad to be done with it, though I was disappointed that I would have to call Laura and tell her the whole thing was off. I really didn't want to do that, so I put it off as long as I could.

A few days later, I was at the McManus & Morgan paper store in downtown LA, buying Guarro, the Spanish paper that Miró used for his aquatint etchings. As I was looking at the shelves, I noticed a paper I hadn't seen before. The store owner said it was nice 100 percent cotton rag fiber, from a mill in the Northeast, and that apparently it was the same paper that the president used as stationery. This clicked in my mind. I remembered a TV show many years before that had shown the federal paper mill where the stock for US money was made. The program didn't say much, but it showed a gray sky and snow on the ground outside of the building, just like you might find in the Northeast. It was of course a long shot, but I wondered if it might be the same. I asked for some off the shelf and when I compared it to the twenty-dollar bill in my wallet, it seemed incredibly, exactly right. I bought two sheets and drove straight to Ray's because I wanted to measure its thickness using a micrometer.

At Ray's, we saw that the paper was thicker than what we needed. It was close, but not close enough. Then, I had an idea. "What if we put it through the press, letting the rollers compress it and make it thinner?" It seemed too simple, almost childish, but of course, with our luck, when we ran it through and measured it again, it was perfect.

This was stunning, but there was still one puzzle that we couldn't figure out. If you looked at bills from the eighties, you would notice tiny red, blue, and gold fibers embedded into the texture of the notes. Any reasonable counterfeiting attempt would need to have them, and no matter what we tried, we could not figure out how to do it. After many trials, I finally had to give up. This time, so did Ray. We were out of ideas and out of options, and I decided to call Laura the next week to give her the bad news.

That weekend, by coincidence, I went to see *To Live and Die in L.A.*, the Willem Dafoe film about a counterfeiter. I hadn't even known what it was about. In the movie, there's a montage where the counterfeiter is going through the process of making fake money. You see him making engraving plates, printing sheets, swapping serial numbers, and carefully painting over imperfections on the negatives, just as I had done on my black-and-white lithographs a few years before.

But the most amazing part of the montage, which I think very few people understood, was at the end when the counterfeiter takes the freshly printed bills and puts them in a clothes dryer. He throws in shredded red, blue, and gold silk rags, a fistful of poker chips, and starts the machine. You can see the bills mixing with the chips and

rags and you can imagine tiny threads fraying off and attaching to the still-tacky bills. When I saw that scene, I literally jumped up out of my seat and said "What the fuck!" out loud in the movie theater. It was like karma, refusing to let me walk away. When I got home, I called Ray and described the scene and I told him, "It's like God wants me to do this."

I know it seems incredible, but back then there was no internet and no real way to research a topic like this. I didn't know it at the time, but the filmmakers had actually consulted a real counterfeiter to create the scene. To me, it was like a how-to video.

Finally, having figured it all out, the spell was broken. Instead of a challenge or a puzzle or the promise of a fortune, the reality of actually doing it flooded in and I began to focus on what could go wrong. The fact was that there was too much I couldn't control. Art is a genteel game. Counterfeiting is not. I didn't want to get mixed up with the mob. I didn't want to get killed on the off chance I might rat. I didn't want to spend twenty-five years in a federal prison.

Anyway, by then, a new plan had already started to take shape in my mind. I called Laura and lied to her. I told her that we thought we had figured it all out but that I wasn't satisfied with our results. I made up excuses, telling her that we couldn't get a perfect registration, that the fibers didn't come out well on the paper, and that the print job didn't look real enough.

She was smart, and though she didn't say it, I could tell she didn't believe me. She asked me if I had actually just changed my mind. I told her that I was a perfectionist and that the money was not up to my standards. I told her it wouldn't work.

Art is what I knew and what I was good at. I told her that I wanted to do something with art, just the two of us, together. I didn't want to let her go, and now it was me trying to convince her, trying to seduce her into doing something with me. She told me she would think about it and then she told me that she had to go. There was nothing else to say. I was sure I'd never see her again.

fourteen

SCHIZOPHRENIC LIFE
(1987)

I N 1987, TOMMY CALLED ME FROM NEW YORK. HE WAS LAUGH-ing and said that he had just seen a Dalí painting I had sold him on the cover of a Japanese exhibition catalog. It was for a retrospective at the art foundation of one of Japan's big car manufacturers. The painting was a portrait of Dalí's wife, Gala, that I had done based on one of his real drawings. In it, she was facing forward with one breast exposed and an elaborate pendant necklace on her sternum.

Except for a kind of halo around her head that I should have darkened more with burnt umber, I thought it had come out well and I was happy with it. I have to say that I was proud it had made the cover. A major retrospective of a prolific artist like Dalí would have included scores of paintings, and the fact that mine had been selected gave me a sense of validation.

Usually I had no idea where my works ended up or who had bought them. Once they left my hands, the rest was up to the

dealers and they could do whatever they wanted. I never liked to ask questions and I figured the less I knew the better. With Tommy, though, I had a close relationship and we talked about things. He had no idea how the painting had reached Japan, but he thought it was great. I wasn't so sure.

Tommy had a good relationship with the cops because of his background. He felt confident he'd get the benefit of the doubt, but for me, things were different. I wouldn't quite say that I was concerned, but I didn't know if this would come back to bite me. In general, I thought it was better to fly under the radar than to be in the spotlight.

Not long after the catalog came out, I heard from Mitch Geller that the Center Art Gallery in Hawaii had been busted. It was a big deal and everybody was talking about it because so much of our stuff had gone through there. Center had already faced a class-action lawsuit about their art investment claims, which they settled, but now they were being accused of selling fake Dalís, and this hit a little closer to home.

Like other art dealers around the world, Center had bought the blank sheets of paper that Dalí had signed and sold. They printed their own art on it and sold it on with the blessing of the artist himself. Legally, it was a gray area because Dalí knew what was happening and seemingly didn't object. As long as he got paid, he didn't care. As far as Center was concerned, it had all been fair and square, but the cops didn't seem to agree.

I didn't like the sound of it, but Geller, Hefflinger, and Sawicki didn't seem too concerned; to them, it was all just juicy gossip, which they loved recounting, along with dark rumors about the owners'

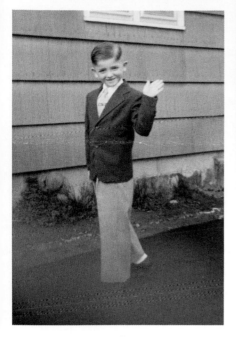

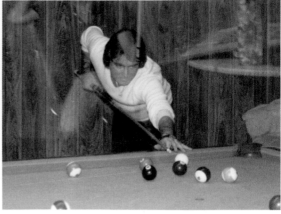

Playing pool in the basement of our family home in Fulton. I was very good, and if I had been better under pressure, you would never have heard of me as an art forger.

Seven- or eight-year-old me on the way to my first communion at Holy Family Catholic Church in Fulton, New York.

The back of my Rembrandt. You can just see the green evidence tag from my trial. As part of my sentence, the court required me to write "Fake" on the back of my paintings.

My earliest Rembrandt, a copy of *The Man with the Golden Helmet*, signed by my alter ego, Petrocelli. I brought the piece to an art fair, but nobody wanted what I was selling.

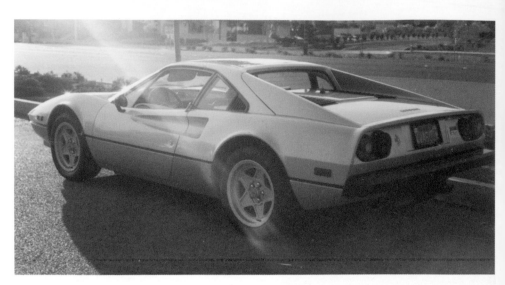

My very first Ferrari, the 1977 308 GTB. For a Ferrari nut like me, buying this car meant that I had finally arrived.

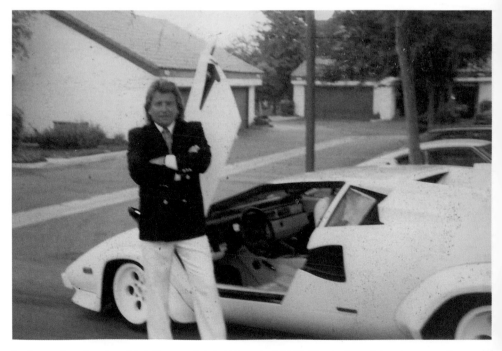

In front of my Lamborghini Countach LP 400 around 1982. Everywhere I drove it around town, it caused chaos. It was like a spaceship landing every time I parked.

My Caravaggio *Sick Bacchus*. Caravaggio never sketched in pencil. He went straight to paint.

I always like to complete the face first.

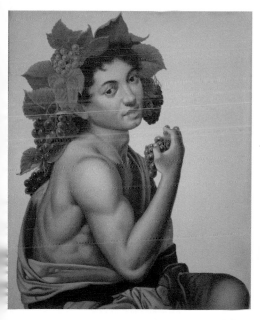

I'm done painting except for the background.

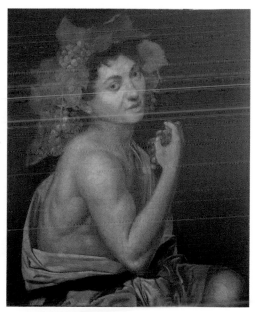

The finished painting, now aged with umber and cigarette sludge.

Celebrating my fortieth birthday. There were eight hundred people at my party.

My Jose Puig Marti surrealist mannequin in my Claremont condo. I met Puig Marti once and he gossiped about his good friend Salvador Dalí.

Me with my forged Ferrari in the good old days before I had to sell it. A friend told me you couldn't forge a Ferrari, so I did, just to prove him wrong. I worked on it for over five years and spent $350,000 on it, but I never even got to drive it once.

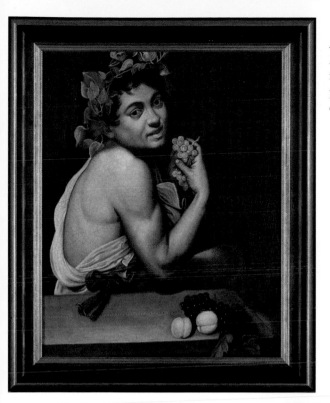

A reproduction of my Caravaggio *Sick Bacchus*, in a fancy cassetta frame from Italy. I don't know what my partner in crime, Laura, did with the original.

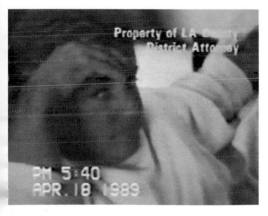

April 18, 1989, a day that will live in infamy. The LA DA investigators filmed my arrest.

My *Galarina as Venus* by Dalí resting in the court's evidence vault.

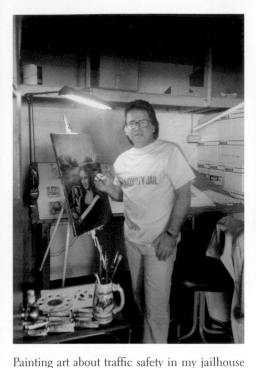

Painting art about traffic safety in my jailhouse studio. At least they still let me paint while I served my sentence.

The Basquiat recreation that I painted poolside at the Newport Classic Inn. At the time, I was down and out and no longer had a studio.

The very first painting I did for a Colorado billionaire, Rubens's *Peace and War*. Even though I wasn't forging anymore, I started making real money and getting back on my feet.

I put two Bouguereaus together to make *Eros Consoling Biblos*. I painted my own face on Eros.

My Dalí *Crucifixion* that the eccentric billionaire James Stunt sent to Dumfries House, Prince Charles's stately home in Scotland.

My Monet, which James Stunt called *Lily Pads*, that ended up with Prince Charles.

My Chagall from Dumfries House. James Stunt called it *Paris Con Amor*.

Another Dumfries House painting, a Picasso that James Stunt called *Liberated Bathers*.

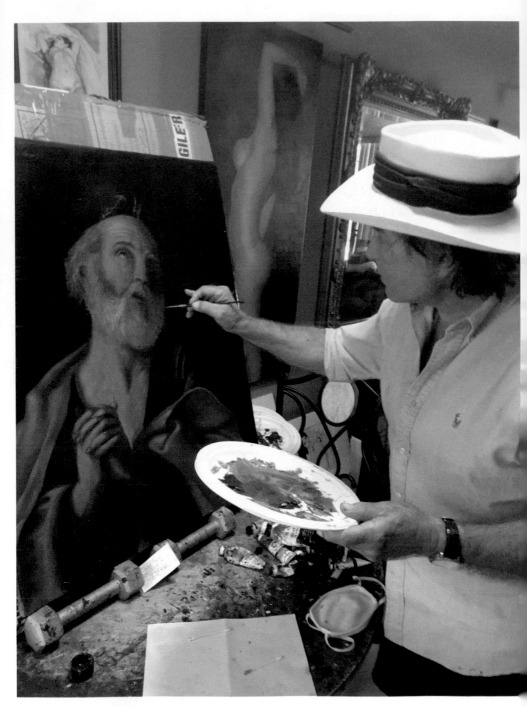

Sixty years later, I still paint at my kitchen table.

private lives. To me, it seemed like the cops had already had them on their radar, so when the Dalí story broke, they swooped down on the gallery, raided them, and confiscated anything they could find.

When the trial began, I heard that the prosecutors recruited a heavily native, local jury who didn't like the haole art dealers, and they soon found themselves up to their ears in trouble. It eventually landed them in prison. At this point, the investigations hadn't hit us yet, but there was definitely trouble in paradise, and it sent ripples across the Pacific.

Back in Upland, I was getting lectured by Joey Marcena, a friend I had known for years. He owned the Blind Duck, one of the popular bars we all went to, and was one of the few people who knew what I did. Joey told me that he was concerned because so many people seemed to know about my art. He told me that I was being stupid and needed to be more careful.

As far as I knew, only my customers and a tight circle of friends were in on the secret—Joey, Vincent, Jimmy Montini, Ed Daniels, my neighbor Frank Reagan, and a guy we sometimes hung out with, Davey Jenkins. I'd be hanging around and mention that I had had a good day and made a lot of money, and then we'd get to talking about what I had done. It didn't seem like such a big deal. These guys didn't know anything about art, and we all knew each other's secrets anyway. Frank had helped with my taxes and helped me get a credit card, so he knew a little more than the others, but it was never a problem, even later when he went downhill and ended up going crazy on coke.

The only real issue I ever had was with Davey Jenkins, who got convicted for financial scams. He'd get investors together to buy a

car wash and then, instead of putting the money to work, he'd buy a new Ferrari for his girlfriend. But instead of going to jail, he ended up in a mental ward as a pathological liar. While he was there, he wrote a letter to the authorities and told them that I was an art forger. I don't know if he was trying to get a deal for himself or if he was just being a bastard, but when the FBI came to my girlfriend's door, they showed me his handwritten letter.

I had to think on my feet, so I told them it was that I was an art dealer and that I had certainly sold some fake art in my day, unwittingly, of course, because it was a well-known fact that up to . . . (I made up a number) 10 percent of all art sold was fake. I don't know what they thought of my story, but I was glad Davey was institutionalized. They didn't believe a word he wrote.

It goes to show you that no matter how well you know someone or think you can trust them, you never know what might happen. They might have a problem with coke or they might end up in a mental ward. You have to watch your back, and sometimes you have to watch the ones who are smiling right in front of your face.

Shortly after lecturing me, Joey invited me to a Fourth of July party at Lake Arrowhead in the San Gabriel Mountains. Now, nobody seems to go there anymore, but then, Lake Arrowhead was full of multimillion-dollar homes and country clubs, and it was a fashionable place where movie stars vacationed. Joey had bought a place, and he wanted me to come along and meet his new set of friends. He asked me to drive my Rolls-Royce and park it in front of the Tudor-style hunting lodge that his friend called home. I think Joey wanted his golf pals to think he was a big shot too, and that he had wealthy friends back in Upland.

I was having a great time at the party. We had just seen an incredible fireworks display and we were having drinks and laughing it up. Little by little, people at the party, friends of Joey I didn't know, would come up to me and introduce themselves. They'd tell me they had heard I was an art forger and they were fascinated by my lifestyle. They'd ask me questions, like what artists I did, how I thought up my subjects, and how I had learned to paint.

These days, I expect people to ask me these kinds of questions because my art forgery is not a secret, but back then it was shocking. Imagine, Joey had just had the balls to lecture me about keeping a low profile, and here he was telling all his new golf buddies and their wives about my illegal activities. I took him aside and blasted him: "How come everybody in this fucking party knows what I do for a living, Joey? How did that happen?"

I knew things had changed from the old days and that I needed to be cautious — it would have been stupid not to — but I also needed to keep working. People might think that I was rolling in the dough, and it probably looked that way, but the way my business worked, the reality was that it was all ups and downs. There were times when I'd be broke, waiting to get paid or when someone had stiffed me, and other times when I was flush, rolling in cash. When I made money, I spent it, even though I should have used it to carry me over the long haul.

To be honest I was just pissing a lot of it away. My Ferrari was still coming along and it was my dream car, but you know what they say about a boat being a hole in the water you throw money into? Well, that's what my car was. And imagine what it costs to own a real Ferrari and a Rolls and a Lamborghini at the same time. With

a regular car you could get an oil change for $12.99; for me, it was $1,000 every time they popped the hood.

I'd go to Monaco for a month every year and travel around Europe. I'd go to Florida to visit my family. I'd stay in Fort Lauderdale, which they called Fort Liquordale, and we'd go out to bars and parties and restaurants. I'd pick up the tab, and though we had a good time and everybody loved me, it didn't come cheap.

I'd go to Vegas and stay at Caesars Palace, where we'd sit ringside at the legendary prizefights they had in the eighties. Hearns and Hagler and Leonard. I'd play blackjack at the casino, and though I had won $25,000 that time in Monaco, it was pretty much the last time I hit it big. After all, they're weren't building fifteen-thousand-room hotels because guys like me were winning.

I'd go to Palm Springs, to places like Cecil's, where I parked my Countach next to Blondie singer Debbie Harry's. We'd go to the Pompeii and get a private room suspended over the dance floor. In Waikiki, I'd stay at the Ilikai. On Maui, I'd stay at the Hyatt Regency. Back home, I'd go to LA and hit Silvio or Jimmy's, Le Dome or Chasen's. I dropped a fortune at the bar in the Mondrian. In Upland, I'd be out five nights a week, and a lot of the time I'd pick up the tab. The money was in one door and out the other.

Then, like pretty much everyone else on the scene in the eighties, I started doing a little bit of cocaine, and then more than a little bit. Cocaine began as a fun and social thing that everybody was just starting to use. It was a happy thing, a little pick-me-up that made people more outgoing, high energy, and upbeat. We'd do a little toot together and have a few laughs.

After a while, it started being routine, just another thing you had to do, like filling your car with gas or getting groceries. For some people, it was the only way they were going to get laid. It made assholes out of lots of guys and panhandlers out of lots of girls. Going for a coke run started to become a constant feature of everybody's life. I was blowing through money like it was going out of style. Honestly, if my spending hadn't been so crazy, I probably wouldn't have taken so many risks.

In the middle of all this I heard from Laura. I was shocked because I was sure I'd never see her again. Hearing her brought back all the images of the night we had spent together. It hit me in the pit of my stomach. I lusted after her badly and I wanted to see her again. She told me that she had been busy and that things had gotten a little out of hand. I asked her if everything was OK with her friends, the mobsters, and she glided over it like it had never happened. Besides she was on to something new.

She told me that she had met someone who had access to someone in one of the auction houses and that, if I wanted, she could get him to help us. I asked her who it was, but she wouldn't say. She just said it was someone who could put a finger on the scale, slightly in our favor. I asked her if it was the same people she had wanted to work with last time and she laughed like it was the craziest idea in the world. "No, no," she said, "it's just art, Tony."

Laura sprung things on me, reappearing out of the blue, but I had already rolled the idea around in my head. I told her that I had been wanting to do a Caravaggio and that the idea fascinated me, that I had been painting copies just for myself over the last few

years, and that I was tired of Picasso and Chagall and Dalí. I wasn't 100 percent sure about it; I still needed to think about it, but I was excited to be involved with Laura again—driven by the desire to make a big bravado gesture after having had to step back from counterfeiting. I was surprised, I told her, and asked her if she was sure she knew what she was doing. She laughed, a little amused laugh, and she told me, "You make the art, and I'll take it from there."

A couple days later, I was with Christine, at a father-daughter dance, dressed up and making small talk with other parents who told me what a good kid Christine was. I was much younger than most of the other parents, and I kind of stuck out, but I tried to fit in, although pulling up in my Dino Spyder a little lit wasn't exactly how Ozzie and Harriet would have handled it.

What can I say? It was a schizophrenic lifestyle. One night I was just another dad enjoying an evening with his kid, and the next day I was in disguise trying to find a way to invent a Caravaggio.

fifteen

MY CARAVAGGIO
(1987)

IT'S HARD TO BELIEVE NOW, BUT CARAVAGGIO WAS NOT CON-sidered a major artist until the 1950s when Roberto Longhi orga-nized a retrospective. Until then, he was considered a second- or third-rate also-ran. No one paid much attention to him until after the war, and so old books on him were rare and facts were easily fudged.

Caravaggio had led an outlaw's life. He was in and out of prison and he painted on the lam. In 1607, he was accused of murder in Rome and was forced to flee to Malta. He was only there for a little over a year, but before long, he was in trouble and forced to flee again. It was a chaotic period, out of the limelight and without a lot of support. This gave me gray area that I could work with. Now we have detailed records of Caravaggio's life based on a Vatican priest's investigation of court, police, and barber-surgeon records, but in the eighties, there was still a vast amount we didn't know.

Forging a modern master like Picasso or Dalí is difficult, but the feat is doable. With an old master, it's almost impossible, and very few forgers have tried. Aside from the knowledge, technique, and materials that a forger must get right, there's also hundreds of years of continuous study on works that may be considered national treasures. The scrutiny can be crushing. With Caravaggio, his long neglect was a benefit. Today, because of infrared spectroscopy, radiometric dating, gas chromatography, and the increased academic scrutiny, I wouldn't even consider forging his work.

When Longhi organized his exhibition at the Palazzo Reale in Milan, almost half a million people thronged to see it. Modern patrons, like their Baroque ancestors, wanted to see this raw, real, and dramatic art. They weren't turned off by Caravaggio's sexual and violent content or the rough, real-life models he painted, with their dirty fingernails and filthy feet. Modern people saw Caravaggio as an iconoclast and a bad boy, and I admit I liked his rebel image too.

By contrast, early chroniclers were unsympathetic. They downplayed his importance, focusing on his unconventional life and belligerent personality rather than on his artistic genius. One biographer, Giovanni Baglione, had previously sued Caravaggio for libel for writing that Baglione's art was "only good for wiping his ass" and "stuffing up his wife's cunt." Years later, when it came time for Baglione to write Caravaggio's biography, it would be fair to say that he did not give the artist a glowing review. By the 1700s, Caravaggio had been all but forgotten by serious scholars. By 1900, he had become almost a footnote in art history.

Now, scholarship and conservation are a highly funded and highly professional enterprise. Before Longhi, the study, restoration,

and conservation of Caravaggio was an amateur and half-assed undertaking that a clever forger could exploit. Think about Caravaggio's hidden self-portrait in his famous painting *Adolescent Bacchus*. In 1922, an Italian conservator noticed a small reflection in the wine carafe toward the bottom left of the canvas. Looking closely, he noticed an image of a painter, with curly, dark hair, holding a paintbrush and standing at an easel. It was Caravaggio himself.

A year later, another conservator clumsily restored the painting, covering the self-portrait with layers of dark paint. Maybe he didn't see it, or maybe he didn't feel it was important. Whatever the reason, the earlier sighting was soon forgotten and the tiny self-portrait vanished. It wasn't until 2009 that experts using high-tech multispectral reflectography rediscovered it—all this on one of Western art's most famous paintings worth hundreds of millions of dollars.

But it wasn't only carelessness and neglect that made a Caravaggio forgery possible; it was also his tumultuous life. When Caravaggio landed in Malta, he was on the run—literally for his life. He had just killed Ranuccio Tomassoni, a gangster, pimp, and bitter rival, over one of his girls and had been given a capital sentence. Anyone who saw him could kill him and turn his severed head in for a reward. Caravaggio only got out in the nick of time and ran off to Naples and then Malta, where, with the help of the Knights of Malta, he hoped to gain a papal pardon for his murder in Rome.

On Malta, Caravaggio hustled to save his life. He painted portraits fast and furiously for influential patrons, hoping to gain their favor. In 1607, he painted a portrait of Alof de Wignacourt, the Grand Master of the Knights, who liked it so much that he inducted Caravaggio into the order and petitioned Pope Paul V for a pardon.

Caravaggio received it, but it didn't last long. Within a year, he had fought with a senior knight, injuring him seriously. He was thrown in jail in the island's fortress and was left to await sentencing. With the help of an accomplice, he escaped and sailed to Sicily, once again on the lam. Caravaggio's short stay on Malta had been so chaotic, and his work so hectic, that it was easy to think he might have completed paintings that were somehow unaccounted for or never properly attributed.

To get a better feel, I called an Italian expert at UCLA, Carlo Pedretti, who specialized in Renaissance and Baroque painters. I wanted to see what he thought about my plan, so I pretended to be an author writing a popular book about art. I enjoyed the conversation and asked him about research from Caravaggio's Malta period. He told me that it was a frenzied time for the artist and that not much was known about his life and habits there. When we spoke, over thirty years ago, there was still a lot of speculation about what the artist had painted, and a number of minor works still were not well understood. There were even some mysteries.

Apparently, Caravaggio had painted two portraits of the Grand Master and one of them had been lost, most likely looted by Napoleon's troops when they occupied Malta around 1800. No one knows whether it was stolen or destroyed, and no image of it survives. It wasn't too far-fetched to think something similar could have happened with my painting.

Pedretti also told me that a number of Caravaggio paintings had been destroyed during World War II when the Allies bombed Berlin. German authorities had evacuated valuable artworks to fortified towers, but as the bombings raged, fires tore through the towers and

over four hundred paintings were destroyed, including works by Rubens, Tintoretto, and Cranach. Three paintings by Caravaggio were also burned, including a portrait of Fillide Melandroni, the prostitute Caravaggio had killed Tomassoni over. Because they had been destroyed before Longhi's exhibition, they had not received what we would today consider adequate attention and scholarship. Other paintings had been lost even earlier. In 1805, an earthquake in Naples destroyed three other Caravaggios, and they, too, fell into oblivion.

In my mind, it all started to come together. It was plausible to think that my Caravaggio could have been a minor work, painted during the artist's chaotic period on Malta, inadequately studied, then lost or looted long before Caravaggio's revival under Longhi. It wasn't exactly a routine or likely scenario, but it was certainly more plausible than many other things about Caravaggio's art and life.

One of Caravaggio's most famous paintings is *Sick Bacchus*, and Michelangelo Buonarroti's first sculpture in Rome is *Drunk Bacchus*. I thought about using elements from both to make a new painting. Like the original, I planned to make my painting a self-portrait using the artist's face as the model for the drunken god. I imagined it would have been hastily completed on Malta and possibly shelved because it didn't meet with the highly religious nature of the Knights.

Sick Bacchus is a wonderful and inventive painting. I had seen it during my trip to Rome and I had watched the master copyist Carlo paint its later cousin, *Adolescent Bacchus*, in Florence. I had seen that Caravaggio sometimes repeated themes and did variations, as he did with *Boy Peeling Fruit*, *Boy Bitten by a Lizard*, and

The Lute Player. It made me think that he might have done something similar with Bacchus.

Sick Bacchus and especially *Adolescent Bacchus* are sensual and feminine, with strong homosexual undertones. I thought of making my *Drunk Bacchus* life sized, more masculine, more brash, and imposing. It seemed to me that the three paintings better encapsulated the full range of Caravaggio's persona: the sensuality, the homoerotic elements, and then his violent, powerful masculinity.

Sick Bacchus shows a pale, sickly boy with a crown of ivy. He is wearing a lavender toga and is seated at a table with grapes and peaches. The way his chin tilts toward his raised shoulder, the way his legs are crossed, and the slight lilt in his wrist show a femininity and flirtatiousness. By contrast, when I started sketching mine, I lowered his shoulder and raised his elbow, eliminating the lilt in his wrist, and spread his legs more. I colored his toga a pale, slightly dirty green and I crowned his head in grape leaves with different varieties of red, black, and green grapes. If you looked at his expression, it would imply drunkenness, not sickness, and there is a drop of wine dribbling from his lips. This Bacchus was a rowdy, drunk, masculine god of revelry, not the delicate youth or seductive boy of earlier efforts.

Since I imagined it as a late Caravaggio, my painting would have the flesh tones of that period, more reddish with sienna and a touch of umber as in the Grand Master portrait, instead of the pale off-white as in his earlier Bacchus. It would have the deep, exaggerated chiaroscuro on the cheek, knee, and hand, along with the dramatic light of his last works. I studied Caravaggio and the

earlier copies I had done and did a number of drawings, taking my cues from the artist's grape leaves, fabric folds, anatomy, and poses.

Ten days later, I was in Rome hunting for a canvas in the antique stores between the Pantheon, where I stayed, and the Vatican. Within a fifteen-minute walk in three directions, I could find whole streets dedicated to ancient, Renaissance, and Baroque art. As I wandered, I passed in front of San Luigi dei Francesi and Santa Maria del Popolo, stopping to study again the Caravaggio paintings I had seen ten years earlier.

Some of the shops I visited were filled with junk; others had beautiful pieces that someone with an expert eye had picked out. I wasn't on the lookout for great art, though; all I wanted was a genuine seventeenth-century canvas with the stretcher bars to match. For that, the jumbled junk houses were a treasure trove.

On Via dei Coronari, the antique dealers were scattered among shops that sold tailored habits for priests and rosary beads for pilgrims on their way to Saint Peter's. I saw hundreds of religious paintings of all sorts—mediocre Madonnas, Bible stories, saints, crucifixions, and angels. I would ask politely if I could come in and browse around, turning over canvases and testing the joints and tacks of old paintings until I found something I could use.

Finally, I found a clumsy *Madonna and Child*, one of the dime-a-dozen depictions that, crucially, had its original unlined canvas still in relatively good shape. It had intact stretcher bars, three inches by one inch, and a thick cross section in the middle. It wasn't in great condition, but it wasn't terrible. It had been patched along the way, which would have been normal, and on the whole, it

was perfect for my purposes. I think the whole thing cost me about $600. I wonder if the shop owner knew what I was up to.

I asked him to remove the frame and make a lightweight carrying case, which he did with thin plywood and a handle. The shopkeeper suggested an excellent framer who had supposedly framed Raphael, Leonardo, and Tintoretto for museums in Europe and churches all over Italy. It wouldn't matter that the frame was new. Old masters were regularly reframed by museums, galleries, and private collectors.

At the framer's, I picked a beautiful gold cassetta with scrolling in the corners and black stripes around the outer molding. The framer measured my canvas, made his notes, and told me it could be shipped to me in a month. At over $1,000, the frame cost more than the canvas itself.

The next day, I went in search of natural pigments. In modern pigments, the material is ground industrially to a powder something like flour. I wanted a coarse cornmeal-like grind that mimicked the way pigments were made during Caravaggio's time—by hand with a pestle and mortar. I don't know that they would have looked very different to the naked eye, but I imagined occasional undissolved particles and thought that they might be noticeable under a microscope. I couldn't find anyone who still ground pigments by hand, but eventually I did find a shop whose pigments were ground on a kind of millstone. I bought bone black, lead white, three types of red, greens, blues, and yellows that I would need for my painting.

When I returned home a few days later, I stripped away the old paint and covered the canvas with gesso that I made by mixing marble dust with rabbit skin glue—the boiled skin, joints, and tendons

of rabbits that had been used for over two thousand years. I mixed this with a nonchemical hardening agent and applied it to the canvas in layers, letting it dry and then sanding it between coats. I repeated this several times, and when it was smooth, I lightly applied layers of lead white paint, sanding until the surface was even, with an almost translucent glow.

Finally, my canvas was ready. I called Laura and told her I was about to start. She said she was glad to hear the news and that she had been in touch with her contact, but she also seemed distracted, almost troubled, like I had interrupted her in the middle of something important. It was a different side I hadn't seen before. While I was in my world with Caravaggio, everything seemed fine. Back in the real world, everything did not seem quite so kosher.

I had intended my Caravaggio as a bold move, showing off my talents and asserting myself, but increasingly other factors came into play.

sixteen

THINGS GO BAD

(1988)

FOR MOST OF US, COCAINE HAD CHANGED FROM BEING SOME-thing fun and exciting to a boring, almost constant ritual. We would be up all night, watching the sunrise and talking, talking, talking, listening to our own bullshit. When you're on coke, you think you're really smart and interesting, but really, you're just boring and self-absorbed. Sometimes I'd get this clarity, like I could hear all the shit I was saying, and I knew it was stupid, but I'd still just keep talking. I hated those conversations. I hated waking up in the morning, gritting my teeth. I hated trying to find a dealer to buy coke. I hated that I wasn't jovial or fun-loving like I used to be. I thought, "How could I waste my life doing coke and talking, talking, talking?"

After being out, I'd usually go to my studio across from the Peach. I'd paint until three or four in the morning, and then go to sleep around six, as the sun was coming up. At one or two in the

afternoon, I'd wake up, have coffee, and survey what I had done the night before. Usually it wasn't great. That I let myself down with my painting was depressing. Being unhealthy and not sleeping added to the depression, and then it would snowball. Sometimes, as I was looking at work I'd done the night before, I'd get a rag and thinner and take off the paint. Sometimes I'd paint over what I had done. Sometimes I'd fuck it all up and bring the whole thing back down to blank canvas.

I'd walk outside to get the paper and I'd see my neighbors coming home with their kids and people working and going about their business, and then that was depressing too, being out of step with people, out of touch. Sometimes I'd just be worn out; cocaine drains your body of vitamins and minerals, and I would just lay around and do nothing. Eventually, I'd shower and make myself something to eat. I wouldn't feel like leaving the house. It was too tiresome, and I didn't want to be around people. I didn't cook much, so I'd make a steak or a hamburger, then watch TV or take a nap.

Finally, around five o'clock, I'd go out to the Peach, have a couple of drinks, and start things all over again. There was always someone I knew, someone to hang out with. We'd drink and figure out where we were going to go later—to the Blind Duck for a different crowd or to Baxter's for live music. Always, there was coke involved. Most of the time, we'd get it at the Peach or we'd stop somewhere and get a gram or an eight ball. We were young then and we'd go out to meet girls, who were always around, especially when there was coke involved.

At the end of the night, I'd go to my studio and paint until finally going to bed as the sun was coming up. I'd wake up in the bright,

glaring sunlight that I hated and drive back to my condo. Nothing makes you feel shittier than waking up in dazzling sunlight and a blue sky when you're hungover. I came to hate the sunlight, like a vampire, because it meant feeling shitty and reckoning with stupid things you said or did or how you acted the night before.

After a while, it dawned on me that this was not fun anymore. Most of my friends were in the same boat. Some kept it together. Others, like Frank Reagan, went off the deep end. Though he had been my accountant and a trusted friend, he ended up getting all fucked up and stiffing me for tens of thousands of dollars before going downhill and losing everything. In the eighties, many wealthy and successful people squandered their lives on coke. For me, it was a financial roller coaster.

While I was spending like a drunken sailor, the market for lithographs, my bread and butter, had pretty much dried up. It had gone from red-hot to stone-cold in only a couple of years. I'd still sell a Chagall here or there, because he was such an important artist, but now instead of big bulk orders, it was one or two, dribs and drabs. I was doing a few aquatint etchings, but by then my customers were more or less exclusively interested in other things, like paintings, gouaches, drawings, and watercolors. It was harder work, more time-consuming and labor-intensive. And, unlike before, when everybody would come to me, now I had to get on the phone and hustle. I'd call up my dealers and tell them what I was doing and ask them to buy something.

And of course, except for Charles and Tommy, who paid like clockwork, the dealers were always stiffing me, backpedaling, and giving me the runaround. Mitch Geller once mailed me an empty

FedEx envelope, claiming that his assistant had forgotten to put the check for $30,000 in it. Of course he was just stalling. Since the night at Silvio, I had been pretty strict about not taking on new customers, but with the coke and the money problems, I probably would have, if someone had asked.

I was working on the Caravaggio, but it wasn't going that well. He painted fast, *alla prima*, meaning he painted wet on wet, without any drawings or sketches as guides. His friend Minniti said he would make a contract for an altarpiece that was supposed to take six months, but then he would finish it in two weeks and walk around drunk, dressed in black, carrying a sword, and looking for trouble. Baglione, the biographer who had sued Caravaggio, criticized him for carefully composing his models and then just painting them quickly and effortlessly as if coloring in a copy. Baglione said it showed his lack of creativity, but to me, it sounded like divine inspiration and genius. It was like a poet taking dictation from God.

For me, painting Caravaggio was difficult, painstaking, and laborious work, full of starts and stops. I still don't know how the hell he did it, but I couldn't quite capture it. I used light, very faint pencil drawings to guide me. I would paint coked up, thinking I was the greatest artist that ever lived, sure that I had cracked the master's style when I went to bed, then wake up in the afternoon thinking, "How the fuck did I screw this up so badly?"

I kept messing up the face and the flesh tones, not quite capturing the mix between the stark chiaroscuro of the late paintings and the more nuanced, more realistic flesh of the Alof de Wignacourt portrait. For some reason, I had a tough time with the hands. Many people say that Leonardo was the best painter of hands ever, but I

think it was Caravaggio, and the difficulty I had proved it to me. The fabric and draping of the clothing were a problem, not as realistic as it should have been. It would frustrate me and so I'd work on something else for a few days. Sometimes, I would have to wipe off the previous night's work, or if the paint had become tacky, I'd paint over it. In the end, I wiped the Caravaggio clean and started over.

While I was struggling with my painting, an LA dealer named Frank De Marigny had gotten busted for trying to sell a phony Renoir *Ballerina* to some businessmen in Little Tokyo. It was nice, but the problem was that it already hung in the Metropolitan Museum in New York. And though it was stupid, and didn't touch anybody in our circle, it still made us nervous because it meant that the cops had started paying attention.

To me, it hit even closer to home because I had met De Marigny and had considered working with him. We had been introduced by a guy who was selling an Aston Martin Lagonda. I wanted to buy it, and when I met the seller, I told him I was an art dealer. He invited me to dinner with De Marigny, and afterward we went for a drink at De Marigny's apartment in Beverly Hills. I didn't end up buying the car, because I couldn't get the money together, but the seller kept calling me. I think he wanted me to work with them. Maybe it was the coke making me paranoid, or maybe I was just leery, but I had a bad feeling and brushed him off. To me, it seemed like the art cops were starting to wake up.

Back in Claremont, the regular cops were definitely fully awake. I took a girlfriend to a nightclub where Sheriff's Deputy Bob Raynes and his cop buddies just happened to be that night. I had told her about Raynes and how all the cops were hassling

me for being a drug dealer. They were on the dance floor when, stupidly, she pointed her finger at him like a gun. She "shot" him and blew the smoke away like a cowboy. Of course, Raynes went nuts. He stormed across the crowd, grabbed her, and arrested her, putting her hands behind her back and shoving her outside toward a cop car.

When I saw what was happening, I ran over and pushed my way through the crowd to get to her. They said I elbowed a cop and arrested me, too, for interfering with an officer. They threw me over the hood of the car, handcuffed me, and took us both away in a cruiser. They even towed my Lamborghini to an impound yard.

It was all bullshit because I had barely brushed past them, and though my attorney got it dismissed, it cost me $2,000 in fees and another $500 to get my car back. Even worse, now I knew the cops would be gunning for me. If they had been a pain in my ass before, it now became a personal vendetta and a priority manhunt.

Not long after the cops busted De Marigny, they raided eight outlets of a big Southern California chain called Upstairs Gallery. It was on TV, breaking news on every channel throughout the day. Upstairs had gotten busted for allegedly selling fake Dalí, Miró, and Chagall lithographs—a lot of which, I think, they had gotten from Leon Amiel. I didn't think they had my stuff, but I called Charles and asked him if he knew anything. He never wanted to talk about anything on the phone, and hardly much more in person, but we met the next day at the Moustache Café. It was clear that this was a wake-up call for Charles. He told me he was going to get rid of everything phony and that we would have to stop doing business altogether. He told me to be careful.

I called Mitch Geller in Chicago and Truman in LA to see if they knew anything, and they were both on high alert. Tommy and I talked on the phone, vaguely in code, saying stuff like, "It sounds like there's a focus on art these days." I could tell that he was concerned, and that, in turn, made me very concerned.

About the same time the Upstairs Gallery raid happened, *60 Minutes* aired a program on art forgery in America, and they showed a dealer who had gotten busted. He was crying, and Vincent, who was watching with me, commented on how sensitive the guy seemed. I could understand. I think any of us would have felt the same way, and though none of the dealers said anything, all the orders stopped. Everything dried up cold—an instant drought. If my money problems had been up and down before, now they were just down. I was wary, but the drought made me desperate.

I don't think that Vincent was doing much better. It looked to me like he was drinking, probably getting in over his head with cocaine, and gambling. I think he had been fired from his big corporate job and now it seemed like he was making book full-time. The problem was that he didn't seem very good at it and it looked like he was losing a lot of money. Being a bookie shouldn't be like gambling. Essentially, your job is to move the line so that you get even money on each side of a bet. Then, whoever wins, they pay each other off, and you just skim a cut for handling the transaction. Good bookies aim for balance, laying off excess money to other bookies to reduce their risk.

Unfortunately, I don't think Vincent was a good bookie. He set his own line and never laid anything off—I think because bookies wouldn't take his bets. If there was a ton of money on one side

and that side won, he'd have no money to pay them out. And that doesn't work for long.

Pretty soon, I think Vincent was selling his stuff; first some land at bargain prices, then his Aston Martin, his pride and joy. He sold out his share in Jimmy's, and I think he got upside down in his mortgage, borrowing against the house until there was nothing left. We were both in dire straits and needed to do something quick. That's when I came up with the idea of selling my Dalí oil, suggesting Vincent act as a seller and that we split the profits.

A few years earlier, I had done two *Nuclear Disintegration of the Head of a Virgin*. One I sold to Charles. The other I kept for myself. It had been, up to then, my absolute masterpiece. I had even produced a fake certificate from Dalí's business manager, Robert Descharnes. The certificate was based on Descharnes's practice of authenticating a painting by handwriting his blessing on a color photograph of the artwork. One of my dealers had given me one of these photographs, and I studied it to perfection, practicing Descharnes's handwriting as well as his signature obsessively.

I took a color shot of my own painting, and with the help of my Belgian friend Pascal Blanc, I wrote up my own authentication, repeating Descharnes's handwriting over and over again. Though it is much harder to forge an entire paragraph than a single signature, I wrote it all out: "According to my opinion, and current knowledge of the work, and after having seen the original, the oil on canvas reproduced by this photograph is apparently by the hand of Salvador Dalí. Signed, Robert Descharnes." It was the perfect provenance.

Because I couldn't show my face, I had Vincent go to an art appraiser in Beverly Hills that Charles had recommended. The

appraiser liked my Dalí and pegged it at $350,000 to $500,000, which in the eighties was a lot of money and would have been a big score for us.

I can't remember how, but somehow, we found a buyer, a character actor from the movies *Dog Day Afternoon*, *Blazing Saddles*, and *Eating Raoul*. He was an avid collector of Dalí and showed a lot of interest in the painting. When we drove to his house in Santa Monica, Vincent insisted I come in with him, I think because he was nervous and felt he might choke if he was asked certain things he didn't know.

I did not want to, and definitely should not have, but I reluctantly agreed to go inside with him. Vincent introduced me as his friend who had just come along for the ride, and I walked around looking at the buyer's art while they talked about my painting. I remember smiling when the collector oohed and aahed over the composition and admired the perfect patina and the faint bit of craquelure on the bottom of the painting.

The collector agreed to buy the Dalí but insisted on having it authenticated at an auction house first. A few days later, he and Vincent met at Butterfield & Butterfield on Sunset. This time I absolutely refused to go. In retrospect, I probably should have because, though Butterfield liked the painting, they sent it on to Christie's in New York to have it confirmed, giving Vincent a receipt for their valuation. When I found out, I was livid, very upset with Vincent that he had let the painting out of his hands. I guess he really didn't have much of a choice with the buyer there, but I was kicking myself for not going. I didn't know what would happen if they decided the painting was a fake. Would they simply

dismiss it and give it back, or would they confiscate it and hand it over to the police?

In New York, Christie's loved the painting, but it turns out that Robert Descharnes happened to be present that day, in the city on business by sheer coincidence. He took one look at my certificate and canned the painting as a fake. The sale was off, and the painting was hastily sent back to LA. Nobody made a big deal, because auction houses are much more worried about controversy than finding fakes, but we were out the money we badly needed. What's worse, now my painting was burnt and would be totally useless. Vincent brought it back and I stuck it in my secret room along with the Descharnes certificate. I tossed the Butterfield receipt in a pile of papers in my den.

Now things were really tight. My customers were all taking cover, my Dalí scheme had gone bust, and I was too well known to go knocking on gallery doors. With no good options, I called Sawicki and told him that I wanted the money he owed me from the Yamagatas and Mirós I had made over a year ago. I was used to getting the runaround from him, but I hoped that this time, he might come through. When I had started making my Ferrari, his bounced checks had caused me to bounce my own checks to Scott Knight, which I hated doing and found embarrassing. I apologized a thousand times and paid him off in cash when I found out. Even my small, independent bank had thrown me out because of insufficient funds due to rubber checks from Sawicki. I once joked that I had brought a check to his bank and that the teller slapped me.

Now, with my mortgage due and bills adding up, Sawicki was a last resort. Not surprisingly, he started stonewalling me. He'd dodge

my calls and promise to call me back. Tomorrow. After a while he stopped taking my calls altogether, and it really started to piss me off. I called his home once and his wife answered. Though I was polite to her and didn't say why I was calling, she told me not to call him anymore. I didn't press her. I could tell that she was shaken and I felt sorry for her because it was between me and Sawicki. But a man should pay his debts. I have always been a man of my word and it's a personal point of honor that I never stiffed anybody and never welched on any bets.

One day, I was recounting my woes to Jim Gladstone, a guy I knew from the Peach, telling him about my efforts to get money from a guy who had strung me along for over a year. Jim was huge, six foot four, 240 pounds, and he looked like a meat locker. He had been a businessman, but he told me that he had done some debt collection in the past and that he could help me get my money for 50 percent of whatever he recouped. I didn't know Jim that well, but I liked him. He was always very square, a respectful and nice guy. He stressed that there would be nothing illegal about what he would do and that his secret to success was just his tenacity, calling over and over and not taking no for an answer.

He would call up Sawicki, politely saying that he had been employed by Mr. Tetro and that he understood there was an out-standing debt. He would leave a message, and he would keep call-ing back. Over and over. And though he never threatened him, and was always polite and professional, I think Gladstone rattled Sawicki. But Mark must have been in some kind of bind because he wouldn't call me back and we didn't speak for a long time, during which I never saw a cent from him.

These should have been good times for me, but they weren't. It seemed like everywhere I turned there was a problem or a hassle. Things were going bad, and I needed to pull myself out of it. The only thing I looked forward to was seeing Laura again. I knew it was bound to give me more trouble than I already had, but I couldn't help myself.

seventeen

THE BUG DETECTOR
(1988)

AFTER WIPING THE CARAVAGGIO TO BLANK CANVAS, I DE-cided to buckle down and get to work, and I resolved to get my shit together. I had pulled another all-nighter and things had gotten ugly. I did not like what I saw and I decided it was time to get off of the train. I gradually tapered off the coke, going from an almost every night thing to a couple days a week and then, finally, maybe a line or two when I was out in Palm Springs. It wasn't dramatic or cold turkey; I just did it less frequently, passing up opportunities when I had them. I guess I was lucky I didn't have an addictive personality. I even started working out with a trainer for the first time in my life.

Having already tried the Caravaggio and failed, this time, with a clearer mind, I quickly made progress. I was still painting at night, but there were fewer highs and lows and now there was no bullshit or drama. It was replaced by the focus and dedication that I had always had before. People always want to emphasize the tortured

genius of painters and how they were inspired visionaries and all that. That's true, but especially in the Renaissance and Baroque period, they were also highly trained artisans who mastered professional skills, practice, and self-discipline.

By the end of the first week, I began to capture the looser sketch-like feel of Caravaggio's late paintings. It wasn't perfect, and occasionally I had to paint over details I had done, but this was normal, even for masters, and these little mistakes and corrections, called pentimenti, helped experts to determine that certain paintings weren't copies because they suggested the painter might be working from scratch, making things up as he went, rather than just copying a fully formed painting in front of him.

When things are going well, I become obsessive, and as long as I'm enjoying it, I don't want things to end. I know what my goals are and I have a clear picture of how to get there. Instead of waking up and hating what I had done the night before, I'd wake up and like the results, noticing only small details that I would touch up calmly.

After three or four weeks of focused work, I was finally happy, satisfied with the painting, and I felt that I had more or less completed it. I flipped it over to the back and left it against the wall so that I wouldn't be staring at it. Two weeks later, when I would look at it with fresh eyes, I would immediately know whether it was good or bad, and what I needed to improve. With my *Bacchus*, when I finally turned it over, I was thrilled with how it had turned out and spent only a day touching things up before deciding it was perfect.

Now, all I needed to do was age, crack, and weather the painting, messing it up to give it a patina of life, which had always been one of my favorite parts of the process. Oil paint doesn't dry out so

much by evaporation as by oxidation, as the pigments are exposed to air over time. I figured the paint also cracked over hundreds of years due to heat and cold, dry and humid air, and because the stretcher bars and canvas were constantly expanding and contracting with the changing seasons and storage conditions.

I had seen Baroque paintings both in Italy and at the National Gallery in London. In London, where the air is cooler and the conditions more humid, the paintings had no cracks at all. With the warmer, drier air of Rome, paintings developed a network of spidery cracks. Probably this difference was due to the preferences of how each country did restoration, but I'm convinced that the wet, rainy weather in Britain also played a role.

In Upland, I knew a guy who had a restaurant. At night, when the restaurant was closed and everybody had gone home, he let me in and I stuck my painting, stretcher bars and all, into the wide-mouthed pizza oven, setting it at the lowest temperature, 140 degrees. It was hot, a little more than the very hottest day in the desert, but it wasn't artificial. It was a temperature you could find naturally occurring on earth.

I left the painting in the oven all night, and in the morning I pulled it out to examine it. It looked good, the paint surface had dried out, and I took it home to test it. Carefully removing the nails so that I didn't bend them or scratch the rust off, I took the canvas off the stretcher bars. Holding it delicately at the corner, I rolled the canvas up into a wide tube and pressed gently on the sides. With the hardened, dried gesso underneath, I could see one or two small surface cracks start to form, but the paint beneath was still too pliable to work correctly.

From a metalworking shop in Claremont, I got a flat aluminum sheet a little larger than the painting and put the canvas on top of it. The sheet spread the oven's heat evenly and kept the canvas off the rack. For a week, I baked the painting after hours, taking it out in the morning to inspect it. Then, I'd pack it back into its carrying case and lock it in the manager's office with a big warning not to touch it. After five or six nights, the paint had finally dried, and I was ready to take the canvas home again. This time, when I rolled it up, a veiny network of cracks formed across the surface of the paint, deeper in some areas and finer where the paint was thin.

Now, with the paint cracked, I set about to create a past life for the *Bacchus* using layers of grime, soot, and varnish to suggest a history of age and neglect. I imagined that the painting had been in an old estate, ignored for hundreds of years, its original varnish spotty and flaked, and the original paint exposed and dirty.

In my secret room, I prepared a kind of tent out of plastic sheets, hanging them from the ceiling over my worktable. Inside, I stuck a small heater fan and a dehumidifier and let them run. The fan provided a steady flow of heat and the dehumidifier slowly sucked the remaining moisture out of the air. As I worked and smoked, I prepared my usual sludge of distilled water and cigarette butts, letting it slosh around and mashing it with chopsticks to squeeze the brown juice out of the discarded butts. During Caravaggio's time, tobacco had only recently come to Europe, but people did smoke and it seemed plausible that the painting might have had faint traces of cigarette residue that had built up over the lower, older layers of paint and varnish.

For my first coat, I made a weak mixture of water with only a few butts. I mixed in dust and pollen that I had vacuumed from my patio furniture and fence outside because I didn't want synthetic fibers from my carpet inside to show up. I took the mixture and carefully swabbed it on, pressing with my thumbs and forcing the sludge down into all the newly formed cracks that had appeared in the paint. When I had covered the painting completely, I put it in the tent with the heater and dehumidifier, letting them suck the remaining moisture out of the sludge, making the canvas dry and the paint more brittle.

I then restretched the canvas over the bars, tacking it back on with the rusty nails. Using a rag, I applied a light, spotty coat of Baroque varnish, a mixture of oil, gum resin, turpentine, and beeswax that Caravaggio would have used. I let that dry and then I swabbed another coat of light sludge over it.

When that layer had dried, I rubbed a more modern varnish over it to simulate a half-assed "restoration" the undervalued painting would have received at the turn of the twentieth century. Finally, I swabbed on a last layer of very dense cigarette sludge, a film that modern smokers would have left over the last varnish, and put the whole thing in the tent to dry overnight.

By morning, the painting had pulled together, taking on the grimy, soot-covered look of an old, forgotten family heirloom. With its patched old canvas, Baroque stretcher bars, and Italian frame that I had glazed with umber and flat varnish, it looked perfect. Today, this painting would not hold up to the battery of scientific tests that it would face—they'd probably analyze the DNA of the dust,

pollen, and tobacco against a database—but thirty-five years ago, it was a beautiful, ramshackle, impeccable sight to behold.

Finally, I was ready to call Laura and tell her that I had finished the painting. I was excited by what I had made and eager to show off my work. Of course, I also wanted badly to see her, and I suggested I fly out. Almost instantly, she killed the idea. In New York, there would be eyes on her and she would run the risk of being seen by either her boyfriend or his associates. Reluctantly, I agreed to ship the painting to her so that she could give it to the expert she had been cultivating. I could imagine her enticing him, drawing him in and charming him so that she could get him to look more favorably on the painting. After all, I had seen her allure firsthand.

An expert with a lot of clout can change the fortunes of an artwork, turning it from a worthless piece of junk into a million-dollar treasure with the stroke of a pen. Often, instead of facts, their opinion is based on relationships, peer pressure, and greed. If our expert played ball, and if a pliable auction house went along, we would have a masterpiece on our hands. After all, it wouldn't be the first time someone gave an opinion in exchange for money, lust, or fame.

I was disappointed that I wouldn't see Laura yet, but I also knew that her plan made sense. I told myself that she had to keep track of many moving parts and didn't want them coming together. Still, I couldn't help feeling that she might be dodging me. I was also a little jealous that she was keeping me at arm's length. Though I knew we needed the expert, I didn't like it.

I shipped the painting to New York and waited for the verdict to come in, imagining how the expert would notice the little details I had invented and appreciate the work I had put into making

everything perfect. I especially liked the idea of fooling this guy, who was probably the same guy Laura had duped with the Degas drawings she had shown me in her hotel room.

Back home, things were not going so well. A few days after I sent the painting, I was walking out of the garage with my daughter when I saw a man standing in my driveway staring at my house. I asked him if I could help him, and he asked me if this was the condo that was going be auctioned. I didn't know who he was or what the hell he was talking about, but it turns out I hadn't paid my homeowner association dues and they had put a lien against the condo, planning to sell it in less than a week. I was floored. I had been so focused on forging the Ferrari and painting and partying that I nearly fucked myself up. I had never paid any fees. Now, I had to come up with $25,000, and if I wanted to keep my home, I needed it before next week.

With the failed Dalí sale and with Sawicki still dodging me, I couldn't cover the dues. The next day, I called a car dealer in Marina del Rey to sell one of the few assets I had. He came out to Claremont with a check for $100,000. In return, he drove away in my 1974 Ferrari Dino. I went straight to the bank and then to the developer to give him a check at his office near the Peach. When I got home, I sat down and did an inventory of all the bills I still owed. I took care of a bunch that had piled up over the last year, and this time, I stashed the remaining cash away, finally realizing that I couldn't screw around anymore.

In New York, Laura's expert was hard at work. He got technicians to look at my painting and perform a range of specialized tests. They X-rayed it, examined the canvas and stretcher bars, and

looked at the chemistry of the paint. Because I had been so meticulous with my materials, the findings came back positive and everything checked out. With a little enticement from Laura, the expert assured her that the painting would get a glowing report.

Laura arranged for the painting to be sent to an auction house in LA where the expert had connections and where it would be examined and valued for a potential sale. In LA things were a little more removed, under less scrutiny, and we could act more freely. We had already agreed that I wouldn't go to the auction house, but I was feeling bold, wanting to show off and wanting so badly to see what they had to say that I said, fuck it, and I insisted on coming too.

Laura tried to talk me out of it, but this time I refused and said I would have things my way. I would be there, though I promised that I wouldn't say a word. I told her I would hang back, pretending to be a representative of the European family who owned the painting and that I didn't speak English. I figured I had been clueless in France and Monaco with only a few words of French, so I could do the reverse in English. It was stupid, but I didn't care.

When the day came, I got up early and got the Countach washed, filled it with gas, and drove to Beverly Hills. I had planned to imitate how I saw rich Europeans dress in Monaco, and though I didn't quite pull it off, I did manage a pretty good impression of Aristotle Onassis. I had seen a picture of him in his wide Maison Bonnet sunglasses, wearing a pinstriped suit with a big handkerchief and his hair slicked back. It would have to do.

I parked and waited for Laura outside the auction house, smoking and checking my watch because I was nervous and anxious to see her again. When she arrived a few minutes later, walking down

the street, I was shocked to see, again, how beautiful she was. It was like the first time I had seen her. When she saw me, she laughed, asking who the hell I was supposed to be. I told her my name was Antonio Petrocelli and that I was a shipping magnate. She couldn't stop laughing at me, though to be fair, I did look pretty ridiculous.

Inside, the auction reps showed us the expert's report. He talked about the extraordinary "archaeology" of the painting, and the bravado of the brushstrokes. For him, the painting was, at a minimum, the work of a contemporary follower of Caravaggio. To the auction house, working on commission, they were pushing for it to be by Caravaggio himself.

I was shocked to find that they had gone so nuts, practically begging us to represent it and setting the value, as a follower painting, around $200,000, and as a real Caravaggio, in the millions. Laura didn't bat an eye. She wouldn't commit, but she did tell them she did not want it to be sold at auction, though the family, preferring to avoid the limelight, might consider selling it to a client privately, if they could locate the right buyer. We shook hands and left the painting with the auction house so that they could finish their reports and prepare it for a potential sale.

As Laura and I walked down the street toward the parking garage, she didn't say anything, though she squeezed my hand excitedly. Then, when we turned the corner, she let out a shout of joy. She turned to me smiling, and said, "You're a genius, Mr. Petrocelli," and she kissed me.

I drove her back to the Mondrian and we went straight up to my suite, barely waiting to get in the room before I tore her clothes off. I had so much pent-up lust for her that I went crazy. Afterward,

we lazed around in bed talking about our plans for the future. I told her I wanted to go live on a yacht in Monaco and sail away. She wanted to go to Europe too, as far away from her boyfriend and his friends as possible.

That night, we had dinner at Nikki Blair's. Nikki was a friend and he sat me in the corner right next to where one of my Chagalls I had given him was hanging. It was a wonderful night, like a big celebration and a new beginning, with wine and champagne and a beautiful, noisy, fashionable crowd. When we went back to the hotel, we passionately devoured each other again. It was like I couldn't be satisfied.

In the morning when I woke up, Laura was gone. She didn't even leave a note. Later, when I got out of the shower, there was a voicemail waiting on the hotel phone. She had to go back to New York and would be in touch. I laid around until noon, then had lunch with Charles and headed home. That night, for the first time in months, I slept like a baby, exhausted from the weeks of painting, the auction house, and Laura.

A few days later, I got a call from Tommy. He told me that Leon Amiel, who was dying of liver cancer, had been questioned by the cops in his hospital bed, that they meant business, and that I should watch my ass. Though he still had friends in the NYPD, he said there was nothing he could do. Tommy had his own problems. Not long after, he was questioned on federal racketeering and felony mail fraud in relation to stuff that Tex had been doing in Beverly Hills.

Amiel had been at the very center of many people's deals and now the whole world of fake art was on high alert. With everything that had happened and with all the raids and arrests and charges

that were coming out, I was getting paranoid. I called Laura and told her to pull the Caravaggio from the auction house immediately. She said that her boyfriend had already gotten the news and that they were taking precautions. She had already instructed the auction house to send the painting back to New York.

At home, I took all the lithographs, etchings, and gouaches that I had in my condo and moved them into my secret room. The Picasso and Dalí oils I had on the walls I left up as decorations, though that was a stupid thing to do.

Everybody was walking around on eggshells. We would talk about Amiel and we'd ask each other if anybody had heard anything, but usually all anybody knew was that things were looking bad. I had already stopped doing business with my customers, but now, we went on even stricter lockdown. Tommy stopped calling me at home, and if he needed to reach me, he would only call me on my car phone. Charles wouldn't talk on the phone at all. If I wanted to discuss anything, I had to do it in person.

I took matters into my own hands. I went to Radio Shack and bought a state-of-the-art phone bug detector. You attached it to your phone and a little light would blink green if your line was being tapped. I didn't know how well it would work, but the salesman assured me it was top-notch. After all, it cost me a whole $19.99.

eighteen

YAMAGATA

(1988)

O N A SUNNY SUMMER DAY IN 1988, THE JAPANESE ARTIST HIRO Yamagata was walking down Rodeo Drive in Beverly Hills with his wife and mother. He had just gotten a big, fat, exclusive contract with Martin Lawrence Galleries, a national chain that specialized in prints, posters, and low-level works by major artists at bargain prices. Today, Martin Lawrence has galleries in Las Vegas, La Jolla, and Lahaina and they advertise framed lithographs at "5 for $1,995." In the eighties, they had a gallery in Beverly Hills, but it wasn't that different.

Yamagata had been around. He had left Japan and moved to Europe in the 1970s, and had hung around Paris with bohemians from the Beat movement. He had gotten into jazz, hosting concerts, and making himself a focal point for a group of artists, writers, and actors.

In Los Angeles, he went mainstream. His colorful, cartoonlike vignettes of Paris street scenes, full of dirigibles, parades, hot-air balloons, were like whimsical Parisian versions of *Where's Waldo?*, and they were a big hit. He did paintings of his friends Goldie Hawn and Geena Davis. He hung out with his new pal Arnold Schwarzenegger and did production design on homemade action films with Arnold's bodybuilder friend Franco Columbu that are widely reputed to be among the worst films ever made. He did art for Ronald Reagan and prints for the 1984 Olympics.

When Martin Lawrence reeled him in, it seemed like a devil's bargain. I read Yamagata complained that the gallery was like a jail, that they checked on him twenty-four hours a day and constantly asked him when he would finish, what he was doing, and where he was. He complained that they didn't care about his work, only money. And it was a ton of money. I read that they ended up making $1.2 billion worth of art in those contract years. Yamagata got rich, but it didn't help his reputation. He would send his art to museums around the country, hoping for an exhibition, but they looked at his work being sold in shopping malls and ignored him.

Martin Lawrence didn't have these pretensions. They advertised him by showing customers how Yamagata could paint Japanese characters on a grain of rice, setting up a display with magnifying lenses in a Lucite box. To them, Yamagata meant gimmicks, bright colors, and cartoons that shopping mall patrons would love. At least I thought the rice showed some skill. I sure as hell couldn't even write my name on something that tiny.

When I did my Yamagatas for Mark Sawicki in 1986, I didn't think about it too much. I had never even seen one of his paintings

in real life. Sawicki had just shown me a book with photographs of his work. The little watercolors were all shown in actual size, only a few inches across and a couple of works per page. For me, it was monkey see, monkey do. I'd take a few of his signature elements—the dirigibles, fat guys with balloons, teddy bears, stretch Bugattis from the thirties, Parisian hotels—and mix them up into panoramic scenes. It wasn't very hard and it didn't take much time. When I handed them off to Sawicki, it seemed like easy money.

That summer day in 1988, as the Yamagatas walked down Rodeo on their way to Martin Lawrence, the family passed in front of another gallery. One of them noticed that this gallery, too, was showing Hiro's paintings in the window. Excited, they pointed them out to Yamagata, but the artist was confused. Why were they showing his paintings here when he had an exclusive contract at the gallery just down the street? As Yamagata looked closer, he was puzzled, then growing more and more perturbed, he exploded with anger as it finally dawned on him. "I did *not* paint those paintings!" he screamed.

Turns out, Sawicki had sold my Yamagatas to the gallery, claiming he had gotten them from a friend of the artist through a backdoor deal. Sawicki was not the smartest guy on earth, but this was one of the dumbest things he could have done, selling the fake Yamagatas only a couple doors down from Martin Lawrence. I mean, of course they're going to see them sooner or later just by walking down the street.

Yamagata was a mild, placid guy, but I heard he scared the shit out of whoever was in the gallery that day. He went completely bananas; they had never seen anything like it.

nineteen

THE BUST

(1989)

APRIL 17, 1989. I FINALLY HEARD FROM SAWICKI. I HAD BEEN up late at a friend's party the night before and was taking a nap, out cold, when the phone woke me up. I was groggy; it took me a minute to get my bearings. When I found out it was Sawicki, I re member I said, "What the fuck, Mark, you just called to say hello? Where's my money?" I couldn't believe it was him. He chuckled a little, nervously, because I was so pissed off, and then he began to tell me that he was sorry he had been dodging me. He said he had been out of town on and off and that he had been avoiding me because I had been such a prick. I couldn't believe it. Imagine, a guy owes you $20,000 and dodges your calls for a year, then he accuses you of being a prick.

I told him that I had almost lost my home thanks to him and that he had really screwed me over. He apologized again and told me that he was calling because he had my money and wanted to

bring it over. I didn't really believe him, so I told him to prove it and come that same night. He couldn't, but surprisingly, he offered to come the next day, which was shocking after all of his cat-and-mouse bullshit.

Mark wanted to make small talk and to act like everything was fine, but I wasn't in the mood for that. I told him he should come with all my money and that it had better not be another one of his infamous checks. He assured me he would bring $20,000 and that all of it would be in cash. I knew there must be a catch. He wasn't going to drive two and a half hours to Claremont just to bring me money.

Sawicki asked me about Jim Gladstone, whose calls he had continued to receive, and he asked me if I could call him off because it was making his wife nervous. I didn't like the sound of that and I knew that he must have been really rattled too, because he kept asking me about him and made me promise to call Gladstone that same night. I told him I would, and we made plans to meet the next day. I hinted that he had better come through or that Gladstone would be back in action.

I was glad that Sawicki had called. The night before had taken it out of me, but the call immediately lifted my spirits. Before I hung up, I told Sawicki how his call had sideswiped me, and that it was like a "fucking ghost calling me."

That night, I went out to dinner and came home early. I slept well, content knowing that Sawicki was finally going to come through with cash. When I woke up the next day, I was feeling invigorated and energetically went to work in my secret room. I cleaned up a Miró and worked on a Warhol at my light table.

The Bust

At four o'clock on the dot, Sawicki showed up at my door. I had left it open because it was a warm day and I wanted the breeze to move through the house. He stepped in and handed me an envelope of cash. True to form, when I opened it, the $20,000 had suddenly turned into $8,000. I can't say I was surprised, and I told him it was a bitter disappointment. I used those exact words, because that's exactly what it was. Sawicki apologized over and over and swore that he had more money coming in over the weekend. Supposedly, a customer was flying in on Saturday who would buy up all the rest of Sawicki's art; then he would pay me off.

Sawicki still seemed concerned about Gladstone and asked me repeatedly if I had called him yet. I told him I had taken care of it and that he wouldn't have to worry about it anymore, but he kept badgering me about it, over and over, asking if Gladstone was a "bone crusher" and what he was threatening to do. I badly wanted to tell him that Jim was going to break his legs, but I told him the truth, that he was a nice guy and was only going to call him very gentlemanlike to insist that the debt be paid. It seemed to calm Sawicki down and we went on to talk about other things.

Sawicki loved to gossip. He would call everybody all over the country and talk about what was going on. Leon Amiel had recently died and Mark, who spoke with other dealers, told me that they universally considered his death to be a good thing. Now that he was gone, all the dealers were going to blame him. If they got caught with anything fake, they would just say they'd gotten it from Leon. The way he put it, "Dead men tell no tales."

We all knew that the handwriting was on the wall, and that things were coming to an end. Sawicki asked me if I was worried

and if I was still concerned about talking to people on the phone. I told him I was worried about everything and that I had bought a phone bug detector, which seemed to interest him. He said he had looked at some at the Sharper Image store and was considering one himself.

In all, Sawicki and I spoke for only about fifteen or twenty minutes. As I walked him to the door, he chuckled and told me that I had sounded surprised to hear from him. How could I have not been? He was almost literally the last person on earth I would have expected to call. I asked him when I could plan on getting the rest of the money. He told me "Soon," and walked through the door without saying goodbye.

I stashed the money Sawicki had given me in the desk drawer in the den, right under the portrait of Winston Churchill. Then, I laid down to watch TV. I remember I was just dozing off when I heard rustling, a commotion, like shuffling feet. Through the venetian blinds, I could see shadows moving outside. Then I heard someone say, "Hey, Tony. You there?"

I barely had time to say yes before twenty-five cops stormed in through the open door. They were wearing bulletproof vests and had their guns drawn. I was just getting up from the couch when the head cop shouted out for me to sit back down and asked me if I had any weapons. I didn't. I'd never shot a gun in my life. Then he calmly said, "A man just gave you eight thousand dollars in cash. I'm going to need that back right now."

I was stunned. Sawicki had fucked me. He had worn a wire and the cops knew everything we talked about. I walked over to the desk in the den, took the envelope out, and mutely handed it over. The

head investigator, Gary Helton, walked me out into the living room and sat me down on the couch. He was friendly, conversational. He told me that he was supposed to handcuff me but that this time he wouldn't do it as long as I cooperated. Then he smiled and said, "Mr. Tetro. You're a very good art forger."

When I had gotten hauled in by the cops in Upland a few years before, my attorney, George Porter, had taught me a valuable lesson. He told me I should keep my mouth shut and only politely say, "I'll be glad to tell you anything you want to know, but I'd just like to have my attorney present." That's what I told Helton and then I didn't have anything else to say.

The cops who stormed in were LA County DA investigators, LA County Sheriff's deputies, and some local cops. Because they still thought I might be a coke dealer, they had also sent a dedicated drug crew, and the head of that unit took me aside to level with me on friendly terms. He told me he had to search for drugs and that I had such a nice place that it would be a shame if they had to tear it all apart. He asked me to just tell him where the drugs were so we could skip the destruction and annoyance.

I didn't have any drugs in the house because I had cleaned up and was on a health kick. The only thing I had was a tiny old flimsy line's worth of cocaine that I had left in a dirty sock in the toe of one of my boots buried in the back of the closet. Without a dog, they wouldn't find it, so I told them I didn't have drugs, though I mentioned that they would find razor blades since we had just finished putting up the wallpaper the day before. It was true, after a solid two years of decorating, we had finally wrapped up the last of the finishing touches the day before. The glue on the wallpaper was still wet.

The cop sighed, clearly not believing me. "OK," he said, "have it your way." He put a point person on me to make sure I wouldn't do anything stupid, and within two seconds, they sprang into action, ripping up my carpets, slicing up my wallpaper, and turning the place upside down. They went through every desk, every cabinet, every box, every tape, CD, and file I had, turning everything over and throwing it all around. They confiscated the knives in my kitchen and dumped every drawer on the floor. They went into the bedroom and sliced open my mattresses. They unzipped the couch cushions and pulled out the stuffing. They even looked inside the toilet tank. I had just finished the condo twenty-four hours ago. Now the place was trashed.

While I sat there, more cops showed up and they all fanned out, pulling books and prints and paintings from the condo and carrying them to two huge panel trucks that they had pulled up into my driveway. From the couch, I watched as the cops paraded out like ants carrying the huge *Dalivision*, the Picassos, Mirós, and Dalís that I had used to decorate my place. They hoisted my mannequins, carrying them out like they were humping them. A photographer took pictures of everything they confiscated and a videographer kept rolling as they carted everything away, sticking the camera in my face and recording my despondent expression.

One of the cops had a clipboard and he was cataloging everything they confiscated. The cops would come up to him and call out what they had: "One landscape painting with gold frame. Signed Salvador Dalí. One framed print depicting a nude woman, by Pablo Picasso." At one point, one of the cops picked up a real framed drawing I had by the French artist Henri Matisse. He held

the drawing up and reported aloud, "One drawing, framed in gold, signed Henry Mattis," butchering the artist's name. When I heard this, I chuckled out loud; I couldn't help it, I was so nervous, it just slipped out. The cop on point chuckled too and we shared a look, smiling, which was the only thing that eased the tension. This really pissed off the cops, and the commander went ballistic, screaming at the point person, "This is not a fucking time to laugh! This is serious business."

Going through my stuff, the cops found a bunch of yachting magazines. I wasn't lying when I had told Laura I had wanted to sail away. I was hatching a plan to buy an old yacht, have it towed into the harbor in Monaco, and go live there. I could do it for less than it would cost down in Newport. When the cops found my magazines, they asked me if I had a yacht and if I was a big shot. Far from it, I said, I was just a guy who liked to dream about it, like most everybody else.

As I sat on the couch watching the cops dismantle my place, they made me fill out a handwriting exemplar, a form that you filled in with the alphabet and sample sentences so that they could check my handwriting against all the stuff that they were starting to collect, old checks, notes, invoices, and signatures. I had to fill out reams and reams of forms, writing hokey stuff like, "Our London business is good, but Vienna and Berlin are quiet." And "A tour through our national parks would be enjoyable to you, Sam, I know."

Somehow, I was composed enough to know that I shouldn't use my real handwriting. As they destroyed my place, I distorted my writing, changing the way I applied pressure, slanting my letters, and transforming my signature so that it wouldn't look like the rest

of the stuff that they would find. I didn't know if it would do me any good, but I was grasping at straws.

When I was done writing, all I could do was sit there, watching them tear the place apart from my couch in the living room. I was facing my massive mirrored mantelpiece. It went all the way to the full height of the condo—maybe thirty feet high—and as I was sitting there shitting bricks, I could see the cops going in and out of the bathroom off the bedroom where the secret room was hidden. I imagined them tapping the walls, tearing up the medicine chest, and jiggling the mirror that led into my hideaway. My heart was in my throat the whole time, hours and hours and hours. I just sat there and stared and sweated bullets. If they found my secret room, they would bury me.

Finally, after six or seven hours, the chief detective decided it was enough and told everyone to quit. Everybody just stopped what they were doing and walked out. It was like they finally had mercy on me. I breathed the biggest sigh of relief in my entire life.

But they didn't leave. They just stood around, silently standing at the doorstep. There was a long, uncomfortable silence. I was confused. I started to stand up because I thought they were waiting to handcuff me.

One of the cops waiting on the doorstep caught my eye, raised his eyebrows, and gave me a shit-eating grin. Then, the chief detective turned around and shouted, "OK, second walk-through!" and all the cops rushed back in, switching places and calling out, "I got upstairs now, I got the bathroom, I'm over here." My heart dropped out of my ass. I collapsed back on the couch and went completely numb.

The Bust

For another hour, the cops went over everything again, while I sat there like a zombie sure that they were going to find my secret room. Somehow, though, they didn't. Somehow, the secret room passed the test. This time, when they were done, the cops finished loading up the trucks, locked them up, and rumbled off. Then, Helton told me it was time to go. He told me I could change my clothes because I wouldn't want to be in the lockup dressed in flimsy little gym shorts. I changed, then he took me outside, handcuffed me, and put me in a cop car.

I was still in shock, but I couldn't believe they hadn't found my secret room. As I sat in the back of the car waiting for them to take off, little by little a realization dawned on me. Maybe, just maybe, I had a chance. I kept thinking of Winston Churchill and his glimmer of hope in the darkest hours, and I started to grin.

My cheerful mood didn't last long. Because my condo was fifty feet within the limits of Los Angeles County, when I asked them where I was going, the answer was LA County Jail—downtown— and that was worse than prison. I am not a tough guy or a violent criminal. When I found out I was going there, I was genuinely scared, worried what might happen to me. As we drove to jail over an hour away, the cops joked and talked about how the inmates would love a tasty little morsel like me.

When we got to jail, they took me in to get processed. They frisked me and took the only things I had brought, a ring my mother had given me and my house key. Helton asked me how much I thought bail should be. I offered up $10,000 and miraculously he agreed. I don't know why he asked or why he was being so nice, but I was worried. I thought they were going to put me in with

hardened criminals, and in fact they did. They stuck me in a group cell with ten other guys who looked like correctional regulars. They were jacked, tattooed, teardrop-on-the-face-type gangbangers.

When they saw it was DA investigators who brought me in, the prisoners were impressed. They asked me what I had done. But I didn't want to talk. I wanted to sit in the corner and not say anything to anyone. I was so nervous and wired and worn out that I could have killed for a cigarette. One of the guys had snuck some in; I don't know how or where on his body and I didn't really want to know. I asked him if he would please give me one. He didn't even move, like he didn't hear me and like I didn't even exist. I might as well have been a chair. It didn't matter; I had disappeared into my own thoughts. All I could think of was how I was going to make bail, and how I was going to get back home and empty out that secret room.

twenty

AFTERMATH

(1989)

BEFORE THEY TOSSED ME IN THE CELL, THE COPS HAD GIVEN me my one phone call. It was after midnight and I didn't know who to call, so I got in touch with Pandora, an old girlfriend who lived in the desert, one of the few people I could count on to handle things. I pleaded with her to bail me out as soon as she could because the jail was such a shithole that I didn't want to stay a second longer than was necessary. That night, she put up her house, the only thing she had, and even got a bail bondsman in Upland so I wouldn't have to go out to the desert to pay it off. I think she must have realized that I was about to enter a world of hurt and that a million problems were about to rain down on my head.

My night in the cell was miserable. After everybody settled down, I found a steel bench and slid under it to block the blinding light from the overhead bulbs. You can imagine what the floor of an LA County Jail cell is like, but that's where I stowed myself, hiding

out and trying to sleep for a few minutes. It was futile. Mentally, I was very fucked up, overwhelmed, and my mind was racing in circles. I thought about everything that I would have to do. I thought about finding an attorney and mounting my defense and I thought about how I was going pay for it all. I knew I didn't have enough money and I knew I would have to sell the cars and the condo that I had just finished the day before.

I was overwhelmed with anxiety, desperately craving a cigarette to ease my mind. I was worried about Ed Daniels, a friend who had showed up at my condo while Mike was building the secret room. He loved to talk and I thought he would be telling everybody in town about it just to feel important. I was concerned about how much it would upset my daughter and I was getting more and more anxious about all the complicated tasks that lay ahead of me. My mind was going round and round like a hamster on a wheel, driven by fear and doubt. In all, I think I slept maybe twenty or thirty minutes the whole night.

Early the next morning, one of the guards rousted me at the bars, yelling, "Tetro, your bond posted." I got out of there as fast as I could. They gave me back the ring that my mother had given me as a baby and my house key, and then they let me out on the curb in front of the jail. Suddenly, the whole world had changed. The night before, I had gone in as a high roller; this morning, I came out as a bum on the street. I didn't have my wallet, I didn't have a dime for a payphone, and I didn't even have the cigarette I desperately needed. As I walked out into the sunlight, I thought about asking somebody for one, but as I saw the people in suits going to work, I thought they wouldn't even talk to me. Now I was like a leper.

Aftermath

I went to a payphone on the shattered sidewalk by the side of the jail. The only other number I could remember was Marguerite's. I hated to bother her, but I had no other choice. I even had to call her collect. When I reached Marguerite, she was distraught. The cops had been to her house and raided her and Christine too. Marguerite and I had grown up together. She was always there for me and I knew I could count on her, but I was sorry that I had brought them into it.

Upland is an hour from downtown LA and all I could do was wait for her, hanging out on the sidewalk, dying for a smoke. I was walking around in circles, the rage welling up inside me from being tired and anxious and wanting a cigarette so badly. When you're a heavy smoker, the urge for a cigarette under stress can hardly be described. It was like a homicidal rage.

As I was standing around, I saw Gary Helton pull up in his car. He rolled the window down and tried to console me. He said, almost apologetically, "I know what you're going through." Helton had been very decent with me, but I was so angry that I started screaming at him, "No, you don't know. Why the fuck did you go to my ex-wife's house? Why the fuck would you question my daughter?" I had all this pent-up frustration that I unloaded on him. Helton must have been an understanding guy because he just let it slide; he let me walk away and then he just drove off calmly.

When Marguerite finally showed up, she was with Christine and both of them had worried looks on their faces. I think the first thing I said was, "Marguerite, I *have* to buy a pack of cigarettes." It was early, both of them must have rushed to the car to come pick me up; they were dressed in pajamas and bathrobes and had come

so quickly that neither one had remembered to bring a purse. I never swore in front of my daughter, but I was so pissed off and frustrated that I shouted, "Goddamn it!"

The whole drive home I was raging inside, so wrapped up in the anxiety and stress that I could barely think straight. I was complaining and bitching and moaning about what had happened to me. And I was mad, unquenchably mad about Sawicki and how everything had come down to him ratting on me. I was venting about how I was going to have to sell my condo and my cars. I was really unhinged. I have never been violent in my life, but I was uncontrollably mad at how messed up everything had become.

When we got home, I let myself in and surveyed the damage for the first time in the cold light of day. The place had been ransacked. When they saw it, Marguerite and Christine gasped out loud. I told Marguerite how much I appreciated what she did. I told her how sorry I was and that I would thank her properly someday but that I wasn't in any state to do it now. I got some money and I asked her if she would please, please go buy me a pack of cigarettes while I walked around the house looking over the damage and picking things up.

Everywhere, carpet was ripped, padding torn out, clothes thrown all over, closets and kitchen drawers emptied onto the floor. There were big, greasy stains on my white carpet where the cops had dropped their pizza and laughed about it the night before. The stuffing was pulled out of the sofa. The wallpaper was ripped off in long, curled scrolls.

In the living room, I saw that the cops had torn my Radio Shack bug detector off the phone and taped it to one of the light fixtures. They left it hanging there like a noose dangling in the air,

just to fuck with me. The cops thought it was hilarious, but I had to chuckle to myself. Twenty-five guys had searched my place for seven hours and, still, they couldn't find an eight-by-twelve room in a little condo. I mean, my place was not exactly Hearst Castle.

As I waited for Marguerite and Christine to come back, I went into my den and moved the sofa back up against the wall and laid down. I was exhausted, but I was so wired that I couldn't shut my eyes. I kept getting up and pacing around. When they finally came back with cigarettes, I tore open the pack like a wild animal. I have never wanted a cigarette more or enjoyed it as much in my life. As I took long, deep inhalations, the nicotine hit my brain cells, and finally I started to calm down. I smoked the cigarette down to a nub and stubbed it out. Then I smoked another. Then, I hugged Christine and Marguerite and I told them I would be OK. A minute later they left and I fell asleep, for hours, like a dead man.

When I woke up in the late afternoon, things seemed clearer, calmer, and I started to think a little more rationally. I didn't want to talk to anybody or do anything. I just laid around and tried putting my place back together a little bit. That night, I took the phone off the hook and went to sleep early.

First thing in the morning, I called George Porter and set up an appointment. George had represented me when the cops had busted me and Jimmy Montini for doing coke and when my girl-friend had "shot" Bob Raynes with her finger. He knew that I wasn't a drug dealer and he knew what my real job was, so he knew what I was up against. He was glad I hadn't said a thing and he told me to continue not saying anything to anyone. Then he asked me to come down right away so that we could talk about it all in person.

On the way to George's, I stopped at a mini-mart to get another pack of cigarettes. I paid with a $5 bill and asked for a bunch of quarters so I could make a call at the payphone. I dialed Laura's number and it rang and rang and rang. I didn't want to leave a message, so I just hung up. I knew that she was laying low, but the fact that she didn't even answer the phone really bothered me.

When I got to George's, he asked me a lot of procedural questions like whether they had read me my rights (they had), whether they had a warrant (they did), if I had invited them in (I hadn't, but I couldn't prove it), and if they had confiscated my stuff (they sure as hell did). As a defense attorney, George had a legendary track record, but he didn't paint a rosy picture for me. He told me that I was probably going to do time and that we would have our work cut out for us if I didn't want to spend a decade in jail.

As I was leaving the office, George told me I would need to get ready for what lay ahead. He advised me to cut all the bullshit out of my life and focus on my defense. On the way home, I stopped again to call Laura. Again, the phone rang and rang and rang, but there was still no answer. It began to gnaw at me.

When I got home, I called Jack, my trainer, and told him I wouldn't be seeing him for a while. I called the wallpaperers and had them come back out. I called a carpet guy to put down new pads and tack the carpet back as well as he could. I paid them a couple hundred dollars I had stashed in my nightstand. Then I called a realtor and told him I was going to have to sell my condo. I even called Joey Marcena and told him to contact a friend who had once expressed interest in my Rolls. If he was serious, I would sell it to him at a discount. Now that I had regained my composure,

I felt like a general, marshaling my forces and getting ready for impending battle.

At this point, nobody knew what had happened to me. Aside from Marguerite and Christine, I think I maybe told Vincent and my brother Don, who didn't seem too concerned. To everyone else, things were normal and nothing had happened. For the next few days, anytime I drove past the mini-mart, I stopped to call Laura, pumping quarters into the payphone and slamming it down when there was no answer. It started to feel pointless and humiliating, all this calling and calling with no answer.

In Upland I used to get together with a bunch of friends for coffee and we'd sit around and bullshit. I figured it would be good to be around friends, so I went to meet up with them. I hadn't intended to say anything, but when I got there, one of the guys told me he had noticed a little blurb in the *LA Times* about my arrest. It was just a short article about the bust in Claremont and didn't seem that sensational. I was surprised that it was news at all. Even my friends didn't seem to make too big a deal of it. I think we just talked about it for maybe thirty seconds before moving on. It wasn't much of an article, but they quoted one of the owners from the gallery where Sawicki had sold my Yamagatas. He said something about me being a big-time art forger and talked about the artists I did.

That was all the DA, Ira Reiner, needed to hear. The next day, he called a big press conference where he announced the bust and took questions from the media. Maybe he had stars in his eyes or maybe he wanted to run for office, but he played it up. I hadn't even thought about me being in the news, but in front of the microphones, Reiner said I was the "largest forger of artworks in the

United States" and talked about the amount of money that had been involved, all the art they had confiscated, and even my white Lamborghini and matching Rolls.

The press went wild. By the time the six o'clock news rolled around, it was a circus. You would have thought they'd found the Lindbergh baby. Every network, every local station, every cable news network like CNN and the BBC announced the story with big head-lines and breathless coverage about an epidemic of art forgery and the kingpin at the center of it. In the end, it was like a feeding frenzy.

What really shocked me, though, was that every single story seemed to end with the same line: "Authorities say they are still searching for the studio where Tetro paints." I knew that it wasn't a coincidence. The DA had put the line out to the news media hoping that someone would come forward to rat me out. That part worried me. I wasn't so concerned about my studio near the Peach. I didn't use it much anymore and there wasn't anything incriminat-ing in it anyway, but the secret room would have definitely put me behind bars.

Once the news programs aired, the phone started ringing off the hook. Every friend and acquaintance I had ever known called me. People I knew from the Peach, people I knew from the desert, and people I knew from around town. They didn't really care about talking to me, mostly they just wanted to gossip and feel like they knew what was going on. And then, the press started calling. Over and over and over. I didn't want to talk about anything, so after a few calls, I just took the phone off the hook and went to bed.

The next day, I was making coffee when the German magazine *Stern* showed up at my door. They asked me stupid questions, like

who I was dating and who I wanted to play me in the movie version of my life. I told them to leave me alone and shut the door in their faces. I didn't have time to waste on them. I had to talk business with George Porter and I had to make calls about the cars and condo.

I made my calls, and then as soon as I hung up, the phone started ringing again. I thought it might be about the car, but it was Mike Beam, my carpenter. Unlike everybody else who just wanted to gossip, he asked if there was anything he could do to help me. I didn't want to say anything on the phone, but I asked him if he could come over the next day with his pickup truck and if he could bring his laborer, Felix, with him. I was going to gut the secret room and get everything out of there before anybody had a chance to find it. I hung up and immediately called Christine to ask her if she could come over too.

The next day, when she showed up, I asked her to take the Lamborghini out and drive it around for an hour and a half. I needed to move it out of the garage, but on the street, it would have attracted too much attention. Chris knew that it was important and she knew not to ask questions. I didn't want to involve her and the less she knew the better. She took off, driving twenty-five miles an hour, and circled around Claremont, stopping for a solid three seconds at every stop sign and making sure her turn signal was on when she wanted to change lanes.

A few minutes after Christine drove off, Mike showed up with Felix. They backed the truck into my garage and in about thirty minutes we gutted the secret room. We were practically running up and down the stairs carrying stacks of Dalís and Chagalls and Mirós, loose, along with certificates and typewriters and paper and

pads and pigments, and stuffed them into the bed of the truck without even putting them in boxes. The garage was partway open, and I could see neighbors peeking through the curtains. I was sure that the cops were going to grab us or that neighbors would tip them off, but somehow, they didn't. By the time Christine came back, everything was done and Mike was gone. He took off so fast that I didn't even have a chance to thank him. He drove straight home, and he and Felix stashed everything in his attic in a flash.

I drove over to the mini-mart and tried to call Laura one last time. This time instead of ringing and ringing, I got a message that the phone had been disconnected. I knew it shouldn't have mattered and that it all made sense, but it really hit me hard. I didn't have any illusions about Laura, but I had no idea what had happened to my painting, and I couldn't help feeling that I had gotten played. It brought me back down to earth.

At another time, it might have really thrown me for a loop, but now, I couldn't afford to feel sorry for myself. My first court date was coming in less than a week and I needed to get my shit together if I didn't want to spend the upcoming decade in a jail cell.

twenty-one

MY TRIAL
(1989 to 1991)

WHEN I FIRST TOLD PEOPLE ABOUT MY ARREST, NOBODY cared; once it was on TV, everybody went nuts. My friends in the art world faded into the shadows, but the rest were titillated and wanted to get as close to the action as they could. Some bragged that they knew me, while others lied that they had known about my art all along. When I told them that now they couldn't say I was a drug dealer anymore, one asshole said, "You know you did that too."

George and I spent a week preparing for my first appearance before a judge. It wasn't a big deal, mostly procedural. We just had to show up and tell them how we intended to plead. I drove two hours to the courtroom and spent three minutes in front of the judge—just long enough for her to yell at me for sitting in the wrong spot. We pled not guilty to the charges, they set an initial date for the preliminary hearing, and that was it.

When I stepped out of the courtroom, a horde of journalists and reporters and cameramen was waiting for me. They shoved microphones in my face and pointed cameras at me, bombarding me with questions. Was I guilty? How many forgeries had I done? Where was my studio? They kept jostling each other to get as close to me as possible. I had to back up, telling them that I had nothing to say and that I would let George do the talking.

George stood in the hallway and made some clichéd statements about how he was going to vigorously defend his client and how he was going to show that I was innocent of all charges. In all, he talked for about ten minutes, mostly about how I was a unique and talented artist and what a wonderful human being I was. It's the least he could do considering how much I was paying him. For sure, criminal defense attorneys are expensive and justice does not come cheap.

We spent the next year going back and forth to the courthouse for motions, hearings, and arcane procedural bullshit. I'd go to Porter's office a couple of times a week. We'd talk on the phone almost daily. Mostly we'd show up before the judge to request delays and continuances and postponements, wasting my time and racking up more and more billable hours while the sword of justice hung over my head.

Marguerite's boyfriend, Larry, had warned me that George overcharged enormously and viciously pursued his clients for payment. Still, when I got the bill, it shocked me. In all, it cost me about $130,000 for George to see me through the preliminary hearing. All it got me was the go-ahead to prosecute me and a trial date over a year away. When I got the bill from the law firm, I fired George. How

the fuck was I going to keep coming up with that kind of money? For a trial, it would have cost me another half a million dollars.

Pretty soon, it was a fire sale at the Tetro residence. I sold my condo to a well-known divorce attorney. When I was showing him around, I gave him a dollar and "hired" him on retainer so that I could establish attorney-client privilege. Then, with confidentiality in place, I showed him my secret room and how it could be accessed by using the phone. He loved it so much, he bought the place on the spot.

My Rolls I sold to the friend of Joey Marcena. He was a cheapskate who took full advantage of the position I was in and ended up stealing the car. I think I gave it to him for $35,000—half of what it was worth. I even threw in the Alpine stereo and phone system, though he bitched and moaned endlessly because he needed to replace a $25 part that was broken.

To eat, I painted two expensive Chagall gouaches on Japon paper for the dealer Truman Hefflinger, who wanted to sell them for me. It was a terrible idea, but I needed the money badly. Not that I ever saw any, though, because he ended up stiffing me. After all, I couldn't call the cops.

Soon, I needed to find a new lawyer. I met Robert Shapiro, the attorney who famously represented O. J. Simpson, and Marlon Brando's son Christian. I would see Shapiro at Nikki Blair's having dinner with all the other hotshots. He would come over to my table and schmooze me, grandly buying me drinks and stopping to chat and introduce me around.

When I went to see him at his office in Century City, it was a different story. Suddenly, he acted like he was doing me a big favor

and that I should be grateful. Though we had set an appointment, Shapiro made me wait for an hour and a half, sitting in the waiting room with my thumb up my ass while people streamed in and out of his office. I left without even seeing him. Later he called me to ask what had happened and why I didn't show up. When I complained about having to wait, he bristled, "Marlon Brando waited for me." I got rid of him immediately. I found out he was planning to plead me out anyway, but I wanted my day in court.

I ended up hiring Jay Tanenbaum, a well-known and expensive troubleshooter who always seemed to find a way to spring his clients. Covington & Crowe had wiped me out, but Jay agreed to represent me anyway. I was getting ready to sell the Testa Rossa I had built, and I anticipated that I'd get over $200,000 for it. To sell the car, I hired a PR firm to orchestrate a gala event at the Sofitel hotel in Beverly Hills. We turned it into a glamorous affair complete with champagne and velvet ropes for the gleaming, polished, gemlike car. I had a full-page ad in *Cavallino*, the foremost Ferrari owners' magazine, and in the *duPont Registry*, a kind of classified listing that specialized in luxury automobiles, real estate, and yachts.

The event was a spectacle, and all the local media showed up to see the notorious art forger unveil his crown jewel while the DA's office did everything they could to put him behind bars. In the end, the billionaire Ron Burkle, one of *Forbes*'s "Wealthiest People on the Planet," bought the car for $210,000, which was a real bargain. I had spent over $350,000 on it, and today the car is probably worth half a million dollars. I could have cried when they took it away. After all the money and time and effort I put into it, I never even got to drive the thing.

My Trial

After I sold the condo, I went to live in an apartment in Upland that my good friend Richard Lewis generously lent me. I stayed there throughout the next year, driving my Honda hatchback back and forth to court. I had already sold the Lamborghini to a guy in Switzerland, and because mine had come directly from the Geneva Motor Show, the guy didn't even have to register it or get new plates. I just handed him the keys.

For over a year, I worked with Jay, driving to his office in Sherman Oaks and talking on the phone almost daily. I went to court so many times that everybody kept mistaking me for a lawyer; when I'd go through security, the guards would say, "Good morning, counselor." One day, I stepped into an elevator with Charles Keating, the central figure in the savings-and-loan scandal. His lawyers wanted to kick me out because they thought I was an attorney too. I was insulted and told them, "I'm not an attorney. I'm an alleged criminal," as if that was better.

We hired experts, in particular, a guy out of Florida who made legitimate copies of famous paintings. We wanted him to talk about how making reproductions was a time-honored tradition that had been around since before the Renaissance. It wasn't cheap. I remember he wrote Jay a letter saying that he always flew first class and stayed in the best hotels, required a hefty daily fee, an honorarium, and a weeklong minimum just to get his ass on a plane to Los Angeles. He probably made more off of me than he ever made painting Rembrandts.

Jay gave me no illusions about my chances. The wire Sawicki had worn, along with his testimony, was pretty damning and things did not look promising. At one of the first meetings, Jay suggested

that I give the prosecution the names of other dealers I had worked with in exchange for a lighter sentence. I couldn't do it. It is engrained in the DNA of every Italian kid in Fulton that you do not rat on your friends, and I told him I would not drop a dime on anyone. He said, "Be smart, Tony, just give them some names." We went back and forth until I finally lost patience and said, "OK, how about Frank Sinatra, Sammy Davis Jr., and Dean Martin?" I thought it was funny, but Jay was dismayed. He gave up and we never had the conversation again for the rest of the time we worked together.

After I got arrested, I stopped taking care of myself and I started going downhill. I quit working out. I was stressed out. I ate poorly. I had all kinds of shit on my mind. I had been on a health kick right before I got busted, but court and lawyers and trials took the wind out of my sails. During this period, I appeared on a PBS program about art forgers called *The Fine Art of Faking It* because Jay thought it would show me in a sympathetic light. I also did a show for the BBC. If you look back at the tapes now, you can see that I look bloated, unhealthy, and stressed out.

After the initial bust and the rush of press, things started to grind along. I'd have a flurry of courtroom activity and then I'd have months with nothing to do, waiting for the court docket to roll along and for my trial to inch closer, day by boring day. After my fifteen minutes of fame, even my friends lost interest in the story.

Charles kept in touch. I would see him occasionally when I went to LA for court and stayed at the Mondrian, until a new manager cut off my free stays. We'd go to the Moustache Café like the old days, and Charles would treat me because he knew I was broke.

He also gave me some work to do—nothing illegal—and the small sum he paid helped me get by when I really needed it. I'd talk to Tommy once in a while, but there wasn't anything left to talk about. He had his own problems and, like me, was wrapped up in court and trials and legal proceedings.

My finances were so dicey sometimes I barely had enough to eat. To keep afloat, I started a small business selling my remaining Tetrographs to telemarketers in Las Vegas at wholesale. They'd peddle life insurance or gold coins or vitamins, and they'd give away a free Chagall lithograph by master copyist Antonio Tetro as a premium. I'd stamp COPIED BY ME, TONY TETRO in big red letters on the back to cover my ass. It wasn't exactly high art, but what can you do? You have to pay the bills.

Finally, in May of 1991, almost two years from the day I was arrested, my trial was set to start. In preparation, I moved out of the apartment that Richard Lewis had lent me and took a room at Griswold's Hotel, the one attached to the smorgasbord restaurant in Claremont. I knew that chances were good I'd be going to jail and I wanted to have all my things cleared out and in order in case I needed to go away.

Griswold's was the first hotel I ever lived in. It was not the Ritz, but it was convenient, with clean sheets and fresh towels every day. To be honest, it wasn't bad and I didn't feel too depressed about it. I'd come home from a long day at trial and I'd walk over to the smorgasbord for the prime rib and Waldorf salad. I figured I'd count my blessings.

Jay told me that all the judges were fighting to take my trial. They dealt with horrible stuff all day—child killers, rapists, murderers.

They knew the trial would take a long time and that it would be a pleasant vacation from all that stuff.

The judge who was assigned to our case, John Henning, was a veteran. He had been on the bench forever, but out of the courtroom for years. Jay even told me Henning was so rusty that he could almost guarantee a mistrial. I didn't know anything about the law, but after a couple of years in and out of courtrooms, even I could see that the judge kept fucking up and kept frustrating the lawyers.

The deputy DA, Reva Goetz, who was prosecuting me, was a nice woman. I liked her even though she was trying to put me behind bars; she was cordial and friendly and the jury seemed to like her, which worried me.

A jury trial is a highly choreographed performance. Once the trial starts, everything you do or say or show is intended to make a certain psychological or rational impression on the jury, the same way that films and plays move us to tears or laughter or empathy. The judge is only there to make sure the rules are observed and that things run smoothly, and the law is less important than the impression you make upon the hearts and minds of the human beings who are deciding your fate.

One of the first things that Jay did was to try to paint a more sympathetic picture of me than might have emerged from the press portrayals or my taped conversations with Sawicki. My daughter, Christine, came to the trial almost every day. Jay wanted to show that we had a good relationship and that I was a normal dad with more to his character than art forgery. He was concerned that the jury would think she was my girlfriend, so early on in front of them, he made her ask me, "Dad, I'm going to go to the cafeteria. Do you

want anything?" It was the kind of thing that had nothing to do with legal arguments but everything to do with emotional connection and sympathy.

My mother made my brother fly out to make sure I was OK and to offer his support. For part of the trial, she came out with my aunt Jean. I had my daughter take them out of the court when the prosecutor was about to play the wiretap tape because in it I had been recorded swearing and saying crude things I didn't want them to hear.

Our defense strategy was a simple one. I admitted to making the paintings and selling them to Sawicki. How could I deny it? But our claim was that I had never sold the art as real and I had never fooled Sawicki. He knew what he was getting, and it was he who sold the paintings as real, not me.

In court, we wanted to show the jurors that copying was a legitimate business and that there were lots of reasons why a person might want a forgery. Maybe a buyer couldn't afford the real thing, maybe they put the real one in a vault and kept a copy on the walls for insurance purposes, maybe they just liked the look of it.

When Yamagata took the stand, he had a Japanese translator. Yamagata spoke English pretty well, but in court I think they wanted to make him look more sympathetic, like a naive artist who had been taken advantage of by crooked villains. On TV, Yamagata had said he couldn't tell the difference between his signature and mine, but in the courtroom, he talked about how I had left white borders around my paintings, which he never did, and how I had made my paintings ugly, instead of warm and whimsical like his own.

Sawicki came off as shifty and uncomfortable. You could tell the jury didn't like him. Not that it mattered to him; he had already

gotten probation, offering up the big fish in order to save his own ass. Jay wanted to show he would have said anything to avoid serving time. When he asked him if he was worried about going to prison, Sawicki answered, "It's a place that I wouldn't want to be." I noticed that one of the younger, longhaired jurors chuckled to himself and smirked.

In one of the taped conversations between Sawicki and me, I had gone to pee while I was on the phone, you could hear it in the background, and Olds, a juror we liked and who was now the foreman, cracked up. These were little rays of sunlight because they showed that despite all the incriminating things they heard me say, some of the jury connected with me.

When I took the stand, I did my best to be calm and jovial, answering Reva's questions politely and trying to show my knowledge, love, and passion for art. They conceded that I was obviously a talented artist and that I loved to paint, but they also focused on my use of the term "bone crusher" that Sawicki had repeated over and over again, trying to make me look dangerous, like a mobster and violent criminal. It hadn't even been my choice of words. Sawicki had used the term and then tried to get me to agree to it, which I think would have made it look like I was extorting him.

What they really hammered me on was that I signed my paintings with the name of another artist. To them, that was crossing the line that indicated fraud. When they raided my condo, they had found the notebooks I had used to practice my Chagall signature. I had signed hundreds and hundreds of times, working hard to get things right. One of the signatures I had circled and scribbled the word *perfect* next to it. Reva used that as evidence to show that I was

striving for a level of perfection that could only be used to fool buyers. She asked me why I had kept practicing. I told her I liked to do things properly and asked, "What was I supposed to write, Mickey Mouse?" The jury laughed, which helped to ease the tension, and this pointed to one of the big points we were making.

If a copyist was going to make a painting to look like the work of a particular artist, it was only natural and normal to also copy the signature, striving to make the copy an actual copy. This was a subtle but important point that the prosecution had to concede; the signature was an integral part of the artwork, an argument that even became legal precedent and was used later in other court cases dealing with art.

On the notebooks, I had scribbled all kinds of notes and reminders. On one page, I had written "Call Carlo Pedretti at UCLA." He was the expert I had chatted with when I was researching my Caravaggio. A handwriting expert compared the natural writing in the notebook to the fake, distorted exemplar that I had filled out the day the cops had busted me. She told the jury that she had never seen a sample of handwriting that had been so systematically altered and she had contributed my case to an academic study as a perfect example of how to obscure your own handwriting.

During the raid, the cops had found the Butterfield & Butterfield receipt Vincent and I had gotten for the Dalí *Nuclear Disintegration* painting that we had planned to sell in Santa Monica. It had Vincent's name on it and a value of $350,000. Since they never found the painting, the DA assumed that I had sold it. In reality, I had retrieved it from Mike's attic and stuck it back in the secret room along with the Descharnes certificate that I had made for it.

When they found the receipt, the DA had called Vincent in for questioning. He covered for me, denying that he knew anything about it, and said that he had no idea why his name was mentioned. Without a painting, and with no way to show that it had been sold, there wasn't much that they could do about it, though on the stand they insinuated I had sold it and they tried to get me to admit it.

Jay and I decided to call their bluff. I got the painting out of the secret room and we produced it at trial, surprising the DA and puncturing their claims in front of the jury. It was a big deal because it showed their allegations hadn't been real at all, and this cast doubt as to how much the jury could trust the DA on other claims.

Before the trial, the prosecution had taken out block ads in the Calendar section of the *LA Times* asking if readers had bought a fake Chagall or fake Dalí or fake Miró, trying to find a victim of my forgeries they could put on the stand. Unfortunately for them, no one ever came forward. There was no little old lady who had been swindled, no family that couldn't send Junior to college, no pension account that had been emptied. And that prompted a question for the jury: Without a victim, what were we really doing here at all?

Of course, the real victim was Yamagata, but I didn't worry too much about him. The trial made him a household name. I used to joke that Tony Tetro was the best thing that ever happened to him. I even had the chance to tell him so. One day I was in the court parking lot changing a flat tire on my beat-up Honda hatchback in the bright sun. Suddenly, a shadow passed in front of me. I looked up and saw Yamagata standing over me, staring down with contempt. I said, "You were a *star* before me, motherfucker, but I

made you a *superstar*." He just sneered and drove off in his brand-new Rolls-Royce.

When the arguments were over and the jury was sent off to deliberate, we had a "Last Supper" at Nikki Blair's. It was a pretty muted affair. The high times were long gone, and I figured chances were that I was going away. My friends from the art world had disappeared, so it was only me and a few friends from the Peach—Crazy Steve, Jimmy Montini, Vincent, and a couple of girls from Upland.

For the next week, while the jury deliberated, I would show up to court early and wait in the cafeteria, drinking coffee and reading books that I had brought with me, twiddling my thumbs while the jury decided where I would be spending the next few years of my life. As the clock tick-tocked away, I waited and waited for someone to tell me what was going to become of me.

This was during the Rodney King trial, and every day there would be huge crowds outside. Protestors, cops, satellite trucks, and press. I'd be in the cafeteria with defense attorneys for the officers Koon and Powell as they reviewed the tapes of the savage beating on their laptop computers. One of them would turn the computer screen toward me so I could see it too. They figured I was bored and that I needed something to do. I'd watch with them for a while, turned off by the brutal beating, and then I'd sit there reading, too tense and worried about the verdict to actually pay attention. Finally, around five o'clock they'd come down and order us into the courtroom just to tell us that the jury was still deliberating and that we'd have to come back tomorrow. I'd drive back home, eat something, and sleep a couple of hours before getting in the car and driving back down the next day.

Finally, on June 11, 1991, the jury came back with a decision. The foreman, our friend Olds, stood up in front of the court and told the judge that despite their best efforts, the jury was hopelessly deadlocked. They voted seven to five and the case was declared a mistrial. When Olds read the verdict, I clenched my fists in the air and shouted, "Yes!" I was a free man.

Outside, the attorneys chatted with the jurors, asking them how they had reached their decisions and how they had responded to various arguments each had made. One of them, a sweet Mexican woman, who I had noticed always listening intently, came up to me and kissed me on the cheek, and then she wished me good luck. I don't know for sure how she voted, but it was one of the nicest things anyone has ever done for me.

twenty-two

BACK TO SQUARE ONE
(1993)

A YEAR LATER, VINCENT DANNATI WAS DRIVING DOWN THE
Pacific Coast Highway in Newport Beach. It was two a.m. and
he had been drinking heavily—as usual in those days. He smoked a
cigarette down to the filter and flicked it out the window.

At the roadside, a California Highway Patrolman saw the or-
ange cherry bounce off the blacktop. He flipped his lights on and
pulled Vincent over. The cop administered a field sobriety test and
took a blitzed Vincent away on a DUI. It was his fourth and an ex-
press ticket to prison.

Vincent didn't know it at the time, but the cops already knew
we were friends. At the trial he hadn't said a word, but now facing
prison, he told them everything he knew. I didn't have any money
left for a defense, and I refused to rat, so off I went straight to jail.
We pled out and I got six months. At the sentencing, the prosecutor
objected, so the new judge, Michael Tynan, upped it to twelve. The

only time in four years that I ever complained, I said, "Your honor, you reneged." The judge corrected me, "No, I *resized*."

During the hearing, Paul Dean, the journalist who wrote a big *LA Times* profile on me, pulled me aside. He told me that he thought some of the prosecutors had been divvying up my loot—the art and paintings and everything they had taken from my condo—and they were going to keep it for themselves. I fought it for a long time and finally got back a few lithographs, some paintings, and my Jose Puig Marti mannequin sculpture. Today, most of my stuff is probably hanging in wood-paneled law offices all over LA County. A journalist even told me that one of the prosecutors has my *Nuclear Disintegration* hanging over his desk. I hope he likes it.

After Vincent ratted on me, I ran into him at a bar. I took a swing at him and we ended up fighting and tumbling into the parking lot, as people tried to pull us apart. To the mob, a rat is a rat no matter what, but I ended up feeling bad for him. At the time, I hadn't really considered how much pressure they must have put him under. Years later when I saw him again, I apologized and told him I was sorry for all the shit we had gone through together.

At my sentencing, the judge saw that I had already spent four and a half years coming and going to court, showing up on time and complying with everything that they asked. He took it easy on me. I wasn't dangerous or violent, and I wasn't going to do anything stupid, so he assigned me to serve my time at the San Dimas Sheriff Substation, reporting there each morning and spending my nights at home.

The judge also ordered me to do community service for a woman who had gotten a federal grant promoting traffic safety. She

read an article in the paper about me and petitioned the court to use me as her painter, making art for posters and teaching kids at high schools and community centers. What I really was, was a mule so she could get her hands on the federal funds.

The judge told me I would be taking instructions from her. She would call every night at nine p.m. to check on me and tell me what I was going to be doing the next day. I thought I was going to be stuck in a cell killing time and doing grunt work like making license plates or breaking rocks or whatever, but this sounded great. At least I would have something to do and could leave the station during the day.

At the sentencing, the judge gave me some time to get things sorted out and ordered me to report to jail six weeks later. Despite what I was told, I still dreaded going to jail. I imagined I'd be in a cell with hard-core criminals, gangbangers, arsonists, and deviants. As the days ticked off the calendar, I would go out with my friends, drinking and living it up while the future loomed over me. I remember I joked to a girl I met at the Peach that we should go home together because I was about to go away to jail. We laughed and I told her I would need something pleasant to think about while I was in the can.

I still had a little business selling my lithographs to the telemarketers in Las Vegas. I figured I would need help with it while I was in jail, so I hired a local guy who needed a job. I kind of felt sorry for him and I figured it couldn't be that hard. All he would have to do is take a call and ship a few lithographs a couple of times a month.

The night before I went to jail, we had a going-away party at the Peach. People clapped me on the back and told me to take care

of myself, while I got drunk and complained, "Fuck, I really don't want to go." For once, at least, I didn't have to pick up the tab.

The next morning, I woke up early, got dressed, and got ready to go to jail. I was younger then and I could bounce back from a big night out. Today I'd be wrecked for a week. I was nervous. No matter how easy someone tells you a jail sentence will be, if you're not a career criminal, you are still going to be anxious about what you're getting yourself into. It's a strange thing to turn yourself in to jail. Usually, you think of the cops chasing someone down, with guns drawn and bullets flying, and it all ending in handcuffs. I drove my Honda to the sheriff's station early, killed some time in a coffee shop next door, and then walked in at seven a.m. on the dot, just like I was going for a job interview.

The guy at the desk had no idea who I was. It was like showing up to the doctor's office on the wrong day. Once they finally figured out what was going on, they checked me in and led me back to a storage room in a separate building at the back of the lot. It was maybe twenty by twenty and full of junk. They ordered a couple of inmates to help me out, and we spent most of the day moving things around and arranging the room so that I could use it as my studio. They had provided me with some counter space and a piece of plywood to use as an easel. Across the bottom, they had nailed a board to serve as my brush tray.

As I looked around the rest of the place, my first impression was relief. There were only about fifteen other inmates and there weren't really any cells, just a room with bunk beds where the rest of the inmates slept at night. There wasn't even any fence or gates

or anything. I was the only one who left at the end of the day, but if they had wanted to, the other guys could have walked off anytime.

The guys in there weren't violent or crazy, and the whole thing had a low-key vibe. Nobody gave me a hard time or tried to hassle me. By the end of the day, I was happy. I thought this was going to be much better than I thought.

For the next year, I settled into a routine. Every morning, Monday to Friday, at six-thirty a.m. I would drive to San Dimas like all the other commuters, except instead of going to an office, I was going to jail. I'd do what I had to do, paint in my studio or at a high school or community center, and then at five o'clock I'd knock off and head back home to Claremont, straight to Magnolia's Peach for happy hour, just like a normal person. I'd chat with my friends, have a few laughs, and eat some dinner.

At nine o'clock I'd turn into a pumpkin and the grant lady, Lyn, would call me to check in. So, I would get home a few minutes early and at exactly 8:59 on the dot, she would call me, usually drunk, always belligerent, hoping to catch me out so that she could report me to the court. She would slur her sentences and bark at me, telling me what I had to do the next day and berating me for whatever little infraction she might have come up with. Once, she told me not to take my shirt off when I was painting outside in hundred-degree weather. Another time she screamed at me for giving a poor kid, who didn't have bus fare, a lift home.

Despite her earlier promises that it would all be fun and that she wouldn't hover over me, I could tell that she didn't like me and wanted to find an excuse to report me to the judge. I reminded her

of that one time, and she said, "You are a criminal. You are in denial about that—and I don't mean the river in Africa." She was very proud of her little zinger, but the reality was that she eagerly waited by the phone each night, right until the appointed hour, praying that I wouldn't pick up so that she could finally bust me. Sadly for her, I disappointed her every time.

The weekends I had off and I would do the things that people with jobs saved for Saturday and Sunday. I would do my banking or run errands, go to the grocery store, or get my car washed. Like most people I went out on Friday or Saturday night.

Jail itself wasn't exactly summer camp, but it wasn't the chain gang either. I'd come in early—I've always been a stickler for being on time—but I never had to sign in. Nobody bitched at me, and I didn't have to wear a jumpsuit or jail stripes. I couldn't travel because they had taken my passport, and I had to be back on Monday morning anyway, but otherwise, if you didn't know where I was going, you would have thought I was just another working stiff with a nine-to-five job.

I got to know the other inmates, which I really came to enjoy. They had separated the guys—the Blacks from the Mexicans from the Whites, but I got to know everybody and when I didn't have to go somewhere, we'd sit around and talk about our lives and our families and pass the time in a way that you wouldn't usually do in real life with people you probably wouldn't have a chance to meet or hang out with otherwise.

Most of the Black guys were in for selling drugs. It was during the height of the crack epidemic in LA, and these guys were the low-level street runners who were just trying to earn a living. I remember

a couple of them telling me how much fun they had during the LA riots, how much stuff they had gotten and how liberating it had been to smash things up and fight the cops who were always hounding them. I'd play blackjack with them when there was nothing going on, and we'd talk about getting together at the Bicycle Casino in Bell Gardens when we got out.

Some of the Mexican guys were drug dealers, but others were in on DUIs; they were quiet, educated guys with decent jobs and families they loved. One guy got in trouble with credit cards because he was trying to start his own business and got in over his head.

Sometimes, when they weren't washing cop cars or pushing brooms, the guys would come over to my studio as I painted. They thought I was an oddity because of what I had done, but they really weren't too inquisitive about art. I remember I did a watercolor of Ira Reiner as an eagle with sharp talons swooping down on me as a mouse. He was about to strike and I was defiantly holding up my middle finger to him. That's the kind of art these guys were interested in.

Because I was the only one who was allowed to leave, when I'd go out, I'd always come back with something for the guys. I'd get burritos and tacos for the Mexican guys and cheeseburgers and the *LA Times* for the Black guys. Sometimes, I'd bring magazines, although I disappointed them because I wouldn't bring them anything pornographic.

I often went to the coffee shop next door. It was run by three nice women and I got to know them very well. I saw them each day and even developed a little bit of a romantic relationship with one of them. Once, she came over to see me in my studio. It was a big taboo and would have landed me in hot water, but the other guys

stood guard for me while Rita and I had a fling in the middle of the afternoon.

The area between the main building and my studio had gas tanks and water hoses and an area where the inmates would wash the cop cars. All day long cops would pull up and get their gas pumped and their cars cleaned. While they waited, the cops killed time in my studio, bullshitting with me about life and cars and girl-friends and whatever else. They'd give me tips about how to stay out of trouble, which inmates I should avoid, and what I should and shouldn't do. I found out that some of the guys went to the Peach once in a while, so I told them to come over sometime and I'd buy them a drink.

The only guy who treated me badly was a sheriff's deputy who I called Smokey the Bear because of the ranger hat he always wore. He was always shouting at me, treating me like a hard-core crim-inal, making clear that I was an inmate and that he was my jailer. I stayed out of his way, and besides him, I never really had a hard time with anybody. Not the cops, not the inmates, not anybody.

In my studio, I painted scenes about traffic safety. I did a Mona Lisa riding in my Ferrari with a seat belt across her chest. I did a comical painting of someone running a stop sign. Lyn loved them, but I don't think she ever did anything with them.

At Hollywood High, I worked with five or six kids who had volunteered for a summer-school painting class. For three months we worked together on three twelve-by-sixteen-foot murals. These were good, eager, earnest kids, from Guatemala and Mexico and Russia, who were determined to do well in their new country. Most of them lived in East Hollywood, with their whole family crammed

into a one-bedroom apartment. As we worked together, we got to know each other, and I got to love those kids. It was Gerardo from Guatemala who I gave a ride home that Lyn had bitched about. After that, I told him to walk down the street and I would pick him up around the corner.

When we were done, to celebrate, I invited the kids and their teacher to dinner at Nikki Blair's—the fancy restaurant in LA. The kids had probably never been in a nice restaurant before and I remember how excited they were. The boys dressed up in their Sunday best, ironed white shirts that were too big for them and dress pants and shoes that were probably shared with older brothers. There was a sweet Russian girl who wore a black dress that her mom had probably hemmed for her grandma's funeral. We had a great time and the kids were hailed as heroes by Nikki himself.

A few weeks before, CNN had picked up the story of this convicted forger teaching high school students to paint. The reporter Roberto Vito and his crew followed us around and came to Nikki Blair's to see the kids in a proud, celebratory mood. It was wonderful to see them so happy giving interviews about what they had done.

A few weeks later when the spot aired, it was almost three minutes long. It showed my studio in jail, the murals at Hollywood, and all the kids at Nikki Blair's. What it didn't show was the teacher and, worst of all, Lyn, who had never been interviewed at all. I hadn't invited her to Nikki Blair's and the CNN crew wasn't interested in her. It really pissed her off, and though I didn't know it at the time, Lyn was not the type of person to let a grudge die easily.

From Hollywood, I went on to South El Monte—where I taught juvenile taggers how to paint a mural of the Statue of Liberty while

lowriders cruised by and hassled me. The kids were great, mostly Mexican kids who knew more about spray cans than schoolbooks. I invited them to my birthday party, and when they showed up in their saggy pants and oversized shirts, the restaurant staff hassled them. I had to tell them they were my VIPs and to leave them alone.

At the schools, I had to pay for my own materials and supplies. I hired Mike Beam to build a wall for one mural, and I bought all the paints and brushes for the kids—which, when you're making giant murals, costs a lot. All in all, I probably spent $3,500 of my own money, which was already pretty thin at the time. One day when I was buying supplies, they told me that the county had an account with the store, and asked me if I would like to use it. I told the store clerk to ask the county if it would be OK.

When Lyn heard about it, she went ballistic and screamed to the prosecutor. They hauled me before the judge and she told him that I had been trying to defraud the county and steal from them. They urged him to give me extra time. Lyn even complained that I had cut her and the teacher out of the CNN program. I addressed the judge directly and told him how absurd this all was. Was I the director of CNN? Did I edit the film and cut them out of it? As for the fraud, I told them how I had paid thousands of dollars out of my own pocket and had only asked the store to check if it would be OK with the county. Judge Tynan dismissed it, but Lyn couldn't let it go.

When the South El Monte mural was done, she organized her own celebration for live TV. She arranged refreshments and invited the LA City Council, Sheriff Block, and all the TV stations and newspapers. She invited the taggers, but she didn't invite me. In fact, I was explicitly forbidden to come.

When the day arrived, Lyn was eagerly awaiting her big debut. But instead of TV fame, right at the last second, a verdict in the case of Reginald Denny, the truck driver who had been pulled from his rig during the LA riots, was announced. The TV trucks and camera crews, the newspapers and reporters, all turned around and headed back to the Criminal Court Building in LA, leaving Lyn alone with the taggers and a couple of trays of cold sandwiches. I had a little laugh to myself. The *LA Times* even wrote an article about it called "The Art of Snub." I still like that title.

Toward the end of my sentence, I was ordered to paint a mural at the Centro Maravilla in East LA. It was run by a stern but wonderful Mexican woman I really grew to admire. She was genuinely a good woman who passionately ran this place for people who really needed help. I liked her and I went all out for her, painting a mural, cleaning another, and fixing the fluorescent lights that lit it.

When I had to report back to Judge Tynan about it, I showed him a photo of the mural and the wonderful letter the director had written for me. The prosecutor insisted that I had conned her somehow, but the judge didn't buy it. He released me three months early for good behavior, and I went home after only nine. I think that Lyn and the prosecutor are still mad about it, but that's their problem.

While I was in jail, my daughter, Christine, got married. It was on a Saturday, my day off. Though I was broke and only getting by on my lithographs, I was proud that I was able to scrape up the money to help pay for her wedding along with her mother.

When I look back on jail, I can't complain at all. Aside from Lyn and Smokey the Bear, everyone treated me OK. I was grateful for the kids and I had developed a relationship with the other

inmates that I wouldn't have otherwise had. It broadened me and made me a better person.

But no matter how easy your time is, a loss of freedom is hard to take. You still have someone who doesn't like you hovering over you, telling you where you have to be and when you have to report.

I could see that if you're doing hard time it could break your spirit and that some people even lose the will to be in control of their own lives. Thankfully, I didn't have that. I was lucky. Compared to how things could have gone, jail was a breeze.

twenty-three

OUT AND DOWN
(1994 to 1999)

WHEN I GOT OUT, THE COURT APPOINTED ME A PAROLE OF-
ficer. I'd go see him once a month at his office in Pomona.
He'd ask me how I was doing, if I had a job, if I was on the straight
and narrow, whether I was doing drugs. I don't know what the rest
of his subjects were like, but I was a model citizen. It was all very
friendly and I was effortless for him. I'd be in and out in ten min-
utes. We'd shake hands and he'd wish me well. For Christmas I gave
him one of the framed Chagall lithographs I had gotten back from
Mike Beam.

I went back to Centro Maravilla to finish up the mural I had
promised. It was the weekend and the place was locked and the
gate was closed. I was so determined to finish that I tried to jump
the fence and keep on working. Luckily, I couldn't manage be-
cause breaking into a place in broad daylight in East LA is a good
way to get shot. I went back on Monday, and after eight or ten days

of work, I finished the mural and took some pictures with the wonderful director.

Back home, the lithograph business was going to hell. The FBI had cracked down on telemarketers with Operation Disconnect and my customers were dropping like flies. I went from ten grand a month, to five, to two. Now, whatever money I made, I ended up giving to the guy I'd hired to help me out. There was nothing in it left for me. Eventually, I had to let him go. To make up for it, I gave him the remaining $16,000 we had in the bank account and let him have the company office. Later, I found out he had been stealing from me the whole time I was in jail. I moved the lithographs to one of those mailbox places and let them handle everything. I'd call them up and they'd pack and ship the art to whatever address I wanted. I should have done that years before.

Theoretically, I still had two truckloads of art that the cops had seized when they raided my place. The court had stuck it into the evidence vault and at the sentencing I learned that the DAs had been grabbing it all for themselves. I should have already gotten it all back, but the court made me fight tooth and nail to recover it, which I desperately needed to do so that I could sell it.

Jay agreed to help me get it back in exchange for a share in the profits and a hold on future earnings. I wish I could say it was a good bet, but I think he picked the wrong horse. When I told him that I didn't know when I could pay him, he told me, "Next life, come back as a lawyer."

As if I hadn't already spent enough days and weeks and years there, we now returned to the Criminal Court Building in downtown LA to petition Judge Tynan all over again. It was chaos. It was

1995 and the court was overrun by the O. J. Simpson trial and the ensuing media circus. From morning until night, the area around the courthouse was packed with satellite trucks, news vans, cameras, protestors, and vendors selling everything from T-shirts and tamales to ice cream and bullhorns. It was like crossing a war zone just to get to the front door.

Inside, I'd see O. J. and F. Lee Bailey and Johnnie Cochran with their entourage of attorneys, assistants, and flunkies all crowded around the elevators. You couldn't get anywhere near them, so I'd have to wait for ten minutes just to go up to my own hearing. Eventually it got so insane that the county had to move all of its other trials to other cities. We ended up at the Santa Monica Courthouse, but it was the same story. No matter how I pleaded, I still couldn't get them to hand over my art.

In Upland life didn't seem fun and vibrant anymore and I wanted to get out. All the places we hung out were going under and friends were moving away. It was perfectly nice if you had a family and wanted to settle down, but I was single and wanted to meet people. When the Peach closed, it was the last nail in the coffin.

I packed my suitcase and moved to Newport Beach. I got a room in a modest hotel by the airport and had fun going to the bars and restaurants and beaches. I met a woman, Bibi, and fell in love. We would hang out at the pool during the day, and at night we'd go to the hotel bar, where Jimmy Hopper's big band played for seniors who danced to the music of Frank Sinatra, Tony Bennett, and Rosemary Clooney. It was endearing to see the old folks having fun.

After less than a year, the hotel kicked me out—for smoking. So I put on a suit and went down to a motel I knew off the PCH.

It wasn't much, but the location was perfect. I asked the manager, George, a sweet old Chinese guy, if he would accept $1,000 per month, about all I could afford, and promised I'd be a good tenant. He agreed and I moved my microwave, books, and souvenirs of the past into the room alongside my old friend, the mannequin, who had been following me around over the last twenty years.

The FBI had started a new nationwide campaign against telemarketers. They had been trying to shut them down for years. Now, with Operation Sentinel, they finally did. They crushed the boiler rooms and put the lights out on my business too. It wouldn't have mattered much anyway; I was almost out of Tetrographs and I didn't have the money to print up more.

To help me out, Charles and Tom Gray asked me to do a few small things for them, not because they needed the art but because they appreciated what I had done for them during my trial. All the other dealers who had walked free because I refused to rat on them acted like they had never heard of me.

Finally, after almost two years and a $40,000 legal bill, the court decided to give me back ten of the forty pieces they had confiscated. There were some Dalí and Picasso oils, a few gouaches, and the Miró *Equinox* that had watched over my Jacuzzi near the entrance to my secret room. I don't know how or why they picked those specific artworks to return. I think that when the judge started asking about them, a few of the DAs got scared and brought the paintings back from their offices. Still, they managed to keep a genuine Renoir drawing that I had traded for. It would have been worth a lot, but somehow that one never made it back.

Out and Down

The art I recovered I stored in a spare room at the motel and little by little I sold it off to pay the rent. Charles bought a few. My new friend Ed Seger, who had a gallery in Huntington Beach, took a couple as a favor. I'd call up art dealers and sell them off for a fraction of what they were actually worth. I don't know if they sold them as real or fake, but I was desperate and had to do it.

For a while, life at the motel was good. I'd sit at the little pool in my bathrobe, smoking in the sun, taking calls on a cordless phone just like in the old days, while George chased the ducks that were shitting in his pool. He was a sweetheart; his family had a Chinese restaurant that was on the second floor, next door to my room. I'd go in there a couple times a week and get dinner or, if I wasn't too hungry, they'd make me some soup or a couple of egg rolls that I'd take back to the room.

I lived right next door to Margaritaville, the most popular bar in Newport. It served as my living room, where I met a whole new cast of characters and big shots—exotic car enthusiasts, develop ers, a retired gynecologist, real estate brokers, sailors, roofers, and tradesmen—guys who hang out during the day and drink. At night, it was packed with beautiful well-kempt women who came in to land a boyfriend or a rich husband.

When I'd see them, I'd think about Laura. Once in a while, I imagined I'd seen her walking down the street. One time in Beverly Hills, I could have sworn I saw her getting into a car. Charles, who knew everyone, said he never heard from her boyfriend again. I think after everything went down, he must have gotten out and moved on to something else. I'm sure she did too.

I never heard about my Caravaggio again. I guess they sold it to the VIP client, and I never saw it hanging anywhere. Nobody ever said anything. Auction houses would rather keep quiet than admit to passing a fake. Once, I saw a picture of Laura at some kind of charity auction in Europe. I'm sure she used her leverage to get herself some kind of role as a consultant. I wouldn't say she was the one that got away, but she was another in a line of women who didn't quite work out.

Not long after I moved into the motel, Bibi reconciled with her boyfriend and the two of them moved to Texas together. I don't blame her. Realistically, I couldn't provide for her daughter and she must have thought, "Where am I going with this guy? He's pushing fifty and he lives in a fucking motel next to a Chinese restaurant." I met women. Plenty. I just didn't have relationships.

Just like with Bibi, little by little things started going south. After I had sold all the art I had recovered, I didn't know what else to do. All I was good at was painting. As the months ticked by and as my nest egg dwindled, I got more and more depressed and then I got desperate, and when you're desperate, you make bad decisions.

I started throwing what little money I had at long-shot deals that I knew would not pan out. First it was the guy who had a bunch of houses in Lake Las Vegas, the fake Italian boomtown on the shores of a fake Nevada lake. I was supposed to decorate his model house with classical paintings, so I got some from Charles and shipped them up to Las Vegas. I bought a plane ticket and flew out there to check out the situation. I spent $2,500 I didn't have and it all turned out to be bullshit.

Then I threw some money into an investment scheme with a guy I knew from Upland. Turns out, he got arrested for fraud. I tried day-trading, but it wiped me out. Just like it always does. I ended up having to borrow money from my brother, and pretty soon I was at the pawnshop hocking my $3,000 Corum gold ingot watch. I got $200 for it and never had the money to get it back.

I sold my Honda hatchback to buy a plane ticket for a family reunion. I flew to Florida and told everyone I was doing great. When I got back, I paid my rent with the money I had left over, then walked around town like a bum.

Christine gave me her old car and so I drove around Newport, one of the wealthiest areas in California, in an old, beat-up Chevy minivan covered in bird shit. I had to park the car at the motel, and twice a day this flock of big black birds would fly overhead and unload all over the car. I remember one time I pulled up to a stoplight next to a beautiful Ferrari in Corona del Mar. I looked over to admire the car and exchanged glances with its driver. He looked the minivan up and down and then looked at me. I smiled wryly and sighed, "This car is a statement of what my life is like right now." He laughed and then peeled out, leaving me in the dust at the intersection.

Pretty soon, things were not so funny. It wasn't long before I could barely afford a drink at Margaritaville. I'd show up early and nurse a bourbon from the well. When it got packed, I'd put a napkin over my drink and go outside to smoke. Sometimes a girl would take my seat and I wouldn't have the heart to make her move. I couldn't buy her a drink, so I'd stand there by myself, broke, in a

corner with nobody to talk to. I could barely tip, and being a dead-beat was humiliating.

A few times, I had barely enough money to eat. I'd try to hide it from my daughter; she had her own husband and kids to worry about. I remember, once, I was on the phone with her while I was counting change. I was trying to see if I had enough for a cheese-burger and she asked me if I needed money. I laughed and pre-tended she was crazy. I was just counting the big pile of change that I had been keeping in a coffee can.

Later, when things fell apart with her husband and it looked like they were getting divorced, I called my son-in-law and asked him not to leave until after Christmas. I wanted to be able to buy presents for my granddaughters, but there was nothing I could do. I had no way to take care of them, and that was the worst feeling of all.

At rock bottom, I was $3,000 behind in rent and George couldn't spot me anymore. I didn't want to cause him trouble, so I moved out, and for five weeks I lived in the minivan. George, who was a good man, let me park next to the motel and he let me shower and use the toilet in the spare room. When I think back on that time, I honestly don't know how the fuck I survived.

Eventually, a friend introduced me to a Silicon Valley big shot. I painted a big eight-by-five-foot *Dalivision* for him and he paid me $12,000. I got a deposit up front because I needed to buy supplies. With the cash, I paid George what I owed him and moved from the parking lot back into the motel.

Not long after, my friend introduced me to a famous Holly-wood film composer. He bought two replica Caravaggios for his studio—a big *Saint John the Baptist* and a smaller *Basket of Fruit*.

For those, I got $15,000. Today I'd charge much more, but then I was scared to ask because I was afraid to blow up a deal that I needed so badly.

A few months later, my friend Scott, who I knew from Margaritaville, wrote an article about me in the local *Orange Coast Magazine*. It showed a painting of my granddaughter as the Mona Lisa and talked about my life, how I had been a high-flying art forger and how now I was living down and out in Newport Beach. After the article came out, a few people contacted me for paintings. They'd call Scott and he would put them in touch with me.

Little by little, I started getting a trickle of work. Mostly, I'd paint novelty pieces, reproductions for people's homes and corny stuff like an eighteenth-century general on horseback with the customer's face painted into the picture. It wasn't high art, but at least I could afford to eat.

twenty-four

THE BIRTH OF TONY MONTANA
(the 2000s)

AFTER A WHILE, THE NOVELTY PAINTINGS TURNED INTO BET-ter and better commissions. First, I did a series of Impressionist paintings for a wealthy family with siblings in Newport and Beverly Hills. And then Bouguereau, Renoir, and Monet for a big shot I met at Margaritaville. He raced yachts and had been worth $20 million before he started drinking. He paid me $35,000 and left pretty much the rest of it at the bottom of a bottle.

With that money I ended up taking my first trip to Costa Rica, which probably saved my life. I had been in the audience at some quack's investment seminar in Newport when I got called up to the stage. It was for a medical device that had to do with heart surgery. He took a black-and-white sonogram of my throat and saw that my carotid arteries were clogged. As I was leaving the stage, he whispered, "Hey, pal, you need to get that checked out."

The next week, I went to the hospital and was shocked to hear that I was 70 percent blocked and that I would need a surgery costing over $150,000. I didn't have the money, and I didn't have insurance, so I ended up in Costa Rica, which had a reputation for excellent private hospitals that could do the job at a fraction of the cost. My friends had been raving about the country for years, and so I figured I'd go down, get myself checked out, and have a little vacation too.

When I got to Costa Rica, they told me that my carotid arteries were 95 percent blocked and declared me a walking time bomb, only minutes away from a massive stroke. I went straight into the Clinica Biblica, where the next morning, they put a stent into my left-side artery. I stayed in the hospital for a couple of days and then they let me out with some blood thinners and a warning to take it easy.

Maybe it was the fresh, unimpeded flow of blood to my brain, but I felt great. I stayed at the Hotel Balmoral and had a wonderful time, meeting a happy, jovial community of American expats, fishermen, rogues, and drinkers, plus the locals who mingled with them. For the first time in a long time, I felt free.

When I returned for the second operation, I flew in a few days early and lived it up with my new friends. At the hospital, I thought it would all be routine, but it turns out my second side was much worse off than they had thought. They had to drill out my artery and put in two more stents and a mesh sack in the blood vessel that led to my brain to catch the debris. It ended up costing me an extra $15,000 that I didn't have and maxed out every single cent on my credit cards.

What's more, I almost died in post-op. At the last minute, they injected me with some kind of adrenaline or something that saved my life. I was totally lucid and could hear them talking about how

I was not going to make it. I guess all that new blood must have shocked my brain.

When I got back to Newport, I was totally broke, but it didn't bother me so much. Now, I had a second lease on life. If I hadn't gone to see that quack and if I hadn't had the surgery, I would have had a massive stroke and I'd be a dead man or an invalid. I was almost cheerful when I brought all my gold watches to the pawnshop. While the guy counted out $7,000 in cash, I counted my blessings.

A couple weeks later, I got a call out of the blue from a billionaire in Aspen. He had a mansion he was decorating and he wanted old masters for the walls. A friend of a friend had told him about me and he was excited to see me right away, but I didn't make too much of it. I'd get requests from people who got excited about paintings all the time and then they'd bow out when it came time to pull the trigger.

This guy was different. The next week, he bought me a plane ticket to Colorado and set me up in his guesthouse. When I arrived, I was amazed at his mansion. It must have been thirty-five thousand square feet and featured a two-hundred-seat auditorium right in the atrium.

As we walked through the house, he showed me where he imagined a whole series of huge paintings—a Caravaggio here, a Rubens there, a Monet in the guest bedroom. Though my mind was racing at the prospect of a big score, I was worried about how I was going to pull it off. I lived in a motel and barely had a closet. Where was I going to paint these massive pieces?

As a trial run, the billionaire picked a huge Rubens tableau, a seven-by-twelve-foot called *Peace and War*. It was full of dynamic activity and featured a dozen figures. He wanted it in eight weeks,

and if he liked what I did, I would have work for the next decade. I told him no problem, but as I rode back on the plane, I had no idea how the hell I was going to do it.

When we landed, I drove straight to the Puente Hills Mall. There, I had met a Korean portraitist who had a little kiosk next to a pretzel shop. I had seen him paint and I had chatted with him, and though he worked in an unfashionable mall in the outer reaches of LA, I could see that he was talented. It turned out that he had an advanced degree in fine art from a top university in Korea and knew what he was doing. He spent ten hours a day painting, six or seven days a week, and had the professional chops that a studio painter in the Renaissance would have had.

In no time, we tacked a huge canvas up in the spare bedroom of his home in Diamond Bar and went to work. T. C. showed me his technique for blending color, masterfully feathering in sfumato so that you couldn't tell where one color started and another ended. In return, I showed him how to paint with textured strokes of color as Rubens would have done.

We worked feverishly for almost two months, and then when we were done, we got the canvas stretched and shipped the painting to Aspen. Though his designer snidely called the painting "an *interesting* interpretation of Rubens," the billionaire loved it and ordered three more. In reality the designer had only trashed the piece because she knew she wouldn't be getting a commission on the scores of paintings that would follow.

Over the course of the next five years, I did ninety-nine paintings for the billionaire—huge Raphaels, Rubens, Caravaggios,

Bouguereaus, Monets, Degas, Tiepolos, and other smaller paintings for his mansions in New York, London, and Saint Thomas.

To handle it all, we hired a couple more assistants, talented, professionally trained painters T. C. knew from his Korean Presbyterian church in Chino. For months at a time, we would work on three or four paintings simultaneously. T. C. would mix the colors for all of us on paper plates and we'd share them across the different paintings tacked up in my new studio—a garage off Orange Avenue in Newport.

It was the closest I can imagine a modern team would be to a Renaissance or Baroque studio, where several artists and assistant painters would collaborate, drawing, painting, and touching up a canvas together.

The billionaire's framer couldn't believe how much work we did and he kept trying to get me to up my prices so that he wouldn't look so bad charging what he did for his frames. I probably could have, but I didn't. Why mess with a good thing when I had finally started making some real money again?

Occasionally, I would fly out to Aspen when the billionaire wanted to talk about art or when he would throw a special concert in his auditorium. He and his wife would sit on these big elevated thrones set in the middle of his guests, and I'd sit next to him, though lower down, like a trained monkey.

His wife would get up and sing for the guests, and after she finished, they'd give her a long standing ovation, each person afraid to be the first to sit back down, just like when Stalin would give speeches at the Supreme Soviet.

Now that I was making money, I moved out of the motel and into an apartment. It wasn't a palace, but it was on the water and quiet. I started going to Costa Rica as often as I could. Being down and out in a place like Newport is not that fun. All anyone cares about is money and that gets boring after a while. I would contrast that with Costa Rica, where the people were nice, educated, and well taken care of, and where the Americans I knew were relaxed and fun-loving. At the airport in San José, there was a sign that said THE HAPPIEST PLACE ON EARTH, and I believed it.

Once, I even took the billionaire with me. I paid cash for everything because he didn't want to have a paper trail. We hit the honky-tonks and bars together, and I introduced him to all my new friends down there. He never had a better time in his life. In fact, he had such a good time that his wife banned him from ever contacting me again. Eventually, my work with him dried up, but with the new commissions coming in, I was back on my feet.

All in all, I probably made over $2 million from that work, and over the next few years I bought four Ferraris—a brand-new 458, a used 599, a 360 Spider—black with tan interior—and a new 599. I went to Costa Rica over 150 times, my escape from reality. I met many new friends. I met lots of women in the bars down there. We'd all go to dinner or out for drinks together. I became friends with my tailor and the hotel owner. I had a driver whose family I got to know. I would bring gifts for everyone when I went down. Every time I'd come to town, my friends would say, "Hey, Tony Montana's here!" It was like a party. Now I've legally changed my middle name to "Montana" so that when they call me that it will be legit.

I even started having a revival. Television shows and the press started contacting me again. Only now it wasn't because of a criminal trial. I was on *Fake or Fortune?*, one of the most popular shows in the UK, kind of like a high-art version of *Antiques Roadshow*. They asked me if I would take a look at a Chagall for them. I did, but it wasn't real. And, no, it wasn't mine.

I was also on an American show on CNBC called *Treasure Detectives*, which was kind of the low-rent version of the British show. It was corny. The director even had me open the door and check from side to side, sneaky, like I was on the lookout for cops.

I was invited to Australia to speak at a symposium about art forgery. I think they invited me there because they knew it would create controversy and good press. I talked about doing forgeries and I brought a Dalí *Crucifixion* and the preparatory drawing for it that I had done years before. I had a handler who would take me from one interview to the next, cameras and microphones back to back to back for three days. When I had to leave, she gave the last interviews instead of me. She had already heard it so many times that she knew my story better than I did.

A guy like me doesn't have much of a retirement account. I pissed away so much money and the dealers stiffed me so much that I still have to work. It would be nice to have a little bit of it back in the bank now, but I'm not complaining. I'm happy where I'm at. I'm not a millionaire, but I'm not in the motel. I'm just a normal guy, who still knows how to paint.

twenty-five

THE PRINCE'S FUGAZIS
(2014 to 2020)

IN LATE 2014, I WAS UP ALL NIGHT. I HAVE TERRIBLE INSOMNIA and I wasn't able to get to sleep for about three days. I had been looking at vintage cars online and I saw one in England. The next thing I knew, I was the proud owner of a replica 1957 330 T4 Ferrari race car. Problem was, there was no way I was ever going to be able to import that car into California because of emissions. I had to sell it back for $28,000 less than I paid for it, and though I doubt it, the dealer may have had a tinge of conscience, because a couple weeks later he contacted me with a possible commission.

A flamboyant billionaire had just been in to see him about some cars. He was interested in art, and the car dealer mentioned he had just sold a Ferrari to the infamous art forger who had been on *Fake or Fortune?* the night before. The billionaire's ears must have perked up because he asked if the dealer could put us in touch.

A few days later, I got a call from James Stunt, a notorious high roller who drove around London with bodyguards and a convoy of exotic cars. He had married Formula One racing heiress Petra Ecclestone, and the couple had just bought Candyland, the 123-room mega mansion in LA that was built by TV mogul Aaron Spelling. It was said to be the largest private home in California. I think they paid $85 million in cash.

Stunt told me he had just seen a Picasso sell for a record $179 million and he, too, wanted to put one on his walls. I suggested a cubist *Matador*, and over the next few weeks, we emailed back and forth about the details. He asked me to keep quiet about the art and say that we had met at the Concours d'Elegance in Pebble Beach. James even sent me a backdated handwritten letter on his personal stationery, complete with fake family crest, to verify the story. At the time, I didn't think much about it because most of my wealthy clients would ask me to keep quiet about their replica art.

When he was in London, James would stay up until morning and, with the time difference, he would call me almost every night. I was the only person who was awake. We would bullshit about art, cars, and life. James was kind of erratic and over the top. Sometimes he'd scream at me like a spoiled child and sometimes he'd be witty, charming, and funny. Most of the time I genuinely liked him and enjoyed talking with him.

Over the next two years, I did about a dozen pictures for him: Picasso, Monet, Dalí, Chagall, Degas, Caravaggio, Van Gogh, Domínguez, and Rembrandt. We would discuss them over email, and he'd forward me pictures of real paintings that dealers, experts, and auction houses would send him from London.

My conservator in LA, a brilliant Russian émigré I met through Stunt, would put magnificent frames on the pieces and I'd drive them over to his house in Bel Air, which he now called "Stunt Manor," though everybody told me they thought the house was bought with Petra's money.

I'd rent a truck to drive the framed paintings over. James would still be asleep and wouldn't wake up, so the maid would come down with $1,000 in cash and an apology, asking me to please come back another day. When I'd come back, this time in the early evening, James would finally be awake. We'd look at the new paintings and talk together about what we wanted to do next. We'd stroll around the house looking at his art, some of which seemed real. I'd see Petra and was surprised at how sweet, polite, and down to earth she seemed, very far from the caricature that the British tabloids portrayed.

In all, I probably went to the house three or four times to deliver paintings and meet James. Once, he asked me to come over with my paints and brushes. He had a cheap eighteenth-century painting by an unknown artist that he thought looked like a Constable. He asked me to paint a rainbow, an iconic feature of the British artist's works, right over the top of the landscape, while he hovered over me and instructed me on what to do. As soon as I was finished, with the paint still wet, he rushed it out the door to an expert to have it appraised. It was foolish. Just as I had told him they would, they stuck it under a black light and concluded it was laughable.

Though I didn't like it, James sometimes paid me with real paintings that he'd grab off the wall, first *Lady in Pink* and then *Mrs. Stanhope*, both by Joshua Reynolds, known for his portraits in

the eighteenth century. I wanted cash because it was less of a hassle, but he insisted on paintings, even writing me a letter saying how he was magnanimously gifting me this fine portrait as a generous birthday present.

One day, when James was back in England, I got a frantic phone call from him. He wanted to buy my Dalí *Crucifixion*, the one I had brought to Australia a couple years before, and wanted me to deliver it to London immediately. I was leaving for Costa Rica that night and didn't see what the big rush was. He went ballistic and insisted that I drop everything and fly over.

I was at one of those mailbox stores, and as he screamed at me over the phone, the owner, my friend, overheard the conversation. She asked if she could help. That same night, she was on a flight to London carrying a Tony Tetro Dalí in the overhead compartment. Stunt's people picked her up at the airport, paid her £5,000 in cash, and then she spent a couple of lovely days seeing Buckingham Palace and Madame Tussauds wax museum.

A couple days later, I was in Costa Rica when James called. He was whispering, "Tell him you didn't paint this." The next thing I knew I was talking to a guy with a heavy French accent. Guess who? Nicolas Descharnes, the son of Robert Descharnes, now dead, the guy who had sunk my Dalí at Christie's thirty years before. We had a friendly conversation and he told me, laughing, that he didn't consider us enemies, just adversaries. I genuinely liked Nicolas. We met a couple of years later and had a friendly drink together.

Turns out, James had hired Descharnes to come to London, had wined him and dined him, and asked him to bless my Dalí. It

was crazy. For one, Descharnes had already seen the painting from internet photos of my Australia trip, and even more crazily, James had claimed that the Wildenstein Institute had authenticated the painting. Anybody in the art world would know this was ridiculous. Wildenstein authenticated Monet and a handful of other French artists and would never even touch a Dalí.

More incredibly, after Descharnes wrote his report saying the painting was fake, James changed the document, said my painting was real, and sent it to another Dalí expert in New York, asking for confirmation. I didn't know if any of this was true: I only learned of this later from journalists who were investigating the story.

In 2017, James invited me to visit him in London. He had just gotten divorced from Petra and was staying at a temporary place in Chester Square. James had told me he wanted to discuss some new paintings and I brought him a Monet and a little Caravaggio portrait I had done on a whim. It was supposed to be a portrait of the young Leonardo, but instead of the Italian artist's face, I put my own face as a boy in its place.

In London I spent most of my time hanging out with Stunt's friendly and gregarious Lithuanian bodyguards, drivers, and security men. I can rarely sleep past seven a.m. anymore, but James would stay up all night and didn't wake up until the late afternoon. To entertain me, the bodyguards would take me to the British Museum or to Trafalgar Square or to the pub, where we'd have fish and chips and a pint of beer. I liked them, and they went out of their way to take care of me in James's absence.

My room in Stunt's home was on the sixth floor. I'd climb all the way up there and turn in early. In the morning I'd trudge back

down to the second-floor kitchen for coffee. Since James wouldn't be waking up for another eight hours, I'd eat breakfast alone.

One morning, as I was having coffee, I saw some documents on the table with Stunt's letterhead. Curiously, they showed pictures of my Picasso, Dalí, and Monet and mentioned a place called Dumfries House. All the paintings had provenance from the Wildenstein Institute and had been assigned fantastical values—completely out of whack with reality: £42 million for the Picasso, £50 million for the Monet, and £12 million for the Dalí. I was intrigued, so I snapped a couple of pictures with my phone.

That evening I had dinner with James, his godfather Terry Adams, who the press alleged was the mob boss of London, and Terry's wife, Ruth. I don't know anything about the mob rumors, but I can say that they were the kindest people I had met in London. Ruth made a roasted chicken and Yorkshire pudding and we had a nice dinner, chatting away about all the things I had done during my stay. They were genuinely interested in hearing about my trip to the British Museum and everything I had seen there. The next afternoon, I got a ride to the airport and flew back to LA while James slept upstairs. That was the last time I ever spoke with him.

When I got back home, I tried to contact James a couple of times, but he never called me back. Over the next year and a half, I'd occasionally see him on his YouTube channel and on Instagram and he didn't seem to be doing too well. His divorce had turned bitter and he had had his assets frozen by the court. The press was hammering him about it. He would rant and rave about his father-in-law, Bernie Ecclestone, and the publisher of the *Daily Mail*,

Jonathan Harmsworth aka Viscount Rothermere, insulting them and making wild claims that they had engineered a frame-up to make him look guilty of money laundering.

At one point James wanted to air a live polygraph test so that he could clear his name. The test never happened, but James did give a tour of his home, which he posted on YouTube. In it he showed off his many paintings and talked about how he had an eye for discovering hidden treasures. At one point, James showed off a Domínguez bull's head that I had painted for him. I had charged him $30,000, but on camera he said he had bought it from an auction house for £700,000. Really? I guess I should have charged him more.

Not long after, I saw an article in the *Daily Mail* that set off alarm bells. Though it didn't give details, it claimed that James was lending art to Prince Charles at his stately home in Scotland called Dumfries House. The article was titled "Why Does Prince Charles Allow James Stunt to Lend Him Art?" I did not want to find out from inside a jail cell. I showed the photos I had taken at Stunt's house to my cowriter Giampiero Ambrosi, an investigative journalist, and asked him if he could figure out what was going on. His findings became the basis of a documentary film that I participated in simultaneously with the writing of this book.

The investigation discovered that the paintings I had photographed at Stunt's kitchen table, plus one of my Chagalls, had indeed made their way into the Royal Collection of Prince Charles via Dumfries House. To me, this seemed ridiculous. The Wildenstein provenance was a joke, and the paintings themselves were

decorative, mostly on new stretcher bars with new paints and only cosmetically aged if at all. Even a casual observer would take one look at them and know that they were replicas for hanging in the den. How they ever got into the prince's collection is still a mystery.

For example, James had given my Monet, which he called *Lily Pads*, a date of 1882, more than ten years before Monet's garden at Giverny, the one with the water lilies, was even built. No expert could have accepted that. You didn't even have to see the painting to know it was fake. I had no idea why James was lending these paintings, but given my history, I had a funny feeling that it was going to bite me on the ass. That's why I decided to get in front of the story and nip it in the bud.

I flew to London and told the *Mail on Sunday*, a newspaper with one of the biggest circulations in the UK, that the Dumfries House paintings were mine and that I had painted them as decorations for James's mansion—just like the ones I had done for my Aspen billionaire and many other wealthy clients. When the story broke, the press, obsessed with anything involving the royal family, went bananas. The news was literally the entire first five pages of the *Mail on Sunday*. It was in *Vanity Fair*, the *New York Times*, the *Post*, the *Times of London*, *GQ*, *USA Today*—everywhere.

When it all came out, James issued an apology to Prince Charles on Instagram and denied that he had lent him any fake art. "The truth is a superpower," he declared, and claimed that all of his art was impeccable. However, Clarence House, the official headquarters of the prince, admitted that they had discovered the fakes and had already removed them from Dumfries. They had been returned, they said, to Stunt.

James kept changing his story. First, he said he didn't know me and that I was a criminal. Then he said that I was a liar and a "fruitcake" and that "he wouldn't hire me to paint his toilet." Finally, he said he had traded paintings with me and that it had all been a lark. To be honest, I don't blame James and I don't hold it against him. I still like him. He was under a lot of pressure, the divorce had shattered him, and I think the drugs he admitted to taking were not really helping.

It turns out that there was a method to James's madness. Not only did he like the ego boost of lending art to the Prince of Wales, giving his paintings the impressive-sounding title "The Stunt Collection at Dumfries House," but he also used the royal stamp of approval to try to get £50 million worth of loans using the art as collateral.

Originally, everyone thought that James had just mixed in a couple of my fakes with impressive paintings from old masters like Van Dyck to pad the value. In reality, most of what James put into the prince's collection were cheap knockoffs by the followers, students, or imitators of the masters. These lowball copies James had bought at auction houses for £5,000, £10,000, or £20,000 only a few years before. With his paintings in hand, James turned to the world-renowned expert, former museum director Sir Malcolm Rogers, CBE, to get his opinion before presenting them to the world as born-again full-blown Van Dycks, with newly minted valuations in the millions.

Rogers wrote fawning letters about James's uncanny knack for uncovering hidden treasures from the basements and remnants departments of auction houses. Though it's not unheard of to find a

real old master masquerading as a student's copy, finding a bunch, by one artist, from one collector, in the space of a few years, is nothing short of miraculous.

In addition to these letters, James had even presented fake sales receipts, saying that he had bought my Picasso, my Dalí, and my *Lily Pads* from the famous mega dealer David Nahmad in Switzerland. The receipts were simply recycled invoices that had replaced the real transactions with the fraudulent millions he supposedly paid for my forgeries. It was crazy: all you had to do was call up Nahmad to confirm that they were fake.

In the final analysis, while Stunt claimed the total value of his art at Dumfries House was worth around £200 million, in reality it was most likely worth somewhere between £2 million and £5 million.

Petra, who had remained silent during all of this, finally made a statement. She claimed that James had never been a billionaire and that his businesses and art and cars had been paid for from her family fortune. She talked about his addiction to serious drugs and his inability to tell the truth. She even confirmed that I had been to the house to deliver my art. It wasn't pleasant, but to her credit, she said her piece and then she was done. She hasn't spoken out about it since.

I still don't know all the details, especially about the royal family. We'll have to wait and see what else happens. Who knows, by the time you read this book, even more may have been discovered. All I know is that whatever happens, this time around, I'm not selling off my cars and I'm not going back to jail.

FINALE

TODAY IF YOU WENT TO 450 BIRMINGHAM COURT IN CLARE-
mont, California, you'd see an unassuming condo with a red tile
roof. Up until a few years ago, if you had gone inside and pressed
#* on the phone, a full-length mirror would have popped open and
you could see inside my secret room. It's gone now, but at one time,
it contained everything that a professional forger would need.

It's hard to believe, but I've been at this for over fifty years.
When I started, it was almost on a whim. I had no idea it would
last this long. I simply saw what other forgers got away with and
it inspired me. I thought, "How could anyone be fooled by this?"
And I wanted to do it better. I think I did. During their era, for
provenance, all Elmyr de Hory had to say was that he was Picasso's
friend. Han van Meegeren, who painted poorly, said, "I got it from
an Italian family who wishes not to be named." Today, provenance

is more important than the painting itself. If I had lived during that time, I'd have been a billionaire.

Still, looking back, even with jail and all the ups and downs, everything turned out wonderfully. I think the best thing that I ever did for Marguerite and my daughter was to take them out of Fulton. Like most of central New York, it went from a Norman Rockwell town to a ghetto. If I had stayed there, I'd probably be dead. I'd definitely be on welfare.

Once, when I was about thirty, I was in Florida and I went with my father in his truck to the hardware store. He introduced me around as his youngest son, joking that I was the smartest of them all because I never worked a day in my life. He judged a man by how hard he worked, and though I wasn't painting houses or digging ditches, he knew I tried hard and had perseverance. He didn't know exactly what I did, and he died before I was arrested, but if he had seen me that night at Silvio when everyone was whispering, "Tony Tetro . . . Tony Tetro . . . Tony Tetro," I think he would have been proud.

I always worked hard and tried to do my best. Even with James Stunt, it wasn't so much that I was upset by what he did; that would be hypocrisy. What I objected to was that everything had been so half-assed, so amateur. I didn't think it lived up to my standards. I mean the new materials, the corny titles, the laughable provenance. He even took pictures for the newspapers with a fake Picasso, saying it was worth millions, when the real one was on display at MoMA. You can't do that.

Anyway, that's all water under the bridge. I wouldn't change a thing. Even jail was a valuable lesson for me. I had fun in the early

days traveling around Europe and going to Monaco. I had fun partying with my friends at the Peach. I made a couple of true friends in Charles and Tommy Wallace. They were honest and sincere, and their word was as good as gold. That's a rare commodity in my business.

I hope nobody reads this book and thinks that they can be a forger too. People ask me all the time to teach them how, but I tell them, "Forget it, you're going to end up in jail." Why put more crime into the world? Besides, with new technology, the ubiquity of information, and the internet, it's impossible to do what we did. That world is gone.

With the time I have left, I want to live it up. I hope that I can stay healthy and travel. I want to go back to Europe again and visit the museums that I loved so much. I would see the Vatican and the Villa Borghese and Uffizi and probably go back to Paris to revisit the Louvre. In a couple of months, I'm going back to London for the British Museum. In a couple of years, I want to retire in South America.

In my remaining years, I'd like to try my hand at fine watches made with precious metals and unique artisan movements, a subject that I've been obsessed with and have studied for over forty years. It could be a family project with my daughter and granddaughter, who both have degrees in business. If I could do that, I would give up painting in a heartbeat. In fact, if I never painted again, I really wouldn't care. I've done enough of that already and I have nothing left to prove.

Acknowledgments

Tony Tetro would like to thank readers of this book and hopes that they found his story interesting.

Giampiero Ambrosi would like to thank Jeff Kleinman, founding partner of Folio Literary Management, and a wonderful, far-sighted agent; he has been an enthusiastic champion of the book and a trusted confidant. Brant Rumble, editorial director at Hachette, who expertly steered the book with intelligence, gusto, and a steady hand; he made it effortless to focus only on writing, and his subtle editorial talent improved the book immeasurably. Mollie Weisenfeld, assistant editor at Hachette, who helped navigate countless details with grace. Sharon Kunz, Hachette's assistant director of publicity, and Ashley Kiedrowski, for passionately telling the world about *Con/Artist*. Amber Morris, Hachette's senior production editor, for keeping the train chugging along. Erin Cox, for her unstoppable positivity, gregarious spirit, and perceptive

insights; she is the cool, brilliant, can-do pro everybody wishes they had in their lives.

Giampiero would especially like to thank his remarkable wife, Denise Ambrosi, for her perseverance and encouragement while he wrote the book and decamped to London for filming. It's now time to swap places so that she can get back to her own endeavors. He would like to thank his lovable daughter, Amelia, the world's greatest reading and wrestling partner, for her enthusiasm and wit.

Heartfelt thanks to Caroline Calvin and Peter Calvin for providing a writing haven one floor up from the commotion of daily life and to Peter Calvin for his masterful photos, use of which he so generously granted.

Thanks to Kief Davidson and Mark Hollingsworth for a great collaboration and a wild ride on the James Stunt train. And to Nick Pyke, Sarah Oliver, Kate Mansey, and Georgina Adam for exemplary work in London.

Special thanks to Andrea Feldberg, Alex Deighton, Matt Turk, Holly Brunk, Sergio Ambrosi, Julie Chang, Leif Drake, Dennis Smith, and Marco Beltrami for kindly reading drafts and offering encouragement.

And to Brenda Simmons, who foresaw it all years ago, many thanks.